Napoleon's
Privates

Napoleon's Privates

2,500 Years of History Unzipped

TONY PERROTTET

HARPER
ENTERTAINMENT

An Imprint of HarperCollinsPublishers

HarperCollins books may be purchased for educational, business, or sales promotional use. For information please write: Special Markets Department, HarperCollins Publishers, 10 East 53rd Street, New York, NY 10022.

FIRST EDITION

Designed by Chris Welch

Library of Congress Cataloging-in-Publication Data has been applied for.

ISBN 978-0-06-125728-5

08 09 10 11 12 WBC/RRD 10 9 8 7 6 5 4 3 2 1

IN MEMORY OF

John Kingsley Lattimer,

OMNIVOROUS COLLECTOR

Contents

Napoleon's
Privates

Welcome to the Secret Cabinet

Whenever someone implies that history is boring, I bring up Napoleon's penis. Suddenly, they're riveted to the spot. While the emperor's *baguette* was notorious enough during his lifetime, it achieved celebrity status in its own right after Napoleon's death in 1821, when it was allegedly sliced off during the autopsy and stolen by his sleazy and resentful physician. The story of Bonaparte's manhood, both while attached to his person and while roaming free, manages to combine everything we need to connect with the past: sex and fame, love and glory, tragedy and farce. It's a rip-roaring saga, bigger than *Ben-Hur*. And history is brimming with such riotous tales.

Back in the dark Victorian ages, anyone who wanted to learn about such juicy history would have had to visit special places called the "Secret Cabinets." These were designated rooms within the great museums of Europe—the Louvre, the Prado, the British Museum, the Museo Nazionale in Naples—where anything deemed scandalous was kept under lock and key, and access was granted only via application (or bribing the security guard). Behind those sealed doors lay a candy store of sinful treats: explicit frescoes from ancient Roman villas; erotic devices discovered in medieval abbeys; volumes of illustrated Venetian porn; wicked relics from Georgian S-and-M clubs.

These days, private lives are up for grabs. Historians are hot on the trail of the most intimate human details, with whole shelves of

books now devoted to the history of masturbation, and *National Enquirer*–style exposés on the bedroom habits of everyone from Joan of Arc to J. Edgar Hoover. In certain academic circles, the only lesbian nun ever found in Renaissance Italy is more famous than Paris Hilton. At the same time, entire fields of human experience that were once deemed unworthy of serious study—food, drink, fashion, wine, drugs—today inspire loving attention. But sadly, many of the best stories are being lost in the deluge of words. Hilarious anecdotes get buried in the footnotes or deadened with jargon; it can be a real struggle to find the gems. Sure, history has come a long way out of the closet, but it still has a distance to go.

Think of this book as a modern version of those original Secret Cabinets—a collection of the choicest morsels culled from the dark recesses of Western history, for the edification of the curious. Crack its spine the way you might swing open a museum's mahogany doors, and poke about at random. One gallery will interest the adventurous lady-about-town, another the open-minded gentleman-scholar. There are scandal sheets on the past's most illustrious figures. Exposés on history's hypocrites, killjoys, and prudes. Reports on orgy etiquette through the ages. The most decadent foods. Tales of financial skulduggery and deceit. And, yes, a drawerful of celebrity body parts.

Far from trivializing history, I hope to bring it fully to life. To enter the past in our imaginations, we need *some* common ground with our ghostly ancestors—and what better place to start than humankind's eternal appetites? Qualities that rule our lives today, such as lust, vanity, fame, and greed, were already going strong two thousand years ago.

Tell strangers at a dinner party that you're obsessed with ancien régime France and you will be greeted with polite smiles and eyes slowly glazing over. But tell them about the dreaded impotence trials of seventeenth-century Paris—or, indeed, the first ups and downs of Napoleon's French loaf—and I guarantee their forks will freeze in midair.

The Champagne Glass–Breast Connection

(AD 1788)

How best to worship the perfect breast? Throughout history, men have dreamed of sipping fine wine from replicas of their lovers' busts, cast in glittering crystal. In antiquity, a temple on the island of Rhodes displayed a goblet that was believed to have been modeled on the breasts of Helen of Troy by her paramour Paris. In the Middle Ages, love-besotted French king Henry II had his wineglasses fashioned on the "apple-like" breasts of Diane de Poitier. And in the late 1700s, the legend sprang up that Queen Marie-Antoinette's breasts were the model for the shallow, broad-rimmed champagne coupes that are still often used today (although the modern fashion is more for the tall, thin, and decidedly unbreastlike champagne flutes).

There is no evidence at all in the case of Marie-Antoinette, although the queen did have a passion for bubbly. If nothing else, her ample figure, admired by her lech of a father-in-law, King Louis XV, and others, would have provided a higher-volume glass than the shallow coupes. But the royal breast–stemware connection may have begun with another, slightly more plausible story: Marie-Antoinette definitely did have a set of breast-shaped porcelain milk bowls created for her by the French porcelain factory Sèvres—and tradition holds that they were modeled on her own. Known as the *jattes tetons,* the creamy white gourds balance on a tripod base that is decorated with carved goats' heads. Marie-Antoinette was a

A NEW CONTENDER

T　*he most recent breasts supposed to have inspired champagne coupes belong to the American model and photographer Lee Miller. As she cut a swathe through 1930s Paris as the lover of surrealist artist Man Ray, Miller was widely regarded to have the most beautiful breasts in the city—thus, it's said, inspiring a French glass company to model a new coupe on her form. Miller's lovely figure appeared in many Man Ray images but was discreetly hidden when, as a war photographer in 1945, she posed naked in Hitler's bathtub in liberated Munich.*

devotee of the "back-to-Nature" movement that brought breast-feeding back into fashion in France, and she had ordered the cups for use at her fairy-tale dairy at Rambouillet, an echo of her fantasy farm at Versailles, where the queen liked to dress up as a shepherd-ess and frolic with her children and ladies-in-waiting. The shame-fully expensive service was delivered during the troubled year of 1788, the year before the Revolution exploded.

If the story is true, the cast of the queen's breast would probably have been made from wax under the control of one Jean-Jacques Lagrenée, the factory's co–artistic director. The four original bowls survive in the Musée National de Céramique de Sèvres in Paris, and the porcelain company still makes reproductions for connoisseurs.

SOURCES/FURTHER READING: Marilyn Yalom, *History of the Breast* (New York: Ballantine Books, 1997); Caroline C. Yung, "Marie-Antoinette's Dairy at Rambouillet," *Antiques Magazine* (Oct. 2000); Antonia Fraser, *Marie Antoinette: The Journey* (New York: Anchor Books, 2002).

Standing Up in Court

The Dreaded French Impotence Trials

(AD 1657)

Think the Spanish Inquisition was harsh? Just as intimidating to many men were the French impotence courts of the sixteenth and seventeenth centuries, when husbands charged with erectile dysfunction were obliged to prove their virility before witnesses.

A husband's inability to perform was one of the few reasons that the church would allow a marriage to be annulled, so disgruntled women who could afford the legal costs would regularly charge their husbands with "injurious non-consummation" before ecclesiastical courts. The legal tradition dated to the 1300s, when theologians agreed that the true aim of matrimony was procreation. Statistics are vague, but by the 1500s, says French historian Pierre Darmon in his detailed account *Damning the Innocent,* courts were faced with "a tidal wave of accusations." The onus was placed on the husband to demonstrate his powers of erection before an expert team of priests, surgeons, and midwives. These learned observers would carefully examine his equipment to reach an opinion on its "elastic tension" and "natural motion," before demanding "proof of ejaculation." Many men found that their powers would fade on first examination. "Just looking at you makes me shrivel," one humiliated husband moaned to his tormentors.

Any man who failed this test had only one recourse to avoid becoming a laughingstock. He could demand Trial by Congress,

wherein he would carry out his conjugal duty before the team of experts as 100 percent proof that he could perform. As recounted in a string of contemporary chronicles, this astonishing piece of legal pornography would take place in a neutral territory agreed upon by both parties. The married couple were examined by the court to make sure they were not concealing any devices—men were known to smuggle tiny vials of blood onto the scene, which would fool observers into thinking that the wife's maidenhead had been taken without actual penetration—then ordered to the conjugal bed. The male surgeons and priests repaired behind a partition to enjoy discreet observation, while the female midwives perched by the pillows watching every move like hawks. With the husband and wife long estranged, the wrestling beneath the sheets was far from amiable: there was bickering and harsh words, with one wife crying that her husband had "put his finger therein [to] dilate and open her by such means alone." One critic of the trials noted that it would take only a "marvelous determined man and even brutish not to turn flaccid." After one or two hours, the experts approached the battle scene with candles to establish whether or not there had been penetration and suitable "emissions." One defeated husband, a certain Monsieur De Bray, although his member had been declared by the doctors "big, stiff, red and long . . . in place and in good order," lost his case as he had only scattered "aqueous" seed upon the mattress.

The women who had the funds to start impotence trials were almost all from the aristocracy, so it is not surprising that each new charge provoked a salacious scandal that was disseminated by Parisian pamphleteers—the predecessors of the modern tabloid press—to a bemused wider audience. By the mid-seventeenth century, a carnival atmosphere was attending the trials, as shown by the case of the handsome young nobleman René de Cordouan, the Marquis de Langeais, recorded in detail by the contemporary chronicler of Parisian life Tallemant des Réaux. Accused of impotence by his wife of

four years in 1657, the marquis appeared to have an open-and-shut case when the first examination suggested that his wife was not a virgin. But there was lingering doubt and innuendo, so the marquis decided to restore his sullied reputation through Trial by Congress.

In Paris, bets were laid on the outcome of the trial and dirty songs composed. Society ladies flirted with the marquis, with a certain Madame d'Olonne declaring openly, "*I* would so like to be condemned to Trial by Congress." When the feuding couple appeared at the site, a luxurious bathhouse, servants had to force a path through the crowd of curiosity seekers. The mob's sympathy was squarely with the dashing de Langeais, who was thought to have been falsely accused by a harridan. The wife, Marie de St. Simon, was loudly booed while the marquis strutted arrogantly before his admirers ("for all the world as if he were already in"). As he slipped beneath the sheets with his wife, de Langeais jauntily yelled to the doctors: "Bring me two fresh eggs, that I may get her a son at the first shot." But disaster struck. The marquis was heard by the doctors to be grunting, cursing, and finally praying. After two hours de Langeais gave up, crying, "I am ruined."

Shock waves rippled through the crowd outside, and the female admiration for de Langeais turned to scorn. His request for a retrial was denied, and in France his name became a byword for flaccidity. The marquis retired to the provinces, where he married again—and sired seven children. When de Langeais boasted of this to a former enemy, the man archly replied: "But sir, nobody has ever had any doubts about your *wife*."

SOURCES/FURTHER READING: Pierre Darmon, *Damning the Innocent: A History of the Persecution of the Impotent in Pre-Revolutionary France* (New York: Viking, 1986); Angus McLaren, *Impotence: A Cultural History* (Chicago: University of Chicago Press, 2007).

Why Castrati Made Better Lovers

(AD 1720)

L ong live the knife, the blessed knife!" screamed ecstatic fe-
male fans at opera houses as the craze for Italian castrati
reached its peak in the eighteenth century—a cry that was
supposedly echoed in the bedrooms of Europe's most fashionable
women.

The brainwave to create castrati had first occurred two centuries
earlier in Rome, where the pope had banned women singing in
churches or on the stage. The voices of castrati became revered for
the unnatural combination of pitch and power, with the high notes
of a prepubescent boy wafting from the lungs of an adult; the result,
contemporaries said, was magical, ethereal, and strangely disem-
bodied. But it was the sudden popularity of Italian opera through-
out 1600s Europe that created the international surge in demand.
Italian boys with promising voices would be taken to a backstreet
barber-surgeon, drugged with opium, and placed in a hot bath. The
expert would snip the ducts leading to testicles, which would wither
over time. By the early 1700s, it is estimated that around four thou-
sand boys a year were getting the operation; the Santa Maria Nova
hospital in Florence, for example, ran a production line under one
Antonio Santarelli, gelding eight boys at once.

Only a lucky few hit the big time. But these top castrati had ca-
reers like modern rock stars, touring the opera houses of Europe

from Madrid to Moscow and commanding fabulous fees. They were true divas, famous for their tantrums, their insufferable vanity, their emotional obsessions, their extravagant excesses, their bitchy in-feuding—and, surprisingly, their sexual prowess. Hysterical female admirers deluged them with love letters and fainted in the audience clutching wax figurines of their favorite performers.

This may seem to anticipate the safe, sexless allure of 1950s teen idols like Frankie Avalon. But congress with castrati was not at all physically impossible. The effects of castration on physical development were notoriously erratic, as the Ottoman eunuchs in the Seraglio of Constantinople knew. Much depended on the timing of the operation: boys pruned before the age of ten or so very often grew up with feminine features; smooth, hairless bodies; incipient breasts; "infantile penis"; and a complete lack of sex drive. (The only castrato to ever write an autobiography, Filippo Balatri, joked that he had never married because his wife, "after loving me for a little would have started screaming at me.") But those castrated after age ten, as puberty encroached, could continue to develop physically and often sustain erections. While most Italian boys went under the knife at age eight, the operation was performed as late as age twelve.

For Europe's high society women, the obvious benefit of built-in contraception made castrati ideal targets for discreet affairs. Soon popular songs and pamphlets began suggesting that castration actually enhanced a man's sexual performance, as the lack of sensation ensured extra endurance; stories spread of the castrati as considerate lovers, whose attention was entirely focused on the woman. As one groupie eagerly put it, the best of the singers enjoyed "a spirit in no wise dulled, and a growth of hair that differs not from other men." When the most handsome castrato of all, Farinelli, visited London in 1734, a poem written by an anonymous female admirer derided English rakes as "Bragging Boasters" whose enthusiasm "expires too fast, While F—lli stands it to the last."

Englishwomen seemed particularly susceptible to Italian eunuchs. Another castrato, Consolino, made clever use of his delicate, feminine features in London. He would arrive at trysts disguised in a dress, then conduct a torrid affair right under the husband's nose. The beautiful, fifteen-year-old Irish heiress Dorothy Maunsell eloped with castrato Giusto Tenducci in 1766, although he was hunted down and thrown into prison by her enraged father. Marriage with castrati was normally forbidden by the church, but two singers in Germany did acquire special legal dispensation to remain in wedlock. Male opera fans, meanwhile, sought out castrati for their androgynous qualities. Travelers report how coquettish young castrati in Rome would tie their plump bosoms in alluring brassieres and offer "to serve . . . equally well as a woman or as a man."

Even Casanova was tempted. ("Rome forces every man to become a pederast," he sighed in his memoirs.) His most confusing moment came when he met a particularly lovely teenage castrato named Bellino in an inn. Casanova was bewitched, going so far as to offer a gold dubloon to see the boy's genitals. In an improbable twist, when Casanova grabbed Bellino in a fit of passion, he discovered a false penis: it turned out that the castrato was a girl, whom historians have identified as Teresa Lanti. She had taken up the disguise to circumvent the ban on female singers in Italy. The pair became lovers, but Casanova dumped her in Venice; after bearing a son that may or may not have been his, Lanti "came out" as a female and went on to become a successful singer in more progressive opera houses of Europe, where women were allowed onstage.

SOURCES/FURTHER READING: Angus Heriot, *The Castrati in Opera* (London: Secker and Warburg, 1956); Susan J. Leonardi and Rebecca A. Pope, *The Diva's Mouth: Body, Voice, Prima Donna Politics* (New Brunswick, N.J.: Rutgers University Press, 1996); Enid Rhodes Peschel and Richard E. Peschel, "Medicine and Music: The Castrati in Opera," *Opera Quarterly* 4.4 (1986–87): 21–38; Cormio et al., "Vasoactive Intestinal Polypeptide (VIP) Is Not an Androgen-Dependent Neuromediator of Penile Erection," *International Journal of Impotence Research* (Nov. 4, 2004); Judith Summers, *Casanova's Women: The Great Seducer and the Women He Loved* (New York: Bloomsbury, 2006).

A Cry from the Chapel

Today, anyone curious about the castrati's unique voices can listen to a recording made in 1902 by the very last of the breed, Alessandro Moreschi (1858–1922). Even though the operation was banned in the early nineteenth century, Italian doctors continued to create castrati until 1870 for the Sistine Chapel, and Moreschi went under the knife at the age of seven. Although he was not on a par with demigods like Farinelli, Moreschi's voice, said an Austrian musicologist who heard him perform live, "can only be compared to the clarity and purity of crystal." Although Moreschi kept performing for the pope until 1913, his fame was assured eleven years earlier, when the American recording pioneer Fred Gaisberg had a few days free in Rome and paid a call on the Vatican Palace. Instead of a studio, Gaisberg set up his unwieldy and primitive gramophone apparatus in a salon surrounded by Raphaels and Titians. The forty-four-year-old Moreschi had only one chance to record and made a few nervous mistakes. "He is surprising, but never exquisite," opined the author and critic Angus Heriot, while one modern British curator dismissed him as "Pavarotti on helium." Still, his voice provides a unique slice of the past. To re-create the sound for the film *Farinelli, Il Castrato*, the Institute for Musical and Acoustic Research in Paris blended electronically the voices of a male countertenor and a female coloratura soprano; the combination emulates the dazzling range of the top castrati, whose voices could trill across three octaves.

SOURCES/FURTHER READING: Nicholas Clapton, *Moreschi: The Last Castrato* (London: Haus, 2004). The audio CD *Alessandro Moreschi: The Last Castrato* (1993) is available from Pearl Records.

First-Night Jitters

The Medieval *Droit de Seigneur*

(AD 1000)

As if it wasn't hard enough being a feudal peasant. Not only did you have to put up with a lifetime of squalor, toil, and gruel, but your landlord would elbow in on your wedding night. Before any peasant marriage could be consummated—so legend holds—the blushing bride had to be delivered up to the castle, where she would be forced to sacrifice her virginity to the brutish master. Often referred to as the *droit de seigneur*, "seigneurial right," although more properly called the *ius prima noctae*, the "right to the first night," this custom has been denounced for centuries in romance novels, operas, and Hollywood films, including Mel Gibson's *Braveheart*, as a symbol of medieval barbarism. But there has long been doubt as to whether the lurid marriage rite ever existed.

One diligent French scholar named Alain Boureau has gone through the evidence piece by piece and decided that, although there was plenty of random sexual harassment in the Middle Ages, there is no reference to any official lordly "right" over newlyweds. The closest thing is a fanciful poem from 1247, where some monks at Mont St. Michel are bitching about how local seigneurs behaved in the distant past, but the tale was not meant to be taken seriously. All the other descriptions date from later eras, when writers wanted to prove just how degrading the feudal system was. One Renaissance author named Boece described in great detail how a Scottish king, Evenus III, was in the habit of having his way with local

virgins, but on investigation it turns out that there was no King Evenus in medieval Scotland; the tale is a complete fabrication. Most references to the *droit* actually date from the years before the French Revolution, when popular disgust with feudal privilege was reaching boiling point: the practice was denounced by Voltaire and is used as a plot device in *The Marriage of Figaro* (which was a hit satirical play by Pierre Beaumarchais before becoming a Mozart opera). It turns out that the *droit de seigneur* is a lot like our modern urban legends—a fiction that confirms a popularly held belief, in this case that selfish nobles with hereditary rights were riding roughshod over everybody else.

SOURCE/FURTHER READING: Alain Boureau, *The Lord's First Night: The Myth of the Droit du Cuissage* (Chicago: University of Chicago Press, 1998).

Sex and the Renaissance Nun

(AD 1450)

Italian nuns have left quite a subversive legacy. This is thanks largely to the literary labors of Pietro Aretino, a Venetian author who is today hailed as the "father of modern pornography." In addition to his groundbreaking book of sonnets—*The Sixteen Postures,* which described a string of athletic sexual positions with handy engravings—Aretino penned the classic *Secret Life of Nuns,* whose panting prose would not be out of place on the nerve.com site today. It depicts lonely young novices in ritualized "jousts" with monks and priests ("First tilt went to the trumpeter . . . spurring himself on with his fingers, he ran his lance right into his lady-friend's target right up to the hilt . . .") and devoted to the *pastinaca muranese,* "crystal turnip," a state-of-the-art dildo made of fine Venetian glass and filled with warm water. The nuns kept erotic manuals hidden in their prayer books and always offered their charity to male pilgrims ("We'll try every which way," declares one nun as the penitents arrive, "there's bound to be *one* that suits us!").

Overheated? Certainly in the details. But while Aretino's work is hardly a documentary of convent life, its roots lie in reality. By poring over contemporary letters, diaries, and legal documents, historians have established that Venetian nunneries were the most liberated in Europe. In the 1400s, the skyrocketing cost of dowries meant that many of the city's noblest families were obliged to place

their teenage daughters, regardless of their wishes, in convents. Few of these developed a spiritual calling. It was openly accepted that the top convents were a "safety valve" for Venice's surplus of wellborn single women, who could go on to enjoy a level of sexual freedom unique for the time.

The nunneries were run like luxury boutique hotels. Novices were given duplicate keys so they could come and go as they pleased from their palatial apartments, which were filled with artworks and overlooked the Grand Canal. Wearing the most fashionable, low-cut dresses, they would entertain male visitors with wine-fueled banquets, then invite their beaux to spend the night in their rooms. They took romantic gondola rides with admirers to private picnics on the islands of the Venice Lagoon and went on poetic moonlit walks in the secluded gardens. The most passionate eloped—presumably with men who were not obsessed with dowries. The mature-age abbesses rode the city in luxury carriages with their pet dogs and oversaw their girls' activities with a maternal eye. If a nun fell pregnant, she would simply give birth in the privacy of the convent and then pass the child off as an orphan abandoned on the doorstep.

Church officials in Venice and Rome turned a blind eye to these activities, but reluctantly investigated some of the most blatant and scandalous cases. The Italian academic Guido Ruggiero has pored over countless documents to find that only thirty-three convents were prosecuted for "sex crimes against God" (as they were called, since the nuns were in theological terms the brides of Christ). The legal details read like a cheesy Italian soap opera. One Sister Filipa Barbarigo was found to have juggled ten different lovers at the same time—an impressive roster of nobles, artists, and even, playing with fire, her own abbess's boyfriend. Violent scenes of jealousy erupted one night at the busiest convent, Sant'Angelo di Contorta, when a certain Marco Bono interrupted his lover Filipa Sanuto in her room with another man and chased him into the street, then went after a dozen other nuns' naked boyfriends with his sword.

A few days later, the brother of one of Sister Filipa's other lovers pursued her angrily through the convent and slapped her for seducing the young boy with her "unbridled lusts." Signor Ruggiero's findings suggest that the church was zealous only in prosecuting nuns who had dabbled in "rough trade"—lowborn boatmen, carpenters, artisans, or gardeners.

By the 1500s, the famous nunneries of Venice even attracted tourists: male travelers from England and Holland were delighted to mingle with such refined women, who, like Japanese geisha, offered private musical concerts and engaged them in sophisticated conversation on literature and the arts. The Venetian diarist Girolamo Priuli denounced them as unofficial courtesans, sleeping with foreigners in exchange for financial presents. This discreet arrangement exploded in scandal in 1561, when a convent founded for reformed prostitutes was found to be in business, with the father confessor as pimp—having had relations with twenty of his charges himself.

Still, only one convent became so flagrant that it was closed down by the pope in 1474, Sant'Angelo di Contorta. The others continued their libertine activities unabated. As the author Elizabeth Abbot sums up, in a line worthy of Pietro Aretino himself: "Unwilling nuns understood only the hot tingling of their yearning loins."

SOURCES/FURTHER READING: Pietro Aretino, *The Secret Lives of Nuns*, trans. Rosa Maria Falvo (London: Hesperus Press, 2003); Margaret L. King, *Women of the Renaissance* (Chicago: University of Chicago Press, 1991); Guido Ruggiero, *The Boundaries of Eros: Sex Crime and Sexuality in Renaissance Venice* (New York: Oxford University Press, 1985) and *Binding Passions: Tales of Magic, Marriage and Power at the End of the Renaissance* (New York: Oxford University Press, 1993).

SAPPHO IN THE CONVENT

*D*espite the rampant bed-hopping going on at Italian nunneries, there is almost no mention of lesbianism in legal records. Sapphic love doesn't even get a passing mention as a sin in Dante's vision of hell. Strangely, while the idea of girls making out is a perennial male sexual fantasy in the modern age, writers in the Renaissance seemed unable to conceive that physical attraction was even possible between women.

Thus Benedetta Carlini, the abbess of the Convent of the Mother of God in Pescia near Florence, has today become celebrated as the only nun in Renaissance Italy to be prosecuted for "unnatural relations" with another woman. In the course of two church investigations between 1619 and 1623, she described visions where the statue of the Virgin Mary tried to kiss her, and her belief that a handsome angel named Splenditello had entered the body of a young nun, Bartolomea, whom she then engaged in ecstatic caresses. Other Italian nuns who were discovered taking male lovers usually received only a rap over the knuckles, but Benedetta was cruelly sentenced to a lifetime of solitary confinement within the convent, where she remained, lonely and ignored, for thirty-five years until her death.

SOURCE/FURTHER READING: Judith Brown, *Immodest Acts: The Life of a Lesbian Nun in Renaissance Italy* (New York: Oxford University Press, 1986).

Who's Responsible for the Stag Movie?

(AD 1915)

Pornography has served as a spur to the development of every new technology from the Gutenberg press to the Internet, but it was the Lumière brothers' first commercial cinema display in 1895 Paris that inspired creative smut on an international scale. The first "blue movies" were staid—pictures of a couple embracing, as in *Kiss in the Tunnel* (1899)—or static, women simply staring at the camera in various states of undress. But soon some anonymous geniuses recognized the narrative potential of the art form. From 1907, directors in France, Germany, and the United States began making one-reel films that included live sex acts with prostitutes, to be shown at bachelor parties. This struck a popular chord particularly in cutting-edge New York. The oldest surviving American stag movie is *A Free Ride* (1915), also known as *A Grass Sandwich,* which was shot in New Jersey and played for years in X-rated Manhattan cinemas.

The plot line, not surprisingly, is simple. A wealthy man-about-town gives a girl a lift in his flashy convertible but stops ten miles from her destination; he then offers to drive her the rest of the way in exchange for sex. She indignantly refuses and walks home. In the next scene, the caddish driver gives her a lift again. This time, he stops twenty miles from home, with the same offer. Again, she refuses. On the third day, he drops her fifty miles from home. This time she relents, and they make love on the grass.

As the girl brushes down her dress, she admits that she had been happy to walk ten miles, or even twenty miles. "But I'll be Damned if I Will Walk 50 Miles Just to Stop You"—cut to her gleeful face—"From Getting a Dose of the CLAP."

SOURCE/FURTHER READING: *Stags, Smokers and Blue Movies: The Origins of American Pornographic Film,* exhibit, Museum of Sex, New York, 2005; http://museumofsex.com/exhibitions/STAGS/index.html.

Napoleon Is Dead! Long Live Napoleon's Privates!

(AD 1821)

Celebrity memorabilia is big business these days, with Marilyn Monroe's bra or Mohammed Ali's boxers fetching astronomical prices at auction. But for specialist collectors, one intimate item is in a different class entirely: Napoleon's penis.

To the horror of the French government, which refuses to accept its authenticity, the relic has drifted around Europe and the United States since the emperor's death in exile in 1821, dried out like beef jerky and kept in a leather presentation box adorned with a gold-embossed crown. Adding insult to injury, the item now resides in a suitcase under a bed in suburban New Jersey. How could such a sacrilege occur? According to its nineteenth-century owners, the organ was illegally removed during Napoleon's autopsy by

his vindictive and possibly murderous physician, Dr. Francesco Antommarchi, then smuggled back to France by his corrupt, greedy chaplain, the Abbé Ange Vignali.

The modern world's most famous prisoner had died a little after 6 P.M. on May 5, on the British island of St. Helena, an isolated speck of rock in the South Atlantic Ocean. Napoleon had languished on the tropical island for five and a half years after the Battle of Waterloo, and for his last eight months he had been suffering from an agonizing and mysterious stomach illness. The postmortem was performed at the ex-emperor's last residence, a gloomy mansion called Longwood House, on the afternoon following his death. The operation was, by all accounts, a grisly and confused event: Napoleon's corpse was laid on a sheet-covered table in a small, dark room, into which seventeen men, British officials and French imperial entourage, were present at different times. The tropical heat was stifling; the atmosphere noisome. It is unclear if any of the observers stayed for the full three hours to witness the entire operation.

In the various memoirs penned soon afterward, eyewitnesses concur that the emperor's liver and stomach were removed and placed in two household containers filled with ethyl alcohol, but other details of the autopsy would soon provoke heated debates. Even the cause of death was unclear: five different autopsy reports were eventually produced, although it is generally agreed today that Napoleon died from stomach cancer. The question is, were other pieces of Napoleon's anatomy "souvenired" in the fading light? Surgeons today have pointed out that sleight of hand is shamefully easy even during modern autopsies. (Sir Arthur Keith, curator of the Royal College of Surgeons in London, reported in 1913 that it was a common medical practice: "I have known cases where great parts of the body were removed under the most strict surveillance.")

It did not bode well for Napoleon that the man wielding the scalpel at Longwood House, Dr. Antommarchi, was an unsavory character who also happened to have a motive for revenge. He was

the last of several physicians to attend the ex-emperor in exile—a second-rate Corsican-born academic who had arrived in St. Helena in late 1819 and immediately earned a reputation for laziness and ineptitude. Napoleon had detested Antommarchi from the start and often humiliated him, abusing him violently in front of others for his unexplained absences (he would disappear in the port of Jamestown whenever Napoleon was sick), his sullen disrespect, and his clumsy, painful treatments. Antommarchi was also the only man in Napoleon's entourage to whom the ex-emperor, pointedly, did not leave a centime in his will. In 1821, the assistant at the autopsy, Napoleon's Corsican chaplain Abbé Vignali, was no more trustworthy a figure: he was an illiterate, uncouth character who would die seven years later in a blood vendetta.

During the autopsy, it is certain that souvenirs were on everybody's minds: once Napoleon's body was sewn back up, the top-ranking British officer, General Sir Thomas Reade, ordered the bloodstained sheet to be torn into strips and distributed among those present. Later, after the ex-emperor's will had been read, Vignali oversaw the distribution of his personal effects among the French attendants, culling the most interesting pieces for himself. The next day (May 7), the British buried Napoleon's corpse near Longwood House within four coffins, as if they were still worried he might escape, one of tin, one of lead, two of mahogany. But stories soon began circulating in Paris that parts of the ex-emperor's anatomy had been smuggled from the island by his aides—locks of hair, molars, nail clippings, slices of his bowels, pieces of his ribs. To scotch rumors, the senior British surgeon who was observing at the autopsy, a doddery old man named Dr. Archibald Arnott, declared that he "had exercised the utmost vigilance in order that no part of the Emperor's body should be removed," and that the corpse had been under round-the-clock guard. In reality, the cordon was far from watertight. To the exasperation of the British authorities, Antommarchi had indeed managed to smuggle Napoleon's actual death mask back to Europe, and even deposited

two pieces of lower intestine, presumed to be Napoleon's, with doctor friends in London. But Vignali's bold claim, back home in his village in Corsica, was far more ghoulish and bizarre.

The long march of Napoleon's privates had begun.

In 1840, the British government allowed Napoleon's body to be repatriated to Paris, where the hero was solemnly interred in a colossal sarcophagus of red porphyry at Les Invalides. (The French also enclosed him in two extra coffins, making six in total.) But Vignali's relatives continued to lay claim to the most intimate part of the imperial anatomy, along with other St. Helena mementos like monogrammed handkerchiefs, white breeches, and teacups, guarding them religiously for nearly a century.

We know that in 1916 the Vignali Collection was put up for auction in London by descendants of the family, with the organ discreetly described in the catalogue as "a mummified tendon taken from [Napoleon's] body during the post-mortem." The *objet de corps* had not been stored in formaldehyde but exposed to the air; although it was placed on a bud of cotton wool in a tasteful blue case of dark brown morocco leather, it was looking much the worse for wear, having dried and shriveled over the preceding century. An unknown British purchaser passed the collection on to a London company called Maggs Brothers, which sold it in 1924 to the flamboyant American bibliophile, A. S. W. Rosenbach, for £400. Home in Philadelphia, Rosenbach boasted loudly of the relic's scandalous nature, showed it off at dinner parties to friends, and in 1927 even allowed it to be displayed in the Museum of French Art in New York. Word got out, and the item drew prurient crowds: "Maudlin sentimentalizers sniffed," a reporter from *Time* magazine noted, while "shallow women giggled, pointed." The actual relic, the reporter noted, was "something looking like a maltreated strip of buckskin shoelace or a shriveled eel." In 1969, the now-notorious Vignali Collection was back on the auction block in London. When it failed to sell, the British tabloids screamed: "Not Tonight, Josephine!" To make it more affordable, it was broken

up and auctioned in Paris in 1977. Although the event was mobbed by curiosity seekers, the French government remained stoically silent.

There, the penis was snapped up for 13,000 francs (US$2,900) by a Columbia University professor, Dr. John K. Lattimer—America's leading urologist. Lattimer himself had a curious history, having been the U.S. Army's specialist for the Nazis accused at the Nuremberg War Crimes Trials in 1946, and an avid collector of offbeat, morbid memorabilia. (He had obtained Hermann Göring's suicide vial, Abraham Lincoln's bloodstained collar, and strips of leather from the seat of JFK's car in Dallas, among other choice items.) Dr. Lattimer kept the Napoleonic prize at home in Englewood, New Jersey, and put it in a suitcase under his bed. He died in 2007, and his children have not made any plans regarding the relic. So far, it has been shown to only one person outside the immediate family—the author. The organ is certainly small, shrunken to the size of a baby's finger, with white shriveled skin and desiccated beige flesh.

Is the item authentic? At present, we can say only that it's not *impossible*. Lattimer had the object x-rayed at Columbia Presbyterian Hospital and found that it is definitely a penis. Its ownership, however, is unproven, and the French remain disdainful. So far, officials at Les Invalides, where Napoleon's magnificent tomb attracts thousands of tourists daily, have refused to even consider opening his coffins for DNA tests or examination. When telephoned by writers curious to discuss the story of Napoleon's missing organ, they slam the phone down with a Gallic oath.

SOURCES/FURTHER READING: Jean-Paul Kauffman, *The Black Room at Longwood: Napoleon's Exile on St. Helena* (London: Four Walls Eight Windows, 1999); Gilbert Martineau, *Napoleon's St. Helena, 1815–21* (New York: Rand McNally, 1969); Anton Neumayr, *Dictators in the Mirror of Medicine: Napoleon, Hitler, Stalin* (Vienna: Medi-Ed, 1995); Louis-Etienne St. Denis (known as Ali), *Napoleon, From the Tuileries to St. Helena: Personal Recollections of the Emperor's Second Mameluke and Valet* (New York: Harpers and Brothers, 1922). For more on the peregrinations of the imperial organ, visit www.tonyperrottet.com.

The Emperor's French Loaf

Whatever we make of the relic saga, one thing is certain: no historical figure has had his genitals scrutinized as often as poor Napoleon.

The public fascination actually began while he was still alive: in fact, unflattering stories about Napoleon's privates emerged in British war propaganda at the very start of his military career. During the Egyptian campaign of 1798, London tabloids reported that his adulterous first wife, Josephine, had nicknamed Bonaparte *bon-pour-rien*, good for nothing, and dwelled on unsavory Parisian rumors about his staying power and potency. After their divorce in 1810, another British cartoon showed Napoleon in the marital sack with wife number two, the nineteen-year-old Austrian bimbo Marie-Louise, who is remarking in horror: "My dear Nap, your bed accommodations are very indifferent! Too short by a yard. I wonder how Josephine put up with such things even as long as she did!!!"

In the two centuries since, Napoleon's entire body has been endlessly poked and prodded by posterity, as if there is something inherently comical about its functions. Tolstoy, for example, in *War and Peace* dwells lovingly on the emperor's toilet, portraying him as vain and decadent, swathing his pudgy, naked body in talcum and cologne, letting out little snorts as his chest hair is brushed by an aide. Hollywood likes to portray him as physically laughable—*Quills* (2000), for example, shows his feet dangling from the French throne like a child's. Today, any reference to Napoleon's private life is still reported in the tabloids, if it is humiliating. Perhaps we still want to cut this upstart Corsican down to size: he may look like a Promethean figure

(continued)

who rose from humble origins to take over Europe, but he was really only human.

SOURCE/FURTHER READING: David A. Bell, "Napoleon in the Flesh," *MLN* 120 (2005): 711–15.

Easy-Reference Chart
Where Are They Now?
Celebrity Body Parts

The fate of Napoleon's special purpose, kept in a suitcase under a bed in suburban New Jersey, is somewhat less illustrious than his life achievements might suggest. But this is hardly surprising. With our current craze for bringing historical heroes down to earth, it suddenly feels like the world is awash with famous bits and pieces.

As the ancient Romans used to say, *Sic transit gloria mundi.*

I. FAMOUS FRAGMENTS

	Provenance	Relic's Journey	Current Status
Joan of Arc's heart **(d. 1431)**	Although she is burned at the stake in Rouen by English, legend holds that Joan's heart miraculously survives in the ashes. (Modern forensic experts say that the heart	In 1867, Parisian pharmacist discovers jar of charred oddments marked "Remains found under the stake of Joan of Arc, virgin of Orleans." French patriots rejoice.	2007 DNA tests show jumbled remains to be Egyptian mummy flesh (a common medical remedy in Middle Ages), piece of linen, and cat's thigh bone—evidently

(continued)

I. FAMOUS FRAGMENTS

Provenance	Relic's Journey	Current Status
is often resistant to fire due to its high water content.) English burn body twice more, then dump ashes in Seine, but rumors persist that fragments were saved.		gathered as part of a nineteenth-century fraud when Joan was claimed by French as national hero.

Sir Thomas More's head

(d. 1535)

| After his execution by King Henry VIII for refusing to accept marriage to Anne Boleyn, head is parboiled and hung on Tower of London for a month. | Daughter Margaret Roper bribes gatekeeper for head as he is about to toss it into Thames ("to make way for others"). Legend has it that she keeps it in a "Leaden boxe" preserved in spices and is buried with skull in her arms. | In 1978, archaeologists open Roper family crypt in Canterbury and find skull in secret niche, one prominent tooth missing, as with Sir Thomas. Unproven, but generally believed to be authentic. |

King Charles I's vertebra

(d. 1649)

| When body of ill-fated British king is exhumed before dignitaries | Fragment is appropriated by Sir Henry Halford, | Halford's embarrassed heirs return macabre object to King |

I. FAMOUS FRAGMENTS

Provenance	Relic's Journey	Current Status
in 1813, fourth cervical vertebra (damaged in 1649 beheading) is accidentally not returned to coffin.	future president of Royal College of Physicians, placed in gold-lined box, and displayed on his dinner table; rumors that he also uses it as salt holder.	Edward VII, who reunites it with royal corpse.

Oliver Cromwell's head
(d. 1558)

In 1661, three years after his death, embalmed corpse of Puritan dictator Cromwell (who arranged execution of King Charles I, above) is evicted from Westminster Abbey, hung, and beheaded by royalists for regicide. Head is placed on pole on display for twenty-three years before being stolen by sentry.	Enters world of private curiosity collectors; in 1799, battered skull painted and displayed in Bond Street freak show; purchased in 1814 by Josiah Wilkinson; in 1950s, descendant Horace Wilkinson shows head to children but refuses BBC crew.	After scientists declare skull authentic, Cromwell's old college in Cambridge, Sidney Sussex, accepts head in 1960 and buries in secret location.

Galileo's finger
(d. 1642)

In 1737, ninety-five years after scientist's death, middle digit	In 1841, put on display in Florence Library, then	Dessicated digit accepted as authentic; still

(*continued*)

I. FAMOUS FRAGMENTS

Provenance	Relic's Journey	Current Status
is removed by Italian admirer Anton Francesco Gori when Galileo's body is disinterred in Padua for reburial in grand tomb. Finger revered for symbolically "pointing the way" from medieval ignorance to modern scientific world.	transferred to local science museum.	on display today in an egg-shaped glass case in Museum of the History of Science in Florence, surrounded by Galileo's scientific instruments.

Franz Josef Haydn's head
(d. 1807)

In midst of Napoleonic wars, two days after hasty burial in occupied Vienna, amateur scientist digs up corpse and pilfers head to study genius composer's cranium (in nineteenth-century pseudoscience of phrenology, intelligence was related to skull shape).	Theft discovered in 1815 when body is exhumed for reburial in Eisenstadt. Skull donated in 1839 to Vienna Academy of Music; in 1895, put on display in Academy museum in glass case on top of piano.	In 1954, skull reunited with body at elaborate church ceremony and reburied in Bergkirche Church, Eisenstadt.

I. FAMOUS FRAGMENTS

	Provenance	Relic's Journey	Current Status
Percy Bysshe Shelley's heart *(d. 1822)*	After drowned Romantic poet's corpse washes up on Italian coast, decomposing body is burned by friends on beachside funeral pyre, evoking Greek heroes. As poet Byron watches, miraculously intact heart plucked from ashes by roughneck Trafalgar veteran and writer Edward Trelawney.	After unseemly squabble, heart is presented to distraught wife, Mary (author of *Frankenstein*). Mary keeps heart wrapped in silk in book of Shelley's poetry, *Adonais*; for next thirty years, shows it off to visitors as part of Shelley "shrine" with original manuscripts and locks of poet's hair.	Inherited by son Sir Percy Shelley; reported buried with him in 1889 in St. Peter's Churchyard, Bournemouth. (Poet's ashes are in Protestant Cemetery, Rome.)
Beethoven's ear bones *(d. 1827)*	Ludwig van's temporal bones removed at autopsy in University of Vienna days after death, in effort to analyze composer's deafness. Last seen in possession of medical orderly, Anton Dotter.	Rumor spreads in Vienna that Dotter sold them to "a foreign doctor" (and music fan). After Beethoven is exhumed with Schubert in 1863 by phrenologists, two three-inch	Ear bones still lost, but skull fragments resurface in 2005 in Danville, California, having been passed down through four generations of Viennese family.

(continued)

I. FAMOUS FRAGMENTS

Provenance	Relic's Journey	Current Status
	pieces of Ludwig's skull go missing.	After DNA tests prove their authenticity, they are donated to San Jose State University.
Abraham Lincoln's skull fragments *(d. 1865)* After Lincoln dies from head wound at Petersen's Boarding House, frenzy of souvenir-hunting occurs; locks of president's hair, his bloodstained collar, suit cuffs, pieces of hotel towel dipped into his blood are removed. Surgeons keep pieces of Lincoln's shattered skull that were removed in treatment and later autopsy.	Relics passed on by family members, soon sought by private collectors at auction.	Skull fragments, locks of hair removed by surgeons, and bloodied suit cuffs are still on display today in National Museum of Health and Medicine, Washington, D.C. Shown alongside is "Piece of John Wilkes Booth, Assassin"—tissue taken from vertebrae during autopsy after execution. Lincoln's death bed, bloody sheet, and towel fragments now on display in Chicago Historical Museum.

I. FAMOUS FRAGMENTS

	Provenance	Relic's Journey	Current Status
Grover Cleveland's "left upper jaw lesion" (*excised 1893*)	Doctors on board presidential yacht remove cancerous lesion from inside Cleveland's mouth; operation is performed in secret due to national stress over financial crisis.	Body sample is donated to Mutter Museum in College of Physicians, Philadelphia.	Still resides in Mutter Museum, now surrounded by skulls of criminally insane and dwarf skeletons. Doctors restudy sample in 1977 and decide Cleveland was suffering from verrucous carcinoma.
Sarah Bernhardt's leg (*removed 1915*)	Upon amputation of internationally beloved (and famously sexy) French actress's right leg, injured in an accident several years earlier, American circus offers $10,000 for right to exhibit limb in public.	Offer turned down; "the divine Sarah" continues acting with wooden leg.	Whereabouts unknown.

(continued)

I. FAMOUS FRAGMENTS

	Provenance	Relic's Journey	Current Status
Thomas Edison's breath *(d. 1931)*	Friend and admirer Henry Ford requests that Edison's son Charles capture Thomas's last breath on his deathbed in a test tube; Ford believes this contains his soul.	A labeled test tube, corked and sealed with paraffin, is found in Ford's belongings on his death in 1950 (along with Edison's shoes).	Tube currently on display in Henry Ford Museum in Dearborn, Michigan, devoted to "authentic objects, stories, and lives from America's traditions of ingenuity, resourcefulness, and innovation."
Einstein's brain *(d. 1955)*	Apparently against Einstein's own wish that he be cremated, genius's brain is removed at autopsy within seven hours of death at Princeton, then spirited off by pathologist Thomas Harvey in mason jar. Harvey also removes eyes and gives them to friend, Einstein's eye specialist.	Harvey soon dismissed by Princeton University for refusing to hand over Einstein's remains. Takes brain to Wichita, Kansas, then in 1997 drives cross country from Princeton to California to present brain to Einstein's granddaughter. (See Michael Paterniti, *Driving Mr. Albert.*)	Brain returned to University Medical Center at Princeton, where it now resides. Eyes reportedly kept in optometrist's drawer for forty years; now in safe deposit box, New York City.

I. FAMOUS FRAGMENTS

	Provenance	Relic's Journey	Current Status
JFK'S Brain *(d. 1963)*	Returned to Kennedy family after 1963 autopsy.	In 1968, Congress orders brain returned for further study, but Kennedy family says it (and some other key items) is missing.	Evidently cremated by brother Robert to stop brain becoming public curiosity piece. Rumors spread that it was disposed of to hide evidence of "second gunman"/frontal shots in Dallas, or to hide signs of JFK's syphilis.

II. MEMBER-ABILIA

	Provenance	Relic's Journey	Current Status
Pharaoh Tutankhamen's phallus *(d. 1324 BC)*	In 1968, X-rays by Liverpool University researchers show Tut's penis missing, apparently "souvenired" four decades earlier by member of the famous 1922 archaeological team that discovered mummy, led by Howard Carter. Fingers pointed at Harry Burton, official cameraman who was left alone with unwrapped corpse in 1922 before it was swathed again for Cairo's Museum of Antiquities.	Mysterious. Burton dies in 1940; heirs remain silent. Some suggest phallic desecration was cause of "mummy's curse" that claimed team members in 1920s, including Lord Carnarvon.	Zahi Hawass, head of Egypt's Supreme Council of Antiquities, declares in 2006 that he has rediscovered King Tut's penis in sarcophagus during CT scan of mummy. Shrunken organ had fallen off in 1968. Skeptics feel Hawass is simply trying to stem disrespect of Egyptian icon.
Jesus Christ's foreskin *(d. AD 33)*	Baby Jesus circumcised eight days after birth according to Jewish tradition.	In Middle Ages, eight different towns in Europe claim to have divine foreskin.	In 1900s, Vatican distances itself from saucy relic; Day of Holy Circumcision

II. MEMBER-ABILIA

Provenance	Relic's Journey	Current Status
When Jesus ascends to heaven, Christians assert, sacred foreskin is left behind; passed on by Mary Magdalene to John the Baptist.	Vatican's officially recognized version in Rome is stolen by soldier in 1557 but ends up in hill town of Calcata, thirty miles north, where it is put on display until mid-twentieth century.	removed from church calendar. In 1983, Calcata parish priest declares that foreskin (which he had been keeping in a cardboard box in his bedroom) has been stolen. Italian conspiracy theorists blame Vatican, Mafia, neo-Nazis, and/or Satanists.
William Lanne's scrotum *(d. 1869)* On death of last full-blooded male Tasmanian Aborigine, known locally as "King Billy," an English doctor acting on behalf of Royal College of Surgeons steals scrotum sack for use as tobacco	Mysterious. Scrotum allegedly passed privately among Australian collectors.	All parts of Tasmanian's anatomy are lost. Skeleton of last female of group, Truganini, put on display in Hobart Museum until 1947, then buried in 1976

(*continued*)

II. MEMBER-ABILIA

Provenance	Relic's Journey	Current Status
pouch and skull for scientific study. After burial in Hobart, locals pillage rest of Billy's remains from grave.		

Rasputin's line and tackle
(d. 1916)

Elephantine member trimmed from "mad monk" after his 1916 murder by jealous Russian aristocrats in St. Petersburg; according to rumor, discovered by palace maid at murder site.	Turns up in Paris five years later, worshipped as fertility symbol by female white Russians in secret ceremonies. Claimed by Rasputin's daughter in California until her death in 1977. Trail elusive: one item bought at auction turns out to be dried sea cucumber.	An 11.8-inch organ is currently on display in Russian Museum of Erotica, St. Petersburg, in formaldehyde jar; owner claims to have bought it from unnamed "French collector" for $8,000. Authenticity seriously in doubt, since early descriptions of relic said it had been dried out, not pickled.

II. MEMBER-ABILIA

	Provenance	Relic's Journey	Current Status
John Dillinger's penis *(d. 1934)*	After death in FBI ambush outside Chicago cinema, newspaper photographs of Dillinger's corpse beneath sheet suggest unusually large (and erect) organ.	Legend says J. Edgar Hoover purloins penis and keeps it in jar, then donates to Smithsonian Institution, Washington, D.C.	Hippy protesters in 1960s who enter Smithsonian demanding to see Dillinger's organ are greeted with blank stares. Evidently, 1934 photograph was trick of light: Dillinger's arm, stiff from rigor mortis, lifted sheet to give impression of monster weapon.

The Nazi Dictator's Other Ball

(AD 1945)

When the Soviets finally released the autopsy report on Hitler's corpse in 1968, some twenty-three years after his suicide, it contained the startling datum that the führer was one testicle short. The body, which had been found in a shallow ditch outside the Berlin bunker on May 4, 1945, and partly burned with gasoline, was identified soon afterward through Nazi dental records (Hitler had terrible teeth, with distinctive metal implants for false incisors). On May 8, the strikingly named Russian autopsy surgeon, Doctor Faust Shkaravaski, found that Hitler's scrotum sack had survived the botched SS cremation intact—"singed but preserved"—but it was very definitely minus a bollock.

Why Stalin kept the report secret from the Allies is a mystery. But when the news on Hitler's ball finally did hit the West in '68, it was greeted with fascination and has inspired a cottage industry of explanations from industrious historians.

Theory #1: The Führer Was Born That Way

The possibility that Hitler was born with monorchism, one testicle missing, provoked a flurry of studies on his psychology, arguing that Hitler's evil was an extreme case of the behavioral changes that have been linked to this physical condition. Freudians suggest that boys with monorchism are obsessed with ordering the world, often

via architecture—and Hitler was certainly fascinated with building grandiose structures (not to mention designing an entire world order). Other psychiatrists have suggested that the genital defect might also induce "narcissistic-exhibitionistic-aggressive [tendencies], sadomasochistic fantasies, eroticized megalomaniac daydreams ... compensatory self-aggrandizement; heightened aggressiveness ..." and "revenge fantasies."

Theory #2: It Was an Old War Wound

Perhaps, historians have mused, the testicle went AWOL during the First World War, when Hitler was wounded by a bullet in the thigh, which possibly damaged the groin. After the Soviet autopsy came out in 1968, Hitler's doddery old former army commander on the Western front declared that, yes indeed, Adolf had been found to be one ball down during a standard VD physical. Later, the author Ron Rosenbaum managed to track down Hitler's even-more-geriatric physician from the 1920s, who insisted that Hitler's genitals were in fact quite normal. (Nazi records don't help here: by the time he had seized power in 1933, Hitler was refusing to undress for doctors; even his trusted personal physician, Dr. Theo Morell, only ever examined him in his underwear.) Such confusion has led some scholars to speculate that the führer was actually subject to a condition called cryptorchism, where one testicle intermittently recedes.

Theory #3: The Soviets Made the Whole Thing Up

The debate has been made even murkier by the suspicious coincidence that a favorite British song from the Second World War impugns Hitler's manhood. Sung to the catchy tune of the "Colonel Bogey March" (used in *The Bridge On the River Kwai*):

Hitler—has only got one ball,
Göring—has two, but very small;
Himmler is very sim'lar,
And Göbbels has no balls at all

The author Rosenbaum, who has probably delved deeper into the subject than anyone, concluded that the whole one-ball idea was a Soviet practical joke. The Russians were far from averse to doctoring information about Hitler to mess with Western minds. Keeping the autopsy report secret helped foster the rumor that Hitler had escaped to Argentina and was still alive. They leaked information about Hitler's skull to suggest that the führer had died "a coward's death" by poisoning rather than shooting himself. So where did the testicle idea come from? Rosenbaum speculates that while they were preparing the autopsy for release in the 1960s, Soviets consulted the defected British spies Kim Philby and Guy Burgess in Moscow, and the pair of upper-crust reprobates suggested including the datum on Hitler's ball as one last "fuck you" to the West.

SOURCES/FURTHER READING: Ron Rosenbaum, *Explaining Hitler* (New York: HarperCollins, 1999); Robert Waite, *The Psychopathic God: Adolf Hitler* (New York: Basic Books, 1977).

Who's Buried in Custer's Tomb?

(AD 1876)

Lieutenant Colonel George Armstrong Custer's wife, Libby, may have erected an impressive obelisk headstone for him at West Point military cemetery, New York, but it is very unlikely that the remains buried below are his. After the Battle of Little Bighorn on June 25, 1876, where Custer and 209 of his men were famously decimated, a full three days passed before an army burial detail arrived. What they found was not a pretty sight—"a sickening, ghastly field" as General Edward S. Godfrey put it. The bodies of the Indian dead had been removed after the battle by their families, but the Seventh cavalrymen had been stripped, scalped, pincushioned with arrows, and mutilated by Indian women venting their anger at the army, while the fly-covered corpses were bloated and blackened from three days under the summer Montana sun. Custer, one of the few who had not been scalped (at this time he had short hair and was balding), was found on Last Stand Hill in a sitting position between two soldiers. He was naked except for his socks, with two bullet wounds, one in his temple and one in the left chest; many years later, Godfrey confided to a friend that Custer also had an arrow forced into his penis, a detail that was kept quiet to spare his widow. Despite his celebrity status as a Civil War hero and bestselling author, the burial detail decided to leave Custer's body on the field. The soldiers were not only sickened by the carnage, they were genuinely concerned about further Indian attacks.

With only eight shovels between them, they hastily threw dirt on top of the dead. Then they dug a shallow grave for the fallen Custer, covered it with an Indian travois (a type of sled made from poles) piled with rocks, and beat a hasty retreat.

The American public wanted a more respectful burial for men they considered fallen heroes. But thanks to the remote location of the battlefield and ongoing fighting, a whole year passed before the military sent a second detail with pine coffins to collect the bodies of Custer, ten officers, and two civilians for burial in eastern graveyards. They arrived to find that the corpses had first been exposed to the harsh western winter and then the bones scattered around Last Stand Hill by coyotes. As Lieutenant John G. Bourke recorded: "Pieces of clothing, soldiers' hats, cavalry coats, boots with the leather legs cut off, *but with the human feet and bones still sticking in them,* strewed the hill." Custer's body had been disinterred from its shallow grave and the travois overturned. After misidentifying a nearby skeleton as Custer's—a note in the jacket pocket revealed that it actually belonged to a corporal—they had to choose another for the coffin. "I think we got the right body the second time," wrote one participant unconvincingly, but another remembered one of the leaders cynically muttering: "Nail the box up; it is alright as long as the people think so." On October 10, 1877, the skeleton was buried at an elaborate ceremony with full military honors at West Point, where it remains to this day.

SOURCE/FURTHER READING: Richard Hardoff, *The Custer Battle Casualties: Burials, Exhumations, and Reinterments* (El Segundo, Calif.: Upton, 1989).

Cleopatra—on a Scale of One to Ten
(40 BC)

I f Hollywood epics have taught us anything about the ancient world, it's that Cleopatra VII of Egypt was drop-dead gorgeous. The original femme fatale has been played only by sultry screen goddesses—Claudette Colbert, Vivien Leigh, Elizabeth Taylor. But just how beautiful was she? According to the ancient biographer Plutarch, men were hypnotized not by Cleopatra's looks but by her wit and charm: her beauty was "not of the incomparable kind that would astonish everyone who saw her," he wrote, "but her conversation was irresistibly fascinating, and her character utterly mesmerizing." She certainly knew how to make a memorable entrance: to meet Mark Anthony on the modern-day coast of Turkey, she arrived in a luxurious gondola dressed as Aphrodite and reclining on a golden bed as naked slaves fanned her with feathers. (The ancients did not share our sense of privacy; the minions would have kept fanning while the couple made love.) She also had a sense of humor, apparently switching with ease from erudite bon mots to the dirty barracks-room jokes favored by her soldier beaus. And she knew how to dress for any occasion: she and her raucous lover Mark Anthony were rumored to have had a riotous time slumming in disguise around the waterfront bars of Alexandria.

So what *did* Miss Personality look like? The problem is that, after her defeat and suicide by cobra bite, almost all of her statues were destroyed by Romans. Cleopatra's profile on many surviving coins,

which were minted in Egypt during her lifetime, is downright ugly: most depict her with a long, hooked nose that today would make her an advertisement for cosmetic surgery. Combined with a scrawny neck, she has what one curator has called "the features of a bird of prey." But these coins cannot be taken as serious portraits: minted during Rome's civil wars, they were deliberately stylized to show the queen as a fierce and terrifying conqueror-goddess, not a pinup girl.

Luckily, we do have a single marble bust that is definitely accepted to be of Cleopatra, although the nose is missing. Displayed in the Vatican Museums of Rome, it shows her as a "young, fresh, willful woman" (as one historian eagerly puts it), with large eyes that would have been accentuated with lavish applications of kohl, and full sensual lips with the hint of a smile. Her hair is pulled back into a bun and tied with a headband or diadem. She is not as Egyptian-looking as Hollywood likes to depict—Cleopatra was of Greek ancestry, the last of a dynasty begun by one of Alexander the Great's generals—but it bears out Plutarch's verdict that she was attractive without being Venus de Milo.

And Cleopatra's nose? Throughout most of Western history, a regal schnozz has been regarded as a sign of strong character; it may actually have been exaggerated on coins to show her imposing nature. In the sixteenth century, the mathematician Pascal would remark: "Had Cleopatra's nose been shorter, the whole face of the world would have been changed." But he was actually admiring the queen's forceful personality and intelligence, much as people might colloquially refer to impressive *cojones* today.

SOURCE/FURTHER READING: Guy Weill Goudchaux, "Was Cleopatra Beautiful?" in Susan Walker and Peter Higgs (eds.), *Cleopatra of Egypt: From History to Myth* (London: British Museum Press, 2001).

More Than Just a Pretty Face?
Giacomo Casanova
(AD 1764)

Casanova hated being told he was handsome. While strolling in the summer gardens of Sans-Souci near Berlin with him in 1764, King Frederick II of Prussia paused and said: "You know, you are a very good-looking man." Casanova had just been discussing arcane details of hydraulics, taxation, and the state of the Venetian military. "Is it possible, sire," he replied coolly, "that after this long, exclusively scientific disquisition Your Majesty sees in me the most trifling of qualities that distinguishes his grenadiers?"

Of course, the adventurer Giacomo Casanova, then age forty, certainly *was* good-looking—five feet nine inches tall, muscular, slim, with a swarthy ("African") complexion, sparkling eyes, and (in the words of one enthusiastic biographer) "greedy lips." But like many a modern starlet, he preferred to be admired for his more substantial qualities—his magnetic charm, his boundless confidence, his sharp intelligence, and his vital energy. (He boasted he had wasted only one day in his life, when he slept twenty-seven hours straight after a Herculean debauch in St. Petersburg.) These were the traits that had transported Casanova—the son of two Venetian actors and grandson of a cobbler, who at age twenty-six decided to call himself the Chevalier de Seingalt—into the most splendid courts of Europe and elevated him from a "merely" handsome gadabout to a celebrated force of nature. Naturally irresistible to many

women tired of overcivilized fops, he was the ultimate self-made man in a world still obsessed with class and privilege.

However Casanova preferred to be known, most people today recall him as the prototype playboy, and for this he has only himself to blame: liaisons with 122 women are described in his classic autobiography, *The Story of My Life*. (The soul of discretion, he gives his conquests pseudonyms, although most have been identified by scholars.) But in his own lifetime, his other achievements were just as startling.

He was the confidant of kings and philosophers, and he debated with the greatest minds of his day, including Voltaire, Catherine the Great, and Benjamin Franklin. He founded the National Lottery in France, which made him a millionaire (a fortune he lost and remade several times at the gambling tables). He translated Homer's *Iliad* into his Italian dialect, improvised poetry in Latin and Greek, and penned a half dozen plays in French. He wrote a three-volume history of Poland and a utopian novel. He produced pamphlets on philosophical issues (*The Soliloquy of a Thinker*), mathematical treatises (*Demonstration on the Duplication of the Cube*), and a protofeminist essay. (It attacked the common eighteenth-century belief that women's maternal drives made them intellectually inferior to men.) There is even evidence that he collaborated with Mozart on parts of the libretto of *Don Giovanni*. A social chameleon, he could discourse convincingly on any subject, posing in various instances as a doctor, an astrologer, and a magician. While still a young man he gained a law degree in Padua, trained as a friar, and was (improbably enough) ordained in Holy Orders. Later, he served for a spell in the military. He became a violinist in an Italian orchestra. He managed a theatrical troupe in Venice. He worked as a spy for King Louis XV of France. He won a pistol duel in Warsaw and led the only known escape from the Inquisition's impregnable prison in Venice.

Casanova managed all this with the assistance of incredible

luck. He can even thank the goddess Fortune for the survival of his *Story of My Life,* the literary masterpiece upon which his fame now rests. At age sixty-one and penniless thanks to a lifetime of profligacy, Casanova was given a sinecure by an admiring young count as the librarian of the Castle Dux near Prague (now called Castle Duchcov, in the Czech Republic). The aging adventurer actually began writing his autobiography on his doctor's orders: he was obsessing so much over mathematical problems that he was ruining his health, and the physician insisted that he write a memoir to relax.

In this endeavor, Casanova eventually filled 3,678 manuscript pages in French, some chapters revised fourteen times. The magnum opus was never published in his lifetime; in fact, it took some 160 years for it to appear in uncensored form.

The chain of fortunate circumstances makes it one of the great publishing success stories. On his deathbed in 1798, at the age of seventy-three, Casanova entrusted the tower of paper to his nephew-in-law. In 1821, the family sold the manuscript for a pittance to a publisher in Liepzig, who translated it, heavily edited, into German. Five years later, this poor German edition was translated *back* into French—a bowdlerized hodgepodge that was again censored, changed, and rewritten—and released in Paris. This wacky French edition was translated into English, while the manuscript languished in Liepzig. The handwritten original miraculously escaped destruction throughout the Second World War and was transferred to Wiesbaden before finally being rediscovered. It was only in 1960 that Casanova's unabridged French manuscript was published the way the author had intended—an epic, in twelve volumes—and translated into a dozen languages, in time for the sexual revolution that would ensure Casanova's immortality. His name is even a noun, listed in the *Oxford English Dictionary* as "a man notorious for seducing women."

SOURCES/FURTHER READING: Lydia Flem, *Casanova: The Man Who Really Loved Women* (New York: Vintage Books, 1997); J. Rives Childs, *Casanova: A Biography Based on New Documents* (New York: Allen and Unwin, 1961); Judith Summers, *Casanova's Women: The Great Seducer and the Women He Loved* (New York: Bloomsbury, 2006).

Always Dress for a Dungeon

Casanova knew the importance of a fashion statement, even when he was arrested by the Inquisition. When the police raided his lodgings in 1755 Venice, the thirty-one-year-old man-about-town insisted on donning his finest lace-trimmed coat and ruffled shirt, with a fashionably long feather protruding from his tricorn hat, before being escorted to the tiny cells called the Piombi, or Leads (so named because they were located under the lead roof in the attic of the Doge's Palace, which made them sweltering in summer and freezing in winter). Fully aware that his dungeon-wear was impractical, Casanova was expressing his contempt for the trumped-up charge of reciting blasphemous verse. More important, the outfit would eventually enable his escape.

Although nobody had ever succeeded in fleeing the heavily guarded prison before, Casanova immediately set to work on a plan. His first attempt was an abject failure. He had found a metal door bolt in the courtyard during one of his brief exercise walks, smuggled it back to his cell, and used it to dig a tunnel under the floorboards. But after several months of painstaking work, the guards thought they would do their likable prisoner a favor by transferring him to a cell that had more light and air. The nearly completed tunnel was discovered, and Casanova was placed under closer watch.

(continued)

Plan B was more daring. Casanova had somehow managed to keep the same metal bolt, which he smuggled to his cell mate next door—a disgraced monk named Martin Balbi. Signor Balbi was under looser surveillance: one night he prized a hole in his ceiling, climbed up, and helped Casanova out of his cell. Carrying his fine clothes in a bag around his neck, Casanova forced a way for them through the lead tiles onto the roof. After a series of hair-raising close calls, the fugitives made their way downstairs through the palace—only to find the front gate barred. This was when Casanova got dressed. One of the guards outside the prison saw Casanova in his fine hat and thought he was a well-to-do citizen accidentally caught inside after visiting hours. When the door was opened, Casanova and the monk pushed past and ran for the first gondola.

The incredible story was recounted by Casanova many years later in a book called *History of My Escape,* which became a bestseller. While some at the time believed the tale was a fabrication and that Casanova had simply bribed his guard, records discovered by twentieth-century historians in the Venetian archives confirm Casanova's flight, although without detail: a prison official simply describes the escape as "prodigious."

Hints of Cherry and Witch's Urine?

(AD 1400)

Today's oenophiles have to consider the possibility that their cherished wine bottles may be corked, oxidized, "maderized" (ruined due to overheating), refermented (gone fizzy in the bottle), or sullied by a contaminant. Things were much more straightforward in sixteenth-century Italy: you could just blame the witches. It was commonly believed that after their satanic midnight Sabbath parties, witches had the nasty habit of invading a village's wine cellars and sullying the vats with their urine or excrement. This, needless to say, did nothing for a wine's bouquet. Thousands of European women were being burned at the stake for their evil powers, but somehow the problem could not be controlled.

The situation was better if you happened to live in northern Italy's alpine province of Friuli on the border with Austria (still a fine wine-producing region), because there dwelt a team of occult heroes: the *benandanti*, or Good Walkers, a revered group of men who practiced white magic for the protection of local vintners. These specialists were identified at birth—they emerged from the womb with their faces wrapped in the caul or amniotic membrane—and as they grew up, they were instilled with a sense of sacred duty. By adulthood, a Good Walker would regularly slip into a deep, trancelike sleep, when his spirit could leave his body

and sally forth to do battle with the witches. Not only would these helpful dreamers protect the wine in the cellars, they saved the annual crops from devastation and stopped witches from sucking the blood from infants or stealing souls from the innocent. Often, these supernatural wine regulators returned from their moonlit journeys victorious; at other times they woke up exhausted and defeated.

Around 1575, the Inquisition grew suspicious of the Good Walkers, but after many extended interviews, investigators decided to class their gifts as "benign magic" rather than satanic, and no executions were ever carried out. Perhaps, like many a gout-ridden cleric of the period, they too were connoisseurs of the grape.

SOURCE/FURTHER READING: Carlo Ginzburg, *The Night Battles: Witchcraft and Agrarian Cults in the Sixteenth and Seventeenth Centuries* (Baltimore: Johns Hopkins University Press, 1983).

• •

NO MORE MÖET FOR YOU!

H itler may have been a teetotaler, but the rest of the Nazi high command made up for it by guzzling as much French champagne as they could get their hands on. After the conquest of France in 1940, the Wehrmacht set up a permanent office at Reims to control production and ensure a constant supply for top Germans. Champagne was the beverage of choice at the German-run restaurants in Paris (Maxim's was one taken over by the Nazis for officers on R & R); gluttons like Hermann Göring filled vast cellars with stolen bottles; and some of the last planes into besieged Stalingrad were actually carrying crates of vintage bubbly to the desperate officers. In the Berlin bunker, bottles were jovially cracked for Hitler's fifty-sixth birthday toast, ten days

before his suicide, even though the führer was a teetotaler. In a form of poetic justice, the surrender of the German army on May 7, 1945, was signed at Reims, where General Dwight Eisenhower set up his Supreme HQ around the corner from the most illustrious champagne houses of France.

. .

Who *Didn't* Have Syphilis in Belle Époque Paris?

(AD 1890)

Nobody who was anybody—at least if you read Deborah Hayden's book *Pox: Genius, Madness, and the Mysteries of Syphilis.* The disease had reached epidemic proportions in nineteenth-century Europe, and before the production of penicillin in the 1940s, there was no effective cure. Paris in the 1890s, as the continent's sex capital, was particularly hard hit. One French specialist in venereal diseases at the time estimated that 15 percent of the city's adult population was infected, a level that anticipates today's AIDS/HIV crisis. Among Parisian artists and writers, whose first sexual encounters were often with prostitutes and who disdained condoms, the level seems to have been much higher—the roll call of famous French syphilitics includes Gustave Flaubert, Charles Baudelaire, Guy de Maupassant, Édouard Manet, Henri de Toulouse-Lautrec, and Paul Gaugin. The art dealer Theo van Gogh was a long-term sufferer, and his brother Vincent may have been driven to his famous ear-lopping incident by syphilis. The disease was almost accepted as an inevitable part of life, and many bohemians even saw their first STD as a badge of honor. "I've got the pox!" crowed the novelist Guy de Maupassant in his twenties. "At last! The real thing"—and did his part as a carrier by having sex with six prostitutes in quick succession while friends watched on. It was even associated with possible romantic genius, as syphilitics were sometimes granted flashes of brilliance. When the poet Baudelaire

was hit by seizures in the streets of Paris in 1862, he wrote with a certain pride, "I felt pass over me the wind of the wings of madness."

As Hayden admits, "retrospective diagnosis" of historical celebrities is a wildly imprecise but irresistible art. It tends to be based on written accounts of the patient's symptoms and autopsy rather than any exhumed physical remains, and the evidence is often open to wide interpretation. Syphilis is the ultimate culprit: doctors once called it the Great Imitator for its wide range of possible symptoms and difficulty of diagnosis. The initial infection, revealed by a small sore on the genitals or lips, is often missed or misdiagnosed. The secondary stage, coming a few months later, involves a long menu of possible ailments, including joint pain, diarrhea, vertigo, chancres, seizures, headaches, and rashes. The disease then goes into remission for years, even decades, before reemerging at the final and most unpleasant tertiary stage—inflicting suppurating sores, damage to the nervous system, occasional blindness, violent mood swings, depression, and insanity. It was enough to send any hypochondriac to the doctor, except that the quack cures were almost as harsh as the disease itself. The most popular remedy was mercury, which could be inhaled as vapor, injected, applied to sores as an ointment, or most easily taken orally, as "blue pills." (These were made of licorice root, rosewater, sugar, and honey, plus a mercury level nine thousand times that recommended for human consumption.) A few patients noticed improvement in the very early stages of infection, but in the later stages doses were so high as to be toxic: most suffered racking pain, damage to liver, kidneys, and brain, the loss of teeth—not to mention bad breath.

It isn't just fin de siècle Paris where celebrities seem to have been plagued by syphilis. Today, if you Google almost any famous person who lived after the 1490s, when Columbus is thought to have brought the disease back from the Caribbean, you can find a historian who has diagnosed them as sufferers. (The explorer himself, of course, might have been a pioneer victim.) Hayden makes the case

for Ludwig van Beethoven, Franz Schubert, Friedrich Nietzsche, Fyodor Dostoyevsky, Edgar Allan Poe, Niccolò Paganini, Abraham Lincoln, Oscar Wilde, and Lord Randolph Churchill (Winston's dad), among others. Of the early twentieth century, the club is joined by Colette, Al Capone, Adolf Hitler, and Karen Blixen, aka Isak Dinesen, author of *Out of Africa*.

Naturally, syphilis is one of the many ailments that have been attributed to Napoleon in his illness-plagued last days in exile. He appears to have been prescribed mercury pills by his British army doctors, but was reluctant to take them.

SOURCE/FURTHER READING: Deborah Hayden, *Pox: Genius, Madness, and the Mysteries of Syphilis* (New York: Basic Books, 2002).

Holding Your Own at Caligula's Orgies

(AD 45)

If you happened to be wandering the streets of ancient Rome at dusk (or in the summer months, the seaside resort of Baiae in the Bay of Naples), you might be accosted by a slave inviting you to an imperial banquet. All rich Romans were expected to be fabulous entertainers—the more extravagant their feasts, the more powerful they were perceived—and the emperors were obliged to be the most over-the-top hosts of all. On most evenings, hundreds of complete strangers—males and females of all social classes, although with a bias toward the well-dressed and the good-looking—would be lured to events in splendid, marble-floored villas, where they would be bombarded with food and wine to the accompaniment of flute music and erotic Asian dancers. Prostitutes of both sexes would be on offer in the back rooms, and there is no question that many all-night celebrations became drunken debauches. And yet, the sort of indiscriminate multiple coupling we associate with Roman orgies was quite rare: the erotic artists of Pompeii only occasionally depict group sex, mostly of boys penetrating one another in "chains," and there are surprisingly few references in Latin erotic literature or even graffiti.

Attending one of Caligula's parties during his brief four-year reign would have been spectacular enough: he took a childish delight in "display foods" like loaves made of pure gold, fish dyed blue to make them seem as if they were still swimming in the sea, and

exotic meats molded into statues of lions and elephants. But the orgy experience was decidedly stressful. Even the most libidinous guests would have had problems getting into the mood when the host was both certifiably insane and unpredictably violent. On one occasion, Caligula chuckled to himself at the dinner table, and when asked why, explained: "Because if I nodded once to my guards, I could have all your throats cut." A slave who was caught stealing silver had both his hands chopped off and hung around his neck, then was paraded before the guests—a disconcerting sight even for Romans hardened by gladiatorial displays. And while sex was certainly on the menu, Caligula's own foreplay also left something to be desired. According to Suetonius, he would invite attractive aristocratic couples to dine, then inspect the wife as if she were a slave up for auction, lifting her skirt to examine her legs, and holding up her face if she dropped it in embarrassment. After a forced liaison in a private parlor, the emperor would return to the table and offer a blow-by-blow critique of her figure and performance for the guests.

The god-emperor himself was no prize; he was balding, thin, and pallid, with hollow eyes and an elongated forehead, and so self-conscious about his exuberant body hair that he refused to have the word *goat* used in his presence.

SOURCES/FURTHER READING: Anthony Barrett, *Caligula: The Corruption of Power* (New Haven: Yale University Press, 1989); John E. Clarke, *Roman Sex 100 BC–AD 250* (New York: Harry N. Abrams, 2003); Marguerite Johnson and Terry Ryan, *Sexuality in Greek and Roman Society and Literature: A Sourcebook* (New York: Routledge Press, 2005); Rebecca Langlands, *Sexual Morality in Ancient Rome* (Cambridge, U.K.: Cambridge University Press, 2006).

THE JOY OF ANCIENT SEX

*F*or members of the Roman ruling class, the lurid cinematic images of *Fellini Satyricon and Gore Vidal's Caligula are not complete fantasy. While the bulk of Roman citizens lived sedate, happily married lives, raised families, and respected the traditional sexual taboos—they never made love in the daylight hours, women covered their breasts even at the height of passion, while men scoffed that only eunuchs would use their tongues "to give a woman pleasure"—the fashionable set openly flouted these restrictions. But taking the writings of poet provocateurs like Ovid and Martial as gospel would be like assuming the* Howard Stern Show *is a documentary of daily life in, say, Salt Lake City today.*

Imperial Roman Sleaze

C aligula has the name recognition, but other Roman emperors did a fine job of setting a historical standard for depravity. Who takes the laurels?

IMPERIAL ROMAN SLEAZE			
Emperor	Signature Perversion	Historical Verdict	Best Pop Portrayal
Tiberius *(reign 14–39)*	Imaginative pedophile. At isolated retreat on island of Capri, likes to swim in grottoes with teams of young boys dressed as minnows, who "nibble at his parts" as he swims.	Nobody knows what really went on in his retreat; rumors may have been exaggerated by enemy senators and muckraking biographer Suetonius.	Peter O'Toole in Penthouse-funded fiasco *Gore Vidal's Caligula* portrays a deranged satyr covered in sores.

(continued)

IMPERIAL ROMAN SLEAZE

Emperor	Signature Perversion	Historical Verdict	Best Pop Portrayal
Caligula *(37–41)*	Sadistic exhibitionist. Sleeps with sister, male actors, teams of budget prostitutes, etc.; sometimes forbids noblewomen he has raped to sleep with any other man again, so honored should they feel.	Definite nutcase; makes horse consul; is convinced he is king of the gods, Jupiter; declares war on sea god Neptune and collects sea shells as trophies.	Outrageous John Hurt in BBC series *I, Claudius;* at depth of madness, takes role-playing as god Jupiter to new extremes by murdering pregnant sister, cutting out fetus, and devouring it.
Nero *(54–68)*	Polymorphously perverse. Sleeps with mother, Agrippina, then has her stabbed to death; kicks pregnant wife, Poppea, to death; marries two male actors, one of whom, Sporus, is castrated to serve as his "wife."	Another certifiable nutter; carnal crimes not quite offset by love of Greek art and poetry. Upon assassination, expires wailing "What an artist dies with me!"	Peter Ustinov gives entertaining if sanitized Hollywood portrayal of art-loving loony in 1951 *Quo Vadis?*

IMPERIAL ROMAN SLEAZE

Emperor	Signature Perversion	Historical Verdict	Best Pop Portrayal
Commodus *(180–192)*	Infantile voyeur. Likes to watch private harem of 300 girls and 300 boys copulate; names them after sex organs; right-hand man Onos chosen because he has "male member larger than most animals."	Sex life less notorious than his habit of appearing as a gladiator in the arena— sometimes against handicapped men armed only with sponges.	Joaquin Phoenix offers convincing loopy look in otherwise fantastical 2000 epic *Gladiator*. (But the real Commodus didn't die in the ring; was stabbed in a bathhouse by an athlete.)
Elagabalus *(212–222)*	Murderous cross-dresser. Comes to power at age fourteen, appears as a woman at public appearances; marries male slave Hierocles; acts out lewd pantomimes where "husband" discovers him in bed with other men and is forced to beat him; works as prostitute in Roman brothels, to local acclaim.	Even allowing for exaggeration, sheer craziness is hard to beat. Convinced he is god Helios, has severed genitals of young boys thrown on sacrificial fire; smothers dinner guests with rose petals; appeals to Roman surgeons to castrate him and create a vagina but cancels sex-change operation at last minute.	Becomes hero of amoral Decadent Movement in nineteenth century; subject of play by "Theater of Cruelty" exponent Antonin Artaud, *Heliogabalus, or the Anarchist Crowned*. Awaits proper movie treatment since 1909 silent portrait.

The Invention of Smut

(AD 1819)

In the nineteenth century, tourists in the grand museums of Europe often had their own private agenda. What they *really* wanted to see were those naughty Secret Cabinets.

The first and most famous of these was the Gabinetto Segreto in Naples, where the raunchy artworks of the ancient Romans, unearthed from the nearby cities of Pompeii and Herculaneum, were off-limits to the general public. Access had been restricted ever since 1819, when the prudish heir to the Neapolitan throne, the future King Francesco I, dropped by the museum on a casual visit with his wife and daughter and was horrified to discover a graphic sex show culled from noble Romans' villas. There were penis-shaped oil lamps and phallic wind chimes. There was a statue of the satyr Pan, having his way with a she-goat. There were hermaphrodites being ravished, virgins deflowered, the god Priapus caressing his enormous member, and a string of eye-popping frescoes from the walls of ancient Roman brothels, where prostitutes advertised their particular carnal skills. Prince Francesco stormed out in disgust, covering the eyes of his blushing daughter.

From that date on, only "mature" gentlemen of "well-known moral standing" were permitted to enter the room—which, not surprisingly, took on a legendary status. Visitors from all over Italy arrived with spurious letters of introduction. Foreign travelers flocked to Naples on their Grand Tours and simply paid off the

guards. It was a turning point in cultural censorship. As the conservative Victorian era progressed, the British Museum, the Louvre, and museums in Florence, Rome, Madrid, and Dresden established their own Secret Cabinets full of banned *objets* open only to citizens "of the right sort."

The British version, known as the Secretum, was locked in Cupboard 55 of the Department of Medieval and Late Antiquities and became particularly famous among connoisseurs for its eclectic range. The core of the collection, donated in 1865 by a doctor-turned-banker named George Witt, was some seven hundred phallic amulets found in ancient Assyria, Egypt, and the classical world. (Dr. Witt, an amateur scholar who had made his fortune in Australia, espoused the theory that all great world religions had begun with phallus worship.) This was soon supplemented by a lewd instrument from a medieval nunnery known as "St. Cosmo's big toe," pioneer porn from the Italian Renaissance, and erotic curios from around the empire, with emphasis on India and the Orient.

Today, the Secret Cabinets have been pried open for the wider public, although not entirely disbanded. In 2000, Italian officials at the Naples National Museum begrudgingly allowed adult women into the notorious Gabinetto Segreto of ancient Roman art by appointment, although under-eighteens are still forbidden. (The room remains by far the most popular destination in that sprawling institution.) For its part, the British Museum began diffusing items from the Secretum among its other collections in the 1930s, with several now on public display. Although some three hundred pieces, many from the former Witt Collection, were still kept in the notorious Cupboard 55 in the late 1990s, the last few were finally removed in 2005. (Today, the storage cupboard is a rather unexciting sight in the shabby back rooms of the Department of Prehistory and Europe, although museum staff will show it, a little wearily, to curiosity seekers. These days, it contains a collection of Judaica. Cupboard 54 next door, however, is used to store a range of Witt's

ancient Roman phallic jewelry and the former Secretum's tidy display of eighteenth-century condoms made from sheep intestines, one with a little pink ribbon.)

On the literary front, the legendary *Enfer* (hell) section of the Bibliothèque Nationale in Paris and the Private Case of the British Library, long the home to risqué books, were disbanded in the 1970s, but the New York Public Library in Midtown Manhattan maintains a "Locked Cage" in its Asian and Middle Eastern Division for dusty volumes on Japanese brothels and Indian sex rites. The motive for the restricted access, librarians tell visitors, is no longer censorship; it's concern that the books will be stolen.

SOURCES/FURTHER READING: César Famin, *Musée Royal de Naples: Peintures, Bronzes et Statues Érotiques du Cabinet Secret, Avec Leur Explication* (Paris: Ledoux, 1836); David Gaimster, "Sex and Sensibility at the Art Museum," *History Today* 50 (9) (Sept. 2000): 10–15; Walter Kendrick, *The Secret Museum: Pornography in Modern Culture* (Berkeley: University of California Press, 1996); Catherine Johns, *Sex or Symbol: Erotic Images in Greece and Rome* (London: British Museum Press, 1982).

Quick, Jeeves, Cover the Piano Legs!
(AD 1837)

Nothing sums up the Victorians' freakish attitudes to sex as the notion that they were aroused by cabinetry. The author Matthew Sweet has shown that this fanciful story actually began with an English tourist in the United States. In 1837, a pompous Captain Frederick Marryat visited a seminary for young ladies in Niagara Falls, where he was astonished to discover the piano legs sheathed in "modest little trousers." These covers, a local guide confided, were necessary to preserve the "utmost purity of ideas" among the impressionable young girls. On another occasion, a Yankee girl told Marryat that even *saying* the word *leg* was considered too risqué in America; *limb* was preferred in a pinch. Captain Marryat dutifully recorded these factoids in *A Diary in America*.

There are no other records of this conservative New York habit; possibly the piano legs were really covered at the seminary to keep off dust. Americans at the time were heartily sick of the endless numbers of gullible English travel writers penning ignorant and patronizing books about their country, and Sweet speculates that the guides and young women at Niagara Falls were just pulling Marryat's credulous "limb."

But the British press seized on Marryat's story with glee. Jokes about idiot Americans hiding their piano legs were repeated in music hall songs and newspaper stories for years; eventually, the story became shorthand in the press for America's pathological

prudery. But the story rebounded on the British. In a rare case of historical justice, when Victorians became symbols of uptight sexuality in the twentieth century, the same piano story was used about *them* in plays, novels, and newspaper stories.

Today, despite the lack of evidence, it is still "common knowledge" that Victorians were feverishly hiding anything curved from impressionable eyes.

SOURCES/FURTHER READING: Matthew Sweet, *Inventing the Victorians* (London: St. Martin's Press, 2001); A. N. Wilson, *The Victorians* (London: Random House, 2002).

Victoria's Secrets

The Victorians can't win: we see them as either sexually repressed killjoys or pathetic hypocrites—lascivious aesthetes addicted to pornography, child prostitution, and opium. But are the strangest stories true?

"LIE BACK AND THINK OF ENGLAND"

This pithy advice was supposedly given by Queen Victoria to her seventeen-year-old daughter, Princess Victoria Adelaide Mary Louise, on her wedding night in 1857 and has become a catchphrase for frigid marital congress. But it is unlikely the queen ever said it; the phrase appears to have become common only after her death in 1901. The earliest found use is actually in the unpublished private diary of a certain Lady Hillingham, written in 1912: "I am happy now that (my husband) Charles calls on my bedchamber less frequently than of old. As it is, I now endure but two calls a week and when I hear his steps outside my door I lie down on my bed, close my eyes, open my legs, and think of England." As it happens, Queen Victoria appears to have had a healthy interest in sex: her diary as a young woman, before her

figure ballooned and she swaddled herself in lace, is filled with frank references to her husband Albert's masculine attractions.

FEAR OF PUBIC HAIR

One of the era's greatest thinkers, John Ruskin, is said to have been so shocked by the discovery of his wife's pubic hair on his wedding night in Venice that he ran from the room and refused to consummate the marriage. Apparently he had only ever seen ancient Greek statues of the naked female form and assumed that his wife's nether regions would be as smooth and polished as Ionian marble. We do know that the marriage night did not go as planned: his wife, Effie, eventually accused him of "incurable impotence" and had the marriage annulled in 1854. In a letter, Ruskin later explained his reaction to his wife's body: "Her person was not formed to excite passion. On the contrary, there were certain circumstances in her person which completely checked it." In 1965, biographer Mary Lutyens speculated that this must have been his first glimpse of Effie's delta, but there is no evidence for it. More recently, biographers have suggested that his new wife must have been menstruating on her wedding night, which shocked Ruskin to the core.

WAS PRINCE ALBERT INTO GENITAL PIERCING?

Queen Victoria's German-born, whisker-bedecked husband is rumored to have had a ring through his foreskin in order to secure his manhood via a chain to either side of his pant leg, in order to control its large size in tight-fitting britches. Actually, the adornment is a modern piercing option today and happens to be called the Prince Albert. The name's origin,

(*continued*)

which dates only back to the 1970s, may have been confused with the German-style watch chain the prince favored, which was commonly called a Prince Albert.

SOURCES/FURTHER READING: Leslie Hall, *Sex, Gender and Social Change in Britain Since 1880* (London: Macmillan, 2000); Matthew Sweet, *Inventing the Victorians* (London: St. Martin's Press, 2001).

For a Good Time, Try
Revolutionary Paris
(1789)

W hile today a certain type of traveler heads for Las Vegas, Havana, and Bangkok, in the eighteenth century, Paris was the unrivaled sin city of Europe. Even the uproar of the 1789 revolution, which was initially supported by many French aristocrats, only helped promote its hedonistic reputation—at least until the Terror of 1793–94 squelched tourism.

No sooner had the Bastille fallen than the capital was flooded with foreigners, curiosity seekers, and political delegates from the French provinces, all looking to enjoy carnal delights while they savored the newly democratic ambiance. To help out-of-town gentlemen navigate the underbelly of the city—and to control the problem of overcharging—a unique and practical guidebook was quickly published for those seeking prostitutes in the Palais Royal, the enormous entertainment complex that doubled as a red-light district. Today, this pocket-sized opus—*List of Compensation for the Ladies of the Palais Royal, and District, and for the Other Regions of Paris, Comprising Names and Addresses*—provides an unusually intimate glimpse of the eighteenth-century sex industry. The anonymous author notes that one lady of the night, nicknamed La Paysanne or "the country girl," charges a very reasonable 6 livres for her services, plus a bowl of punch. (The guide notes that La Paysanne works only during the day, preferring to sleep at nights.)

Mme Dupéron and her four friends at salon No. 33 are far more expensive, he warns, at 25 livres, while a certain Georgette is definitely to be avoided if she is drinking ("a perfect disgrace"). The classy La Bacchante is famous for her beauty and charges on a sliding patriotic scale—6 livres for young revolutionaries, 12 livres for a "mature man." La Bacchante can also be hired as a consort on a weekly basis: not only will she provide foreign whelps with an unforgettable erotic education, she will help them shop for decent clothes in the best boutiques and teach them the niceties of etiquette.

For the new revolutionary era, the Palais Royal was soon renamed the Maison Egalité, Equality House. While prostitutes thronged the sprawling complex, their presence did not deter visits by young couples or families. Conveniently placed opposite the Louvre, the palace's gracious open spaces included gardens, cafés, clothes boutiques, theaters, billiard halls, and amusement-park attractions. There was a natural history museum, the world's first wax museum, owned by Dr. Curtius (where the young Madame Tussaud was apprenticed), a zoo, and freak shows where you could gawk at a 632-pound giant and 200-year-old woman. There were astronomical machines showing planetary movements and a vehicle pulled by a mechanical deer, which would go backward or forward on command. For refreshments, you could head to the Café Mécanique, where steaming mocha coffee was pumped through a pipe in the middle of each table.

According to historians' best guesses, the prostitutes continued to ply their trade untroubled by the Revolution's increasing violence. Less lucky was the owner of the Palais Royal, the Duke of Orléans, an aristocrat who dubbed himself "Citizen Equality" and tried to ride out the waves of fury that had been unleashed. In 1793, he voted for the death sentence of his cousin, King Louis XVI, but was sent to the guillotine himself about ten months

later—one of twenty-eight hundred Parisians who were as well. Today, the Palais Royal is a pleasant and remarkably unsleazy tourist attraction set around a quiet lawn.

SOURCE/FURTHER READING: Robert M. Isherwood, *Farce and Fantasy: Popular Culture in Eighteenth-Century Paris* (New York: Oxford University Press, 1986).

Napoleon Unzipped #1:
An Innocent Abroad

(AD 1787)

According to his own report, Napoleon's famous privates entered active service in this very Palais Royal. It was a few months before the Revolution in November 1787, when the shy eighteen-year-old lieutenant lost his virginity to one of the innumerable prostitutes there. Napoleon recalled approaching a young woman on a freezing night and plying her with questions: Wasn't she cold? How did she come to Paris? How did she lose her virginity? Evidently guessing the situation, the woman finally said: "Let's go to your place . . . We'll get warm . . . Come on. You'll have great pleasure."

Unlike many of his peers, the young Corsican officer did not have a mistress, but continued to visit these ladies of the night, awkwardly making conversation about where they had bought their dresses before finally popping the question. He was still sexually anxious when, as a prominent young general, he fell in love with the older woman-of-the-world Josephine eight years later.

SOURCE/FURTHER READING: Christopher Hibbert, *Napoleon: His Wives and Women* (New York: W. W. Norton, 2002).

Ancient Greek Temples of Sex
(and Why They Should Be Reopened)

(500 BC)

Nothing gets a classical scholar's heart pumping like the sacred prostitutes of Corinth, the Greek port that is depicted as the free-living "Amsterdam of the ancient world." After landing at the Corinthian docks, sailors would apparently wheeze up the thousand-odd steps to the top of a stunning crag of rock called the Acrocorinth, which offered 360-degree vistas of the sparkling Mediterranean. There they would pass beneath the marble columns of the Temple of Aphrodite, goddess of Beauty and Love, within whose incense-filled, candlelit confines one thousand comely girls supposedly worked around the clock gathering funds for their deity. Since the Renaissance this idea had gripped antiquarians, who liked to imagine that congress with one of Aphrodite's servants offered a mystical union with the goddess herself—uninhibited pagans coupling in ecstasy before her statue in the perpetual twilight of the temple.

In fact, this lusty vision of Corinth was created entirely from a three-line report by the Greek geographer Strabo, who writes around AD 20:

> The temple of Aphrodite was once so rich that it had acquired more than a thousand prostitutes, donated by both men and women to the service of the goddess. And because

of them, the city used to be jam-packed and became wealthy. The ship-captains would spend fortunes there, and so the proverb says: "The voyage to Corinth isn't for just any man."

Modern historians have found that the image of a pagan free-for-all needs some serious qualification. ("Feel the longing, the desire, in this collective delusion," write Mary Beard and John Henderson of historians' sweaty-palmed accounts.) For a start, Aphrodite's servants, who may or may not have been attractive, were not exactly willing volunteers. In fact, Corinth's many cosmopolitan *pornai,* or prostitutes, were slaves purchased by wealthy Greeks and dedicated to the temple as a form of religious offering. (Once, a victorious athlete at the Olympic Games donated one hundred women in a lump sum.) Also, recent excavations at the Corinth fortress have found the temple too small for one hundred women to be working, let alone one thousand, so few—if any—carnal rites were conducted at the goddess's feet. More likely, the sex slaves received their clients in charmless brothels around the temple, huddled on lumpy straw mattresses in small, dark, airless stalls rather like the ones preserved in Pompeii, with illustrations painted above the booths demonstrating each girl's specialty. It is true that Aphrodite was the patron goddess of Corinth, and that women there had a special relationship with her—but this didn't do them much practical good. Greek males were riotously chauvinistic. Even their wives were regarded as chattel, suitable only for raising families; married Greek men went to prostitutes and young boys for "pleasurable sex."

Not all Greek men, however, were enamored of prostitution, sacred or otherwise. The philosopher Diogenes thought the habit of paying for love absurd, once telling a crowd that he himself "met the goddess Aphrodite everywhere, and at no expense." When

asked what he meant, Diogenes lifted up his tunic and pretended to masturbate.

SOURCE/FURTHER READING: Mary Beard and John Henderson, "With This Body I Thee Worship: Sacred Prostitution in Antiquity," *Gender and History* 9 (1997): 480–503.

. .

BRITISH PROWESS

E ver since Strabo's steamy account was rediscovered in the Renaissance, campaigners for sexual freedom have cited Corinth's temples as the ideal of socially accepted prostitution—in effect, church-run brothels. In 1826 London, the women's rights activist Richard Carlisle even argued in his opus Every Woman's Book or What Is Love? *that new versions of the Temples of Aphrodite should be opened all around Britain by the government, so that inept young men could receive practical sex education and thus save the local womenfolk from lives of frustration. Carlisle felt that lack of sexual pleasure was a serious health problem for British girls. If men knew what they were doing, he argued, we would not see "every third female sickly, consumptive, or wretched for want of sexual commerce." The suggestion set off angry demonstrations in London and shocked tirades in the press (it didn't help that the book's cover showed Adam and Eve without their fig leaves and described the Cross as a phallic symbol). Despite this,* What Is Love? *became a bestseller and stayed in print for over sixty-five years.*

SOURCE/FURTHER READING: M. L. Bush, *What Is Love? Richard Carlisle's Philosophy of Sex* (London: W. W. Norton, 1998).

. .

Kitchen Fantasies, Renaissance Style

(AD 1400)

For rich insights into any hard-to-quite-imagine historical period, check out the cookbooks. Take those of the Italian Renaissance. Many of the recipes double as kooky magic acts or practical jokes with which a host can entertain his friends, and you can also find card tricks, alchemic formulas, and medical remedies. The culinary scholar Jeremy Parzen has found the following examples from manuscripts in the Pierpont Morgan Library of New York, and some of them can be tried at home today:

* *Secret for Making an Egg Walk Around the Room:* Make a hole in an empty egg, insert a live cockroach, and seal up the hole. If you hold a candle near the egg, the cockroach will flee and the egg will roll across the table.
* *Flying Pie:* Prepare two pies, one a hollow shell, the other smaller but very delicious. Just before serving, tie a half dozen live birds to the small pie and place them into the larger, empty crust. At dinner, whip off the upper crust and the birds will carry the pie to the rafters. ("This is done to entertain and amuse your company.")
* *How to Dress a Peacock with All Its Feathers, So That When Cooked, It Appears to Be Alive and Spews Fire from Its Beak:* Colorful and regal, peacocks had been favored party fare since ancient Roman times. For this recipe, the chef should carefully

peel the skin and feathers from a freshly killed bird in one piece, maintaining the head intact. Once the meat has been roasted, the skin should then be carefully sewed back around it. Long iron needles should be inserted through the legs of the peacocks so that they appear to stand, and through the neck to keep it upright. To make the peacock spew fire, cotton wool dipped in camphor should be inserted in the beak and lit before serving. For even grander effect, the cooked bird could be encased in gold leaf, which is revealed only when the bird's skin is cut for serving, or magnets inserted inside to make the bird appear to jump on the table.

* *How to Make Worms Writhe on the Flesh:* Cut lengths of harp or lute strings, made from animal gut, and place them on hot roast meats. When the serving platter is opened, the heat of the flesh will make the strings slowly twist and squirm. The author predicts, "They will appear to be worms and those that see them will get sick. And you, and your companions, will eat them as if they were whiskers, etc."

* *Floating Fish:* One final spectacle, also guaranteed to awe, is to bake a fish into a large slab of gelatin. Keep in mind that glass technology was poor in the Renaissance and there were very few aquariums; so in a dark dining room, the flickering candle lights and rippling gelatin will give the impression that a live fish is being brought to the table. As the author assures us, "it will be a fine thing to see."

SOURCE/FURTHER READING: Jeremy Parzen, "Please Play with Your Food: An Incomplete Survey of Culinary Wonders in Italian Renaissance Cookery," *Gastronomica* 4, no. 4 (2004): 25–33.

NOSTRADAMUS ON CONDIMENTS

*T*he cranky French seer Nostradamus is beloved among doomsday theorists for his apocalyptic predictions, but he must have been in a more frivolous mood (or hard up for cash) when he wrote his 1555 book on cooking preserves, A Treatise on Jams: How to Make Every Liquid Jam, Not Only with Sugar and Honey, But Also with Cooked Wine. *A true Renaissance man, Nostradamus also wrote a book on women's cosmetics and included a string of health food recipes (in the typical habit for books to mix genres at the time). But few readers would have been able to sample his most powerful health elixir, since it required a string of insanely expensive ingredients: dissolved pearls, ivory powder, ground lapis lazuli, and "one drachm of unicorn scrapings," the grated tusk of a narwhal. Nostradamus assures us that this concoction, "when drunk by a sick man even on his deathbed," guarantees immediate recovery—which is about as convincing as his "prediction" of World War Three.*

How Wretched Were the Impressionists?

(AD 1865)

We all know there is supposed to be a correlation between suffering and art, especially if you're French. But the Impressionists are so famous now, with blockbuster exhibitions of Manet, Cézanne, Degas, Renoir, et al. clogging museums every year, we hardly believe they had real lives. If we judge by their paintings, this chummy bunch enjoyed idyllic surroundings, lounging by sun-splashed rivers, reclining in dreamy cafés, wandering through wheat fields filled with golden light, and picnicking with naked models—with the occasional absinthe party thrown in just to vary the pace. But the truth is that they endured grinding poverty and innumerable petty humiliations, all the while battling hostility from the public and critics alike. Even the term "Impressionist" was initially a form of mockery by the press: taken from a title by Monet, *Impression: Sunrise,* it reflected the feeling that their paintings were sloppy and half-finished.

Since new light has recently been cast on the fleeting mortality of these superartists, we can now track the correlation between agony and ecstasy.

SOURCES/FURTHER READING: Sue Roe, *The Private Lives of the Impressionists* (London: HarperCollins, 2006); Jeffrey Meyers, "Monet in Zola and Proust," *New Criterion* (Dec. 2005): 41–47.

IMPRESSIONIST MISERY INDEX

	Childhood	Start as Artiste	Early Humiliation
Édouard Manet (A café fixture in Paris: vain, handsome, charming, and fashionable boulevardier; luxuriant ginger hair, piercing eyes, charming and witty; swaggering style. Seductive despite "satyr-like nose.")	Comfortable. Son of wealthy, cultured Parisian judge; spends his summers in the country with friend Antonin Proust (uncle of Marcel). A high society figure, he grows up longing for recognition.	At seventeen, abandons naval career for art school in Paris; drifts aimlessly until father rents him an art studio.	Saucy picnic scene *Le Déjeuner sur l'herbe* provokes open laughter at 1863 Salon de Refusés—one critic says "the sharp and irritating colors attack the eye like a steel saw"—but wins celeb "bad boy" status.
Claude Monet (Outgoing, popular but fiery temperament; rebellious, defiant, and often selfish; obsessed with criticism and fame. Tough constitution— Known to paint in subzero winter temperatures with icicles hanging off beard.)	Charming. Born into affluent family of grocers in Le Havre; childhood filled with sun-dappled beach holidays in Normandy.	Draws caricatures for 15 francs each; drops out of high school to become art student in Paris, despite parents' bitter opposition.	Main target of jeering by Parisian art world in first Impressionist group show of 1874. Press says Monet and friends have "declared war on beauty." Loses money on show.

IMPRESSIONIST MISERY INDEX

Romantic Anguish	Career Low	Wretched Dotage?
At age nineteen, begins affair with Dutch piano teacher, then marries her in secret ceremony when she falls pregnant; raises family in secret from father for ten years. She overlooks his affairs and visits to prostitutes.	Drafted as artilleryman during siege of Paris in 1870 Franco-Prussian war; carries portable easel while training in icy, ankle-deep mud. Family cat eaten by starving Parisians.	Receives *Legion d'Honneur* just after he is struck by tertiary syphilis; dies in agony at age fifty after gangrenous leg amputated in home living room (and, according to some reports, thrown by harried doctors into fireplace).
Father cuts off allowance in 1867 when he learns Monet is living with young, penniless (and very pregnant) provincial girl, Camille Doncieux. Financial woes deepen.	In 1868, family evicted, paintings seized by creditors, throws himself into the Seine. Wife dies in 1879 after years of poverty; forced to borrow from friends to retrieve her favorite locket from pawnbroker.	In "faux-feudal" retreat Giverney, achieves wealth in his sixties as France's most beloved painter—but suffers from double cataracts of eyes while painting his acclaimed water lily series.

IMPRESSIONIST MISERY INDEX

	Childhood	Start as Artiste	Early Humiliation
Camille Pissarro (Self-declared atheist and anarchist; prophet-like appearance with dark eyes, aquiline nose, and a white beard. Generous to other artists and passionately committed to social justice.)	Exotic. Raised on Caribbean island of St. Thomas; moderately affluent Portuguese Jewish family with domineering mother.	After stint at French boarding school, advised by art teacher to draw "as many coconut trees as you can!"	House in Louveciennes used as abattoir by soldiers in 1870 Franco-Prussian war; nearly fifteen hundred paintings used as butcher aprons, swabs, and bathroom paper.
Paul Cézanne (Intense, brooding, and paranoid, with looks "like a cutthroat": tall, swarthy, black pointed beard, and wild eyes. Prone to depression. Comes to dinner wearing belt rope and itching from fleas.)	Solitary. Raised in sunny Aix-en-Provence, often fighting with stern father. Has fantasies of escape with friend Emile Zola.	Drops out of law school to study art, but finds Parisian life pointless; plunged into depression.	After failing to get a place in École des Beaux Arts, slashes canvasses and takes job in father's bank.

IMPRESSIONIST MISERY INDEX

Romantic Anguish	Career Low	Wretched Dotage?
In 1860, falls for his mother's maid, buxom blonde Julie Vellay, and moves to modest farm; scarred by tragic death of two young daughters.	In 1876, a restaurateur friend raffles off his paintings at 1 franc per ticket; the winner, a servant girl, prefers to take a cream bun.	Despite growing reputation, dies at age seventy-three convinced that the Impressionists are misunderstood and undervalued.
Erratic behavior and gloomy sexual tension in work eases after meeting young waif Hortense Fiquet in 1869, but remains sullen over lack of recognition.	Convinced that Emile Zola based morose, pathetic failed artist character in *The Masterpiece* (1886) on him; cuts off relations with childhood friend.	Battling depression and diabetes, becomes increasingly reclusive in Provence. Dies at eighty-six, a great influence on young painters but still an outsider in the art world.

IMPRESSIONIST MISERY INDEX

	Childhood	Start as Artiste	Early Humiliation
Berthe Morisot (Rare female painter in Impressionist circles; dark-eyed beauty, clever, pale, quiet, "wafer-thin and invariably dressed in black." Dedication to painting career confuses family, self.)	Sophisticated. Daughter of powerful civil servant who mingles in elegant artistic circles of Paris.	Taking art classes with sister Edma, becomes infatuated with Manet, who paints her in a series of erotically charged portraits.	Critics appalled at a woman's presence in first Impressionist show in 1874. Note sent to her mother: "one does not associate with madmen except at some peril."
Edgar Degas (Dark "soulful" eyes, incessant talker and famous wit; but also a shy, solitary figure, who declares "the artist should live apart." Known for shaky understanding of women.)	Confused. Born to stolid Neapolitan banker and gorgeous, sexually adventurous Creole mother, who dies young.	Abandons legal studies for art, painting women "without their coquetry, in the state of animals cleaning themselves."	When model complains that her nose is badly drawn, Degas throws her naked into the street.
Auguste Renoir (Feisty, likable working-class knockabout. Unpretentious, happy-go-lucky, fascinated by ordinary life; a lover of animals and children, tries to set up tiny-tot center for indigent infants in Paris.)	Earthy. Son of a hardworking Parisan tailor, family evicted from home during Haussmann's renovation of Paris.	Begins selling profiles of Marie-Antoinette on teacups at age thirteen. Later shares cold-water garret with Monet and knocks out 50-franc portraits.	While painting in Fontainbleu forest in 1849, nearly beaten up by mocking gang of picnickers.

IMPRESSIONIST MISERY INDEX

Romantic Anguish	Career Low	Wretched Dotage?
Oppressed by unmarried status; at age twenty-seven complains, "I feel lonely, disillusioned and old." After pining for Manet, decides to marry his younger brother Eugene.	1877 review by *La Chronique des Arts*: "children entertaining themselves with paper and paints do better."	Artistic output dwindles to nothing after birth of daughter. Dies of flu at age fifty-four, largely forgotten by art world until rediscovery by feminists in 1970s.
Despite fascination for ballerinas and women's clothing, never marries. ("Imagine having someone around who at the end of a grueling day in the studio said, 'that's a nice painting dear.'")	By mid-1880s, forced into ever-tinier apartments; starts using his painting studio as a dressing room. ("Is it too much to ask for a good woman to cook and clean for me?")	Eyesight deteriorates, but keeps drawing with magnifying glass. Reflects on misogynist reputation in old age: "Perhaps I have thought about women as animals too much."
Eccentric bachelor until at age thirty-nine he falls for comely, down-to-earth nineteen-year-old Aline Charigot.	While painting outdoors during bloody 1871 Paris Commune riots, dragged off by government soldiers as a spy; saved from firing squad at last minute.	Rheumatism and arthritis cripple him late in life, but keeps painting in retirement in Cagnes, southern France, as "national treasure."

Did Mary Ever *Say* She Was a Virgin?

(AD 1)

When the crowd asks Mary, "Are you a virgin?" she mutters in embarrassment, "Piss off!" and so they nudge one another knowingly: "She is." On the subject of Christians' wishful thinking, *Monty Python's Life of Brian* isn't so far from the mark: there is no surviving testimony from the young Jewish woman Mary herself about the Immaculate Conception, the ultimate in vitro fertilization—or anything else, for that matter. Even her name is a matter of confusion: in some gospels she is called Mariám (a version of Miriam) more often than Maria. The details of Mary's miraculous pregnancy were actually added to the gospels of Matthew and Luke around AD 80, some decades after Mary's death and based on oral traditions that had perhaps blended with fantasy. In fact, the whole virginity business was not considered terribly important for Christians until around AD 200, when theologians began to associate physical pleasure with spiritual evil and promote Mary as the ideal Latin woman—a mother who never had sex. From the start, nonbelievers had a field day: a scurrilous rumor started in Alexandria that Jesus was really the son of a Roman centurion called Pantherus; others said that Mary had conceived the boy with her own brother, a scandal that her family had to hush up.

Over the centuries, church theologians had their work cut out for them trying to explain the finer details of Mary's biological

adventure to literal-minded congregations. How was the sacred seed implanted? Some suggested that the Archangel Gabriel slipped it through Mary's ear, others that it entered through her mouth via the Holy Spirit. The unknown artist who sculpted a 1430 relief in a Würzburg, Germany, chapel showed God blowing his semen down from heaven through a long tube. And how did the Blessed Mother remain intact while giving birth? The baby Jesus must have floated magically from the womb, scholars reasoned; according to one colorful story, when Mary's midwife Salomé doubted this fact and tried to give Mary an exploratory probe, her sacrilegious finger was withered by a divine fire. By the way, whatever happened to Jesus' siblings? The gospels mention on several occasions that he had brothers and sisters. But these other children, theologians argued, must have been Joseph's by an earlier marriage.

By the Renaissance, the Mary story was really getting complicated. Early anatomists believed, despite some fairly obvious evidence to the contrary, that both male and female partners must derive pleasure during intercourse in order for conception to occur; it was thought that, during the woman's orgasm, the ovaries ejaculated their own seed or "semen" in the coital fluid that would blend with the male's. Thus in the late fifteenth century, the Spanish Jesuit Tomás Sánchez was forced to consider the question of Immaculate Enjoyment: "Did the Blessed Mary emit semen in the course of Her relations with the Holy Spirit?"

His answer: Basically, it's none of our business.

SOURCES/FURTHER READING: Elizabeth Abbott, *History of Celibacy* (New York: Scribner, 1999); Marina Warner, *Alone of All Her Sex: The Myth and the Cult of the Virgin Mary* (New York: Vintage Books, 1983); Leo Steinberg, "'How Shall This Be?' Reflections on Filippo Lippi's 'Anunciation' in London, Part One," *Artibus et Historiae* 8 (1987): 25–44.

Postguillotine Stress Disorder

(AD 1795)

The end of the revolutionary Terror unleashed a wave of euphoria in Paris as citizens celebrated the fact that they were still alive. Hardly had the guillotine been trundled out of sight than some one hundred dance halls opened around the city, using any space available—even abandoned monasteries and half-wrecked churches. Parisians were finally allowed to don their finery again, with the men reemerging as powdered dandies and women in scandalous dresses of a diaphanous white gauze that was almost entirely transparent, although they did wear flesh-colored body stockings underneath. But the most frenzied events were allegedly *les bals des victimes* (Victims' Balls), which could be attended only by family members of those who had gone to the guillotine ("shaved by the national razor," as the euphemism went). Some historians suggest that these wild underground parties never occurred, since most references to them were published years later, in memoirs and histories of the 1820s. But many believe there is an element of truth, since they were referred to in the Parisian journal *Le Censeur Dramatique* and émigré newspapers in 1797, and the popular memory of the events is so vivid.

According to the memoirs of supposed eyewitnesses like Etienne de Jouey and General Philippe Paul de Ségur, the *bals des victimes* were organized by the surviving aristocrats in 1794 and 1795. To enter, guests had to provide proof of their loss with documents at

the door (it had to be an immediate family member; a cousin would not do). Once inside, they could join a champagne-fueled *danse macabre* beneath glittering chandeliers. Women took to wearing blood-red ribbons around their necks as badges of their loss. Some, like the lovely Josephine de Beauharnais, the future Madame Bonaparte, had only barely escaped the guillotine themselves and had had their hair cropped while in prison, ready to face the block. This ragged style became a new fashion craze and was dubbed *la coiffure à la guillotine*. Like White Russians 120 years later, guests indulged in manic excess in order to blot out the evil memories. "France is dancing!" wrote one nineteenth-century historian of these wakes, which mixed posttraumatic stress disorder with survivor's guilt. "She dances to avenge, she dances to forget!"

The Victims' Balls eventually petered out, but other post-Terror innovations included the first personal ads in the Year IV (1796). These Petites Affiches in Parisian newspaper classifieds were often penned by women describing themselves as between the ages of eighteen and twenty-two, beautiful, broadly educated, and looking for "a position with a single gentleman"—evidently women of the former royal court who found themselves unprovided for. Other authors were more independent: a fifty-year-old lady advertised herself as possessing "accommodation, money and a not-too-ravaged appearance," while a younger belle offered her heart to "any man who truly deserved it."

In postrevolutionary Paris, as emotions ran high for aristocrats and patriots alike, psychotherapists would have had a field day.

SOURCES/FURTHER READING: Jean Robiquet, *Daily Life in the French Revolution* (New York: Macmillan, 1965); Ronald Schechter, "Gothic Thermidor: The Bals des Victimes, the Fantastic and the Production of Knowledge in Post-Terror France," *Representations* 61 (Winter 1998): 78–94.

Will Lincoln Ever Be Outed?

(AD 1837)

Gay-bashing Republicans have been distressed in recent years to hear that the icon of their party, Abraham Lincoln, may have been playing for the other team. It had been whispered for years that Lincoln was gay, and there is no doubt that some of his behavior would point that way today—most notably, sharing a bed for four years with an athletic young friend, Joshua Speed. The intense relationship began in 1837, when twenty-eight-year-old Lincoln, then a tall, calloused-handed frontiersman with soulful eyes, turned up at Speed's general store in Springfield, Illinois, hoping to make it as a lawyer. Lincoln couldn't afford the bed on sale, so Speed helpfully offered to share his own mattress upstairs. From that day on, the pair became passionate and all-but-inseparable buddies. When Speed finally did move out of the mattress to be married, Lincoln was shattered, sinking into such a black depression that friends removed all sharp objects from his room. For years afterward, he wrote Joshua long and tender letters signed wistfully "Yours forever." As one biographer put it in 1926, the friendship had "streaks of lavender, and spots as soft as May violets." Historians also noticed that Lincoln as a young man seemed indifferent to women: although he eventually fathered four children, his marriage to Mary Todd Lincoln was a tortured, almost masochistic affair.

Then, in 2005, *The Intimate World of Abraham Lincoln* by gay

activist and former Kinsey researcher C. A. Tripp brought the whispers into the open by revealing a broader pattern of male bonding. Before Josh Speed, Lincoln had another close bedmate in New Salem, his eighteen-year-old cousin Billy Greene, who drooled over Abe's muscular physique, writing that "His thighs were as perfect as a human being Could be." Later, as president, Lincoln developed a crush on Elmer Ellsworth, a debonair assistant to his election campaign, and arranged a high military position for him. When Ellsworth was killed by a sharpshooter while removing a Confederate flag from a hotel in Alexandria, Virginia, the disconsolate Lincoln began spending his nights with a studly young bodyguard at the presidential retreat outside Washington, D.C. Thirty years later, the regiment's official historian proudly recalled that this new favorite, the young Captain David Derickson, "advanced so far in the president's confidence and esteem that in Mrs. Lincoln's absence he frequently spent the night at his cottage, sleeping in the same bed with him, and—it is said—making use of his Excellency's night shirt!" The pressures of hiding his homosexual urges, Tripp argues, help to explain Lincoln's recurring depressions.

So was he or wasn't he? The evidence will always be ambiguous, since there is no "smoking gun"—a confessional letter that gives a blow-by-blow account of Lincoln's bedroom romps. (In 1999, playwright and AIDS activist Larry Kramer announced that he had found Joshua Speed's diary, which included scenes that would remove all doubt about Lincoln's gayness. It turned out to be fictional.) Maybe Lincoln was too afraid to write in anything but veiled and coded terms; or maybe nothing happened in those shared beds. In the nineteenth century, men were often obliged to sleep together, especially on the frontier; it wasn't just two to a bed, it could be four or six. They often indulged in "passionate friendships": photographs show men unself-consciously lounging on one another's laps and embracing with casual affection. Victorian women, too, when a girlfriend came to visit, would boot their

husbands out of bed so they could share it with their companion for the night, without exploring the Sapphic possibilities.

Sharing a mattress in the nineteenth century was as common as people sharing an apartment today; it was no more erotic than sitting next to someone on a wagon seat. Perhaps it is too difficult for us now to remove the sexual element from the situation, but Lincoln seems to have: even as president, he spoke about his male bedmates quite openly, oblivious to the idea that they would one day be called his lovers.

SOURCES/FURTHER READING: C. A. Tripp, *The Intimate World of Abraham Lincoln* (New York: Simon & Schuster, 2005); Joshua Wolf Shenk, *Lincoln's Melancholy: How Depression Challenged a President and Fueled His Greatness* (New York: Houghton Mifflin, 2005).

. .

SYPHILITIC ABE?

A long with the suggestion that he was gay, Lincoln has now been accused of infecting his wife with syphilis. Long after her husband's death, the once-vivacious Mary Todd Lincoln began to behave erratically. She took to wandering the streets of Chicago with cash pinned to her bloomers. She would purchase dozens of expensive gloves at a time and once entered a hotel elevator believing that it was a bathroom. Her son had her committed for insanity, but some historians believe that the medical verdicts—dementia and degeneration of the spinal cord—were consistent with tertiary syphilis. Lincoln himself confessed to William Herndon, his friend and law partner for sixteen years, that he had contracted the disease from a prostitute around 1835—although he may have misdiagnosed the elusive symptoms. He was also known to take little blue pills, apparently mercury, for many years. If Lincoln's suspicions were true, he would have passed the contagion on to his wife.

. .

The White House's Closet

While Lincoln's sex life has stolen the limelight, some historians have proclaimed that America's first gay president was really his predecessor, the now-obscure James Buchanan. (He was the fifteenth president, serving 1857–61.) Buchanan is the only bachelor to ever have held America's top office, and his private life raised many eyebrows while he was alive. From the early 1840s, he had shared a "passionate friendship"—as well as his lodgings in Washington, D.C.—with a flamboyantly effeminate senator from Alabama, William Rufus King (who became America's only bachelor VP). The U.S. capital was then little more than a shabby provincial town, and King was cruelly derided by roughneck politicians from the frontier who called him "Miss Nancy," "Aunt Fancy," and Buchanan's "wife." The pair drew mockery and suspicion for their dapper, dandified dress and fastidious habits, a sure sign that they were "Siamese twins"—slang for a gay couple. Buchanan was certainly fond of his housemate: when King had to depart for a spell as envoy to France in 1844, he mourned to a friend that "I have gone wooing to several gentlemen but have not succeeded with any of them." King died in 1853, and Buchanan lived alone when he became president in 1857. A little suspiciously, all personal correspondence between the two men was burned by their heirs, so the question of whether they were lovers or simply Victorian chums will never be resolved. This hasn't stopped historians weighing in. The only recent biography of Buchanan, by Jean H. Baker, argues that in photographs he displays "eunuchlike, endomorphic features of body and face as

(*continued*)

well as the low hairline characteristic of low testosterone men"— which leads her to suggest that he had "little interest in sex," and probably kept his hands off King as well. Regardless of his carnal potency, Buchanan's political career was fairly abysmal: he is generally voted by historians as the worst president in American history for mishandling a string of crises and dithering his way toward the Civil War.

SOURCES/FURTHER READING: Jean H. Baker, *James Buchanan* (New York: Times Books, 2004); James Loewen, *Lies Across America: What Our Historical Sites Get Wrong* (New York: Touchstone, 2000).

Oh, Behave! Clubbing in Boy's Own Britain

(AD 1740)

The 1960s saw a renewed fascination with the lusty men's clubs of the Georgian era. British swingers felt a kinship with the colorful rakes, libertines, and mountebanks of the eighteenth century who would guzzle vast amounts of claret then descend on the theater, where ladies like Oyster Moll would, in the ornate prose of *The Secret History of Clubs* by Ned Ward, "open the wicket of love's bear garden to any bold sportsman who has a venturesome mind to give a run to his puppy." In the London of Hogarth, there were dozens of clubs catering to every carnal taste and interest group. But the wildest sex club of all was based, improbably enough, in Scotland—then a drizzly, booze-soaked land more famed for its haggis than its hot-blooded lovers—and a young gentleman visitor to Edinburgh might be lucky enough to attend one of its meetings.

Founded in 1732 in the county of Fife, the club went under the peculiar name of the Most Ancient and Puissant Order of the Beggar's Benison and Merryland. The Beggar's Benison, or blessing, was drawn from an old legend: When King James V was traveling in Scotland incognito, he gave a gold coin to a local wench for carrying him on her back across a river. The delighted woman offered the king her blessing, "May prick nor purse never fail you"—immortal words that became the club's credo.

The club has gained immortality first for its unique initiation

ritual, which flew in the face of a growing popular prejudice against onanism. According to the records, the president would solemnly place a pewter platter on a table, around which some two dozen club members would gather dressed in their flamboyant official regalia, complete with silk sashes and medals carved with lewd images. The initiate, having somehow aroused himself to a priapic frenzy, would emerge from a closet to four blasts of a trumpet. The group would then join together to shoot "a horn spoonful" into the platter with the newcomer. (The club secretary's minutes for one meeting in 1737 are suitably terse on the masturbatory experience: "24 [members] met, 3 [initiates] tested and enrolled. All frigged.")

The happy new member was then given a mock-legal diploma attesting to his virility, and everyone drank a toast of port from the club's specially designed "prick glasses"—blown-glass phallic drinking vessels—and joined in a rousing chorus of the club motto.

The regular meetings were even more bizarre. Local "posture girls" were hired to display themselves in erotic positions, like art modeling classes without the art. "Every Knight passed in turn and surveyed the Secrets of Nature," one guest recorded, adding that members were strictly forbidden to touch. There was much guzzling of Madeira, snorting of snuff, perusing of pornographic drawings, and "bawdy talk," with toasts to "Firm Erection, fine Insertion, Excellent distillation, no Contamination" and to the ideal woman, "Well-hipped, well-breasted, easily mounted." But this saucy misbehavior was balanced each meeting by sober guest speakers who specialized in topics of natural history as well as anatomy. Such riveting talks included: "The engendering of Toads; the menstruation of Skate; and the gender of an Earthworm." Unlikely as it seems, this formula inspired chapters of the Beggar's Benison to open in Glasgow, Edinburgh, and even, among Scottish expats, in St. Petersburg, Russia.

We are fortunate to know so much about the Beggar's Benison. Unlike many sex club records of the period, which were destroyed

by embarrassed ancestors, the minutes of the Beggar's Benison have survived and are today housed in St. Andrews University Museum, fifty miles north of Edinburgh. The museum also holds the famous Test Platter used at initiation rites—it's a beaten-up-looking item engraved with the ubiquitous phallus and the phrase "The Way of a Man with a Maid"—and a pair of the blown-glass "prick glasses" in presentable condition. Curators confide that the glasses are designed as joke cups, spilling their liquid contents down the shirt of anyone who drinks from them.

An even more imaginative use of sexual totems was made by another Scottish institution called the Wig Club, whose members venerated a wig made of female pubic hair plucked (legend said) from the many mistresses of King Charles II. This evidently tapped into ancient belief that hair conveyed Samson-like strength and potency; although the wig was lost around 1910, its wooden stand and box also survive in St. Andrews.

SOURCE/FURTHER READING: David Stevenson, *The Beggar's Benison: Sex Clubs of Enlightenment Scotland and Their Rituals* (East Linton, U.K.: Tuckwell Press, 2001).

Damnation, Members Only

Rumors have long swirled around the notorious British Hell-Fire Clubs, which were said to spice their orgies with a dash of satanism. The original Hell-Fire Club was a mysterious gathering of upper-class rakes and ladies in London whose scandalous rites led them to be shut down by order of Parliament in 1721. In the decades that followed, copycat clubs sprouted from Oxford to Dublin, mostly patronized by bored twentysomething aristocrats looking

(continued)

for the next shocking thrill. But the most outrageous were the so-called Monks of Medmenham, who supposedly congregated in an English country abbey for blasphemous sexual rituals and were revisited in the inane Stanley Kubrick film *Eyes Wide Shut*, where Tom Cruise stumbles across a kinky cult operating in a remote manor.

We do know that the real Monks of Medmenham (pronounced Med'num) began meeting in 1753. They were led by a brilliant and sadistic young libertine named Sir Francis Dashwood, who squandered much of his enormous family fortune to construct a faux-Gothic abbey, Medmenham, as an exclusive riverside clubhouse on his estate in West Wycombe, Buckinghamshire, thirty miles outside of London. (The club's official name was the Order of the Friars of St. Francis of Wycombe.) Twice a month, club members in their monkish habits would arrive by gondola from London for an evening's debauchery with Dashwood's inner circle, known as his twelve "apostles." They would enter the candlelit abbey beneath an arch inscribed with a Rabelais motto, *Fay Ce Que Vouldras,* Do What You Will. We know they would pore over pornography that was bound together as sermon books and drink vast amounts of wine from cups supposedly made of human skulls. At the banquets, they tossed scraps to the club mascot, a baboon dressed up as a chaplain (which was once released into a village church service, making the congregation flee in terror) and were entertained by dancing "nymphs," local girls dressed up as nuns, who would later accept members in their private cells. Rumor had it that Sir Francis would also conduct Black Masses over the prostrate naked body of a drunken member and that guests from the highest level of British government would attend to direct the fate of the land, but these sinister

doings have never been proven. Certainly, not all of the club's meetings resembled frat-house booze-ups; at its peak, celebrities such as Benjamin Franklin and Laurence Sterne, author of *Tristram Shandy,* attended to raise the tone.

After thirteen years of hard partying, the club petered out when the monks quarreled over politics. But Sir Francis, now Lord le Despencer, kept his own shady reputation alive by having strange tunnels carved in the chalky hills on his estate, including dank little rooms, occult carvings, and a bridge across an underground river he dubbed the Styx— the setting, it was whispered locally, for more Hell-Fire heathenism. He spent much of his later life drinking himself to death in the steeple of his local church. Unfortunately for posterity, his relatives were so ashamed of his wicked club that after his death they destroyed all its records and relics, and the abbey burned down. Only the strange tunnels are left, today a cheesy tourist attraction called the Hell-Fire Caves.

SOURCE/FURTHER READING: Geoffrey Ashe, *Hell-Fire Clubs: A History of Anti-Morality* (London: Wildwood House, 1974).

Napoleon Unzipped #2:
The Trouble with Josephine

(AD 1796)

Napoleon's appendage first attracted public fascination in France during his early years with Josephine, when their dysfunctional marriage became a national scandal.

They were an odd couple—as if a young Bill Gates had somehow tied the knot with Britney Spears. When they met, Napoleon was an up-and-coming twenty-seven-year-old general who, while intellectually dynamic, cut a clumsy figure at elegant Parisian soirees with his lack of social graces and woeful sense of fashion. Marie-Joséphe-Rose de Beauharnais (nicknamed Josephine by Napoleon) was a high-society sophisticate six years his senior, a widow from Martinique with two children whose narrow escape from the guillotine had convinced her to live for the moment. Gleefully superficial, driven by "a frantic need for pleasure" in the words of historian Steven England, Rose spent outrageously, entertained lavishly, and attended one all-night ball after another with a roster of rich lovers. Like Cleopatra, this Caribbean party girl was not classically beautiful, but men found her hypnotic. She had "an undefineable something," Napoleon said of her later, that made her irresistible. Her turquoise eyes were shaded by long eyelashes, and although her teeth were appalling—gray and worn down to stumps—she had learned to laugh without revealing them.

After a whirlwind courtship and rushed wedding, the pair had only thirty-six hours together before Napoleon had to depart for

his first important campaign, in Italy. The interlude sounds quite successful, since the entire time was spent in Josephine's oval bedroom, which was equipped with floor-to-ceiling mirrors. But we know the pair parted with very different ideas. For Josephine, this was a marriage of convenience; she was taken aback by Napoleon's incandescent outpourings of emotion, which she regarded as adolescent and rather ludicrous. Within weeks, the Caribbean spitfire had taken a handsome young hussar as a lover, a fact that was an open secret around Paris. Napoleon, on the other hand, was besotted—and blind. He began shooting off two semicoherent love letters a day in a barely legible script, his pen often tearing the paper in his frenzy. These missives are today known to historians as "the honeymoon letters"—an ironic name, given that Josephine repeatedly refused invitations to join her new husband in Italy, inventing fake illnesses and even a false pregnancy to stay away.

Josephine wrote rarely and her few letters are lost. But Napoleon's missives almost all survive. They form a unique collection. No other historical celebrity has bared his emotions so nakedly for posterity, squirming like a teenager in love.

"Honeymoon Letter" Timeline: (Not Tonight, Napoleon)

WEEK ONE: "Citizeness Bonaparte . . . You are the eternal object of my thoughts. My imagination exhausts itself wondering what you are doing . . . Here for you are a thousand and one kisses of truest, tenderest love."

WEEK TWO: "Not one day has passed that I have not loved you, not one night that I have not clasped you in my arms . . . My imagination frightens me: You love me less, you

(continued)

will find consolation elsewhere; someday you will cease loving me . . ."

WEEK THREE: "Love me as you love your eyes. But that is not enough. As you love your very self."

WEEK FOUR: "To live through Josephine—that is the story of my life."

WEEK SIX: "You let many days go by without writing to me. What, then, are you doing? . . ."

WEEK SEVEN: "There is no one else, no one but me, is there?"

WEEK EIGHT: "You will come, won't you? You will be with me, on my heart, in my arms, on my lips . . . A kiss on your heart, and then another, a little lower, much, *much lower.*" (The last two words are stabbed through the paper with the pen.)

WEEK TEN: "Josephine, you were to have left Paris [to join me] on the fifth. You were to have left on the eleventh. You still had not left on the twelfth. The word perfidy I avoid. You have never loved me . . . A thousand daggers rip my heart."

WEEK TWELVE: "My life is a perpetual nightmare. A fatal premonition stops me from breathing. I am no longer living . . ."

WEEK FOURTEEN: "Make mock of me, stay on in Paris, take lovers, let all the world know it, never write to me—and then? And then I shall love you ten times more than I did before! . . . A thousand kisses upon your eyes, your lips, your tongue, your c—"

WEEK SIXTEEN: When Josephine was finally forced to join Napoleon in Italy, a friend noted that she wept, "as though she were going to a torture chamber . . ." For consolation, she brought her twenty-four-year-old boyfriend,

Lieutenant Hippolyte Charles, along for the trip, to the astonishment of everyone except her husband, who remained blind to the situation. At one dinner party, reported Baron Hamelin, the lovesick Napoleon began "caressing her so boldly, so heartily, that I considered it best to walk away to the window and pretend to be checking the weather."

The scandal of Josephine's behavior went from a French farce to international news two years later, while Napoleon was on campaign in Egypt in 1798. Despite all the evidence and rumors, the love-besotted Napoleon *still* believed that his wife was being faithful. Finally, one of his closest fellow officers broke the sad truth to him in a desert camp by the Nile: he was a laughingstock. The young general turned pale as a ghost, his secretary Bourienne reported of the moment, "his features were suddenly convulsed, a wild look came into his eyes, and several times he struck his head with his fists."

Adding salt to the wound, Napoleon's first private letter on the subject of his wife's adultery, written to his brother Joseph, was then intercepted by the British navy. The tormented missive was transported to London, published in a bound volume by the gloating British government, and reported word for word in the *London Standard* newspaper. In the impassioned screed, Napoleon declared that all his military victories were like ashes in his mouth. "The veil is now entirely rent," he wrote. "I am disgusted with human nature . . . My emotions are spent, withered. Glory stales . . . At the age of twenty-nine, I have exhausted everything; life has nothing more to offer."

Napoleon soon forgave Josephine, to the exasperation of his friends and family, and their romance became the most famous of its era. In a stunning role reversal, Josephine became a devoted and faithful wife while the ever-more-powerful Napoleon, in revenge,

took a parade of lovers himself, humiliating his wife on a regular basis until their eventual divorce in 1810. But Josephine's early adultery would remain a gold mine for British propagandists, who focused on the size and strength of Napoleon's *baïonette*. The offending 1798 letter is still in the possession of the British Library, although no longer on public display.

SOURCES/FURTHER READING: Steven England, *Napoleon: A Political Life* (New York: Scribner, 2004); Evangeline Bruce, *Napoleon and Josephine: The Improbable Marriage* (New York: Scribner, 1995); Frances Mossikere, *Napoleon and Josephine: Biography of a Marriage* (New York: Simon & Schuster, 1964).

GREAT MOMENTS IN ADULTERY

* *Ancient Romans were surprised that the five children of the notoriously licentious Julia, wife of Marcus Agrippa, all looked like their father. When asked how this was possible, Julia explained, "I never take on a passenger until the cargo hold is full."*

* *According to the Renaissance gossip Pierre de Boudreille, the Seigneur de Brantôme, a French noblewoman always insisted on the superior position, so if her husband demanded whether a man had mounted her, she could protest her innocence with a straight face.*

* *The Marquis de Sade vociferously proclaimed his right to total sexual freedom, but he took pride in never trying to seduce a married woman: "Women's infidelity . . . has such fatal and dark consequences that I've never been able to tolerate it." During his years in prison he was tormented by jealousy about his own wife, the demure and devoted Pélagie, who he was convinced was sleeping with every man she met. He went into insane rants that she was dressing like a whore and insisted that she must never leave her room or see any other human being.*

Desperate Crusader Wives:
Who Wore the Chastity Belt?

(AD 1196)

Long-distance relationships have always been problematic. Tradition holds that it was the first Crusaders who devised chastity belts to keep their wives faithful while they were on campaign in the Holy Land in 1196. But as with the *droit de seigneur*, the Middle Ages get a bad rap: these sadistic fashion accessories were actually invented in Renaissance Italy some two centuries later. Today, the oldest authentic chastity belts date from the 1500s; other versions once thought to date from the Crusader era have been discredited as nineteenth-century copies made for Victorian collectors as "erotic" curios. What's more, while there are still quite a few fiendish-looking examples of "iron knickers" (as the English called them) on display today in the museums of Europe, there are as yet no firsthand reports from any women who were forced to wear them.

Studying the authentic belts, scholars have charted how their design evolved over time. The simplest had a leather-padded metal band around the waist and an "eagle's beak" of metal or ivory that cupped over the vagina. Soon, Italian husbands realized that this left their wives still vulnerable to "the methods of coitus which were said to have been introduced into Italy from the East" (in the discreet words of learned chastity belt specialist E. J. Dingwall). A new model offered a metal band that could be locked between a woman's legs, leaving only a small opening for both anus and

vagina. The style-conscious Italian artists beautified the belts with heart-shaped orifices, golden inlay, elaborate scrollwork, and tasteful images of Adam and Eve. One at the Museum of Kalmar in Sweden has a naked woman grabbing a fox's bushy tail as he passes between her legs ("Stop, little fox! I have caught you. You have often been through there!").

The obvious discomfort and impracticality of wearing these torturous items has led some historians to insist they were never really used. But the consensus today is that they probably were worn by some unfortunate women, in rare cases and for short periods of time. (Specific references are thin on the ground and late in date, but in France in 1750, a Nîmes lawyer prosecuted one Pierre Berlhe for deflowering a young lady and then locking her in a belt. A female skeleton from the 1700s was exhumed in a small Austrian cemetery and found to have a rusted belt locked around the hips. And as late as 1892, Parisians were shocked by the sensational case of a man named Hufferte who tied his wife to a bed in a belt.) Obviously, there were some serious hygiene issues. As the author Elizabeth Abbott sums it up with excessive clarity in *A History of Celibacy*: "The interior of the belt must soon have been fetid, soiled, and caked with errant excrement. Sleeping must have been nightmarishly difficult, as the belt pressed down into the flesh. Washing the enclosed areas was impossible, for the sharp metal teeth at each womanly aperture would be as lethal to fingers holding a cloth as to a penis."

SOURCES/FURTHER READING: Elizabeth Abbott, *A History of Celibacy: From Athena to Elizabeth I, Leonardo da Vinci, Florence Nightingale, Gandhi, & Cher* (New York: Scribner, 1999); Alcide Bonneau, *Padlocks and Girdles of Chastity* (New York: Macmillan, 1931); E. J. Dingwall, *Girdles of Chastity* (London: Routledge, 1931); Mark Jones, *Why Fakes Matter: Essays on Problems of Authenticity* (London: British Museum Press, 1992).

Columbus Discovers the Clitoris

(AD 1559)

Renaissance men could barely keep up with all the exciting discoveries of their era, not least in the field of anatomy. Sixty years after Christopher set off for the New World, another Italian by the name of Renaldus Columbus (no relation) announced to his spellbound colleagues that he had finally discovered "the seat of a woman's delight." A lecturer in surgery at Padua University, this Columbus was in the new wave of scholars who were exploring the inner workings of the human body, mostly by dissecting cadavers. Obviously Columbus was also doing some fieldwork: in 1559, he announced in his textbook *De Re Anatomica* that he had identified a female appendage that would "throb with brief contractions" during sexual intercourse, causing a woman's "seed" to flow "swifter than air." Columbus named his discovery *amor Veneris, vul dulcedo,* "the love or the sweetness of Venus"; the word *clitoris* first appears in English in 1615, according to some philologists taken from the ancient Greek *kleitor,* "little hill."

Soon scholars were falling over one another claiming the discovery. A certain Gabriello Fallopio, who was the first to identify fallopian tubes, insisted that *he* had found the clitoris first. (This is probably true, but Fallopio did not publish his findings until two years later, in 1561, so the laurels officially go to Columbus.) Unseemly squabbling among anatomists continued for a century, until a Dutch physician showed that the clitoris had actually been

known to science since the Greeks and was written about in great detail by the second-century AD doctor Galen.

Fallopio may have missed out on the clitoris, but history does honor him as the inventor of the condom: in 1564, he reported that he had created a fine linen sheath that could be tied around the head of the penis. Its purpose was not as a birth control device but to protect against the new scourge of syphilis, which was cutting a swathe across Europe in the 1500s, probably brought to Europe by explorers from the Americas. Fallopio claimed to have tested his device on exactly eleven hundred men, apparently with local prostitutes, and proudly reported that not a single one had become infected.

Recently, Columbus was acknowledged by the Argentine novelist Federico Andahazi in *The Anatomist,* which imagines his practical experiments on the clitoris with a beautiful Spanish widow, Inés de Torremolinos; the novel's hero is finally burned at the stake by an outraged Inquisition. Other, more sober texts admit that we know few details about Columbus's life, and his actual research methods are still, well, fantasy.

SOURCES/FURTHER READING: Thomas W. Laqueur, *Making Sex: Body and Gender from the Greeks to Freud* (Cambridge: Harvard University Press, 1990); Katherine Park, "The Rediscovery of the Clitoris: French Medicine and the Tribade, 1570–1620," in David Hillman and Carla Mazzio (eds.), *The Body in Parts: Fantasies of Corporeality in Early Modern Europe* (New York: Routledge, 1997).

Milestones of Modern Love

As even the most frustrated male academics have pointed out, the "discovery" of the clitoris was no more news to women than the existence of the New World to Native Americans. But the history of sex is a Coney Island of such illusory breakthroughs.

C. 1700: SEX "AS WE KNOW IT" INVENTED

"Some time in the eighteenth century, sex as we know it was invented," writes Berkeley historian Thomas W. Laqueur. Before that time, Laqueur argues, most anatomists accepted the ancient idea expressed by the Greek doctor Galen that there was really only one gender: women's sexual organs were essentially the same as men's, except they were inverted due to a lack of "vital heat." The vagina was matched by the penis, the ovaries by the testicles ("stones of women"), the labia by the foreskin, the uterus by the scrotum. This appealed to classical notions of cosmic harmony and allowed doctors to argue that women were simply inferior versions of men. But in the eighteenth century, scientists began to see men and women as complete biological opposites— profoundly different creatures, distinct in body, character, and even soul. (This was no great improvement for women's rights, since male thinkers promptly argued that men were "sexually charged" and essentially active, women were essentially passive.)

C. 1730: FEMALE ORGASM OFFICIALLY DEMOTED

For most of Western history, doctors believed that conception could occur only when both men and women experienced pleasure; this law of nature was even written into handbooks for midwives. The buildup of "seed" in unsatisfied women could be downright dangerous, scholars felt, resulting in hysteria and madness. Then, around 1730, anatomists proved that the female orgasm was not necessarily essential for reproduction. The Dark Age of the bedroom had begun, as male medical experts played down the importance of female satisfaction to the sex act and to

(continued)

women's happiness in general. By the Victorian era, doctors were asserting that women were not, in fact, capable of a true orgasm. "As a general rule," intoned the English urologist William Acton in 1875, "a modest woman seldom desires any gratification for herself. She submits to her husband's embraces, but principally to gratify him; and were it not for the desire of maternity, would far rather be relieved of his attentions."

1864: PORN IDENTIFIED

The word *pornography* first appeared in the English language at the height of the Victorian period, when *Webster's Dictionary* listed it in 1864 to describe "licentious painting employed to decorate the walls of rooms sacred to bacchanalian orgies examples of which occur in Pompeii." The word had actually been invented in Italian four years earlier by the Neapolitan museum curator Giuseppe Fiorelli, when he wrote a brief catalog to the notorious Secret Cabinet of the Naples Museum, packed with ancient Roman erotic art, for discerning (and generally lascivious) visitors. Fiorelli combined the ancient Greek word for prostitutes, *pornai*, with writing, *graphos*, to describe the restricted-access collection. Over time, pornography became synonymous with any image that should be viewed privately and furtively.

1892: HOMOSEXUALITY ACKNOWLEDGED

It wasn't until 1892, three years before Oscar Wilde was put on trial for corrupting young men, that the word *homosexual* entered the English language, when an 1868 work by the Austrian sexologist Richard Freiherr von Krafft-Ebbing, *Psychopathia Sexualis,* was translated. (Along with this "male-on-male activity," the word *bisexual* also premiered in the

same opus.) Although sodomy had been illegal in Britain since 1533—and a capital offense from 1562—men had never been labeled purely "gay" or "straight." Obviously, this is not to say that homosexual activity did not exist. Far from it. In ancient Greece, it was openly acceptable for men to have physical relations with teenage boys. In the Middle Ages, the prodigious amount of homosexual behavior was regarded as just one of the many categories of carnal sin, to be dealt with by priests and church courts, not the state. However, as the nineteenth century wore on, there was an increasing tendency for men to define themselves—and be defined by the law—as part of a distinct sexual category, either heterosexual, homosexual, or bisexual. Although the death penalty was dropped from sodomy charges in the 1860s, pressure built for the passage of the Criminal Law Amendment Act in 1885, which made acts of "gross indecency" between males, "in public or in private," subject to two years of hard labor. The criminalization of homosexuality, copied in the United States, remained on the law books until the 1960s.

1908: AGE OF AQUARIUS FORESEEN

According to Virginia Woolf, the modern world began on the day fellow author Lytton Strachey visited her apartment and, pointing to a stain on her friend Vanessa Stephen's dress, inquired politely, "Semen?" The upper-crust Bloomsbury author Woolf was impressed by the refreshing openness about the body, which she contrasted to the hypocrisy of the nineteenth century: "It was, I think, a great advance in civilization."

As if to confirm her conviction, a mini sexual revolution got under way after the First World War, heralded by popular

(*continued*)

114

Tony Perrottet

books like Dr. Harland Long's *Sane Sex Life and Sane Sex Living* (1919) and Dr. Lee Harlan Stone's classic *It Is Sex O'Clock* (1928).

SOURCES/FURTHER READING: Peter Lewis Allen, *The Wages of Sin: Sex and Disease, Past and Present* (Chicago: University of Chicago Press, 2000); S. M. Connell, "Aristotle and Galen on Sex Difference and Reproduction," *Studies in History and Philosophy of Science* no. 3 (Sept. 2000); 31, 405–27; Jonathan Ned Katz, "Coming to Terms: Conceptualizing Men's Erotic and Affectional Relations with Men in the United States, 1820–1892," in Martin Duberman (ed.), *A Queer World: The Center for Lesbian and Gay Studies Reader* (New York: New York University Press, 1997); Walter Kendrick, *The Secret Museum: Pornography in Modern Culture* (Berkeley: University of California Press, 1996); Thomas W. Laqueur, *Making Sex: Body and Gender from the Greeks to Freud* (Cambridge: Harvard University Press, 1990); Virginia Woolf, "Old Bloomsbury," in *Moments of Being* (London: Harcourt Brace Jovanovich, 1985); Naomi Salaman, "The Taxonomic Effect," www.art-omma.org, no. 10.

Make-Your-Own Condoms

(AD 1600)

After Fallopio's silk prototype, Renaissance men took to wearing "gold-beater skins" woven from the dried intestines of sheep, calves, and horses. The scholar H. M. Hines speculates that it was a slaughterhouse worker who first came up with this technological advance, aiming for a more durable yet still sensitive sheath. The best-quality items, sold by Italian artisans, were hand sewn at one end and tied by an elegant pink ribbon at the other; they were expensive, but could be washed, dried, and reused.

Acceptance of the invention was slow all over Europe. In 1671, the French noblewoman Madame de Sévigné warned her daughter that condoms were worse than useless in the bedroom, "armour against enjoyment, and a spider web against danger." Young Casanova blew them up like balloons to amuse girls at parties; later in life, riddled with STDs, he reluctantly donned "the English raincoat," as Italians now dubbed the sheaths, despite complaints from one mistress that she could feel no affection for *ce petit personage* when hidden away. In England, "French letters" went on sale in several specialty shops run in London by women with warm, domestic names like Mrs. Philips and Mrs. Perkins. James Boswell became an avid fan, boasting that he invited a comely wench to Westminster Bridge and there "in armour complete did I enjoy her

upon this noble edifice." But even Boswell was not always satisfied: his diary reports in 1764, "Quite agitated. Put on condom; entered. Heart beat; fell. Quite sorry."

The first person to publicly extol the contraceptive virtues of the condom was the Englishman Richard Carlisle in his 1826 best-seller, *Every Woman's Book, or What Is Love?* Carlisle noted that condoms could be purchased in London from waiters at most reputable taverns, but still suggested to British girls that they never leave home without their sponges. Ever since the ancient Greeks, dried sponges and sheep's bladders inserted into the vagina had been used as rudimentary diaphragms. "The French and Italian women wear them fastened to their waists," noted Carlisle, "and always have them at hand." If caught, women should fall back on coitus interruptus, the withdrawal method, to avoid conception. European women "make this part of the contract before intercourse, and look upon the man as a dishonest brute who does not attend to it."

Incidentally, the name "condom" first appeared in English in 1665, in a poem by syphilitic literary genius John Wilmot, the Earl of Rochester, "A Panegyric upon Cundum." For many years, it was rumored that a certain Colonel Condom, royal physician, had invented the device for the randy English king Charles II to stop him producing more bastard progeny, but exhaustive modern searches have shown that the man did not exist.

SOURCES/FURTHER READING: Jonathan Margolis, *O: The Intimate History of the Orgasm* (London: Grove Press, 2004); Angus McLaren, *A History of Contraception: From Antiquity to the Present Day* (Oxford: Basil Blackwell, 1990). The most detailed treatment is Dr. H. Youssef, "The History of the Condom," *Journal of the Royal Society of Medicine* 86 (1993): 226–9.

ONE SIZE FITS ALL?

E *ven after mass production of latex condoms made them familiar items in the 1900s, they have always remained an object of humor. In the Second World War, according to an apocryphal story, British prime minister Winston Churchill was asked by the Soviet leader Josef Stalin to help out with the Russian army's serious condom shortage. Churchill ordered a special batch of condoms made at double regular size, then had them shipped to Russia with the label "Made in Britain—Medium."*

Weimar Berlin Voted World's
Most Decadent City

(AD 1923)

mericans might have flocked to Paris in the 1920s, but the really wild and crazy guys preferred Berlin. The brief spasm of German democracy from 1919 to 1933 (referred to as the Weimar era, after the small city where the constitution was drawn up) produced a mythic moment of no-holds-barred depravity. Up and down the grand boulevards, frenzied partygoers, fueled by high-octane cocktails, morphine, and exotic designer drugs like the petals of white roses frozen in chloroform and ether, "writhed like creeping plants . . . in the blue lights of bars," wrote the author Friedrich Hollander. Popular travel guidebooks to the city listed over two hundred gay bars and eighty lesbian "social clubs." Hard-core pornography flooded the bookstores; prostitution boomed in the suburbs; the world's first sex institute, directed by Dr. Magnus Herschfeld, researched questions that would not be pondered again until the 1960s.

Vaudeville was a big part of the decadent package in this Teutonic Babylon; you couldn't order a glass of lager or plate of wurst unless it was accompanied by a jaw-dropping chanteuse or lewd stand-up comic. At least 150 Berlin venues called themselves "cabarets," although only perhaps a dozen of those were the kind portrayed in Marlene Dietrich films or *Cabaret*, where a witty MC introduced short acts of a dark and cynical nature. The rest of the clubs simply offered erotic pageants, euphemistically known as

Beauty Nights, where seedy patrons viewed the talent with opera glasses even though only fifteen feet away.

The most infamous of the genuine cabarets was Weisse Maus, the White Mouse, where aficionados could admire the "demonic" queen of Berlin herself—Anita Berber. She was a confrontational performance artist who acted out her own self-destructive, drug-induced fantasies onstage, long before Iggy Pop started eating lightbulbs or Ozzy Osborne live bats. Berber was also Berlin's fashion pacesetter, a beautiful redhead dancer and silent film star who gadded about with her face powdered a ghoulish white with a vivid slash of scarlet lipstick, stark naked beneath a mink coat except for a gold chain around her ankle and a pet chimpanzee hanging on her shoulder.

Seeing this woman onstage was, by all accounts, an unforgettable experience. For a wad of devalued reichsmarks (or three American dollars), patrons were given masks for anonymity and shown to dimly lit booths to drink overpriced champagne. With a discordant burst of music, the artiste sprang catlike, and usually stark naked, onto the stage to begin her hypnotic dance movements. Berber's most provocative works, *The Dances of Depravity, Horror, and Ecstasy*, were performed with her equally demented husband, Sebastian Droste, whose heavily kohled eyes and gaunt features made him look like a cross between Nosferatu and a Gap model. For one wholesome dance piece named *Cocaine*, the stage set was lit by a flickering streetlamp resembling a monumental syringe. Wearing a corset that laced up below her bare, porcelain-white breasts, Berber convulsed to an unidentified piano piece by Saint-Saëns while her husband chanted, "Cocaine—Shrieks—Animals—Blood—Alcohol—Pain—Much Pain . . ." For another piece, *Salomé*, she emerged naked from an urn full of blood and writhed orgasmically to the improbable strains of Richard Strauss. But the duo's crowning artistic achievement was *The Depraved Woman and the Hanged One*, wherein Droste masturbated while

strung up by the neck and Berber caught his semen in her open thighs.

By all accounts, the audience was transfixed. Anything could happen during a Berber performance. If she felt that a member of the crowd was not showing her proper respect, she might spit brandy in his face or jump from the stage and slap him—the victims being occasionally mistaken, since she was badly near-sighted. After her act, Berber would exit the theater with a train of androgynous admirers in tow, entrusting her gold purse full of greenbacks to an escort while she binged on cognac. Once, at a bar, she shrieked to her panting fans, "Shut up! I will sleep with all of you!" Her show was finally canceled after she cracked a wine bottle over an audience member's head. She fell rapidly from sight, dying in 1928 in a Beirut nightclub; not yet thirty, she looked fifty.

SOURCES/FURTHER READING: Susan Laikin Funkenstein, "Anita Berber: Imagining a Weimar Performance Artist," *Woman's Art Journal* 26 (2005): 26–31; Mel Gordon, *The Seven Addictions and Five Professions of Anita Berber: Weimar Berlin's Priestess of Depravity* (Los Angeles: Feral House, 2006); Mel Gordon, *Voluptuous Panic: The Erotic World of Weimar Berlin* (Los Angeles: Feral House, 2000); Karl Toepfer, *Empire of Ecstasy: Nudity and Movement in German Body Culture 1910–1935* (Los Angeles: University of California Press, 1997).

Weimar vs. Vegas

Berlin in the 1920s boasted a string of theme restaurants that rank as the forgotten precursors of the Hard Rock Cafe and Planet Hollywood. The most popular was the colossal Haus Vaterland (Fatherland House) on Potsdamer Platz, where customers entered beneath an electric sign that announced "Every Nation Under One Roof" to wander through a domed entertainment complex that took up a

whole city block. Inside were twelve kitschy restaurants, each with live music and its own international gimmick— Turkish café, Western saloon, Hungarian peasant tavern, Spanish flamenco bar. The most popular was the Bavarian Wine Terrace, which gave an ersatz view over a painted Rhine. Every hour, the lights dimmed, fake lightning flashed, thunder clapped, and sprinklers sent a light summer rain shower to refresh the happy crowd.

More exclusive was Heaven and Hell on Kurfürstendamm, where the maitre d', dressed as Saint Peter, would direct diners to either side of a stage. The "infernal" side was a flaming cavern bathed in red light, where waiters dressed as devils would occasionally torment the diners with pitchforks. The less adventurous could choose the side of "heaven" for soft lighting and calm blue decor; here, the tables were decorated as puffy cotton clouds and waiters were winged angels. Both saints and sinners got to enjoy a moral lapse at midnight, where leggy showgirls would enact *Twenty-five Scenes from the Life of the Marquis de Sade* or *The Naked Frenchwoman: Her Life Mirrored in Art.*

But the most original Berlin boîte—whose style is still copied but has never quite been equaled—was the Residenz-Casino on Blumenstrasse, where eighty-six thousand electric lights reflected off spinning mirror balls that opened like flowers, and mechanical geysers shot towers of colored water from gilded fountains. Its unique attraction, depicted in the film *Cabaret,* was the private telephones at each of the numbered tables, so you could speak to any attractive stranger whose gaze met yours across the room. To court one another further, guests could choose from a special

(continued)

menu of 135 small gifts and have them sent through an elaborate system of pneumatic tubes to other tables: perfume, rings, cigars, even leather-bound tickets for dirty weekends would appear magically with a sensual *purr* of pumped air.

Alexander the Great Fairy?

(330 BC)

You might think that a 2,300-year-old sex scandal would lose some of its bite. Not when it comes to paragons of masculinity like the world-conqueror Alexander the Great, it seems. With his 2004 film *Alexander*, writer-director Oliver Stone caused outrage among stiff-necked military types for his depiction of the macho Macedonian king, history's most brilliant warrior, flirting with his boyfriends up and down the Khyber Pass. In between gore-splattered battles, Alexander (played by Colin Farrell) flounces about in makeup at drunken Babylonian banquets, shoots suggestive glances to his male entourage, and indulges in a passionate kiss with one of his officers—all the sort of behavior that would be frowned upon in the U.S. military today, for example. But according to Paul Cartledge, Professor of Classics at Cambridge University, the film is actually very coy about Alexander's busy homoerotic life. There is no real doubt that he took a young Persian eunuch named Bagoas as his lover in Babylon, and that at the height of his power he was still carrying on a torrid affair with his studly childhood sweetheart, Hephestaion. On the other hand, we also know that Alexander sired at least one son—with his wife, the lovely Afghani princess Roxanne—and that he maintained a bevy of voluptuous mistresses as he stormed his way across the Middle East.

So was Alexander bisexual? In fact, the Greeks themselves would not have understood the question. They were shocked by Alexander's love life for other reasons.

In ancient times, as we have seen, there were no separate categories for "homosexual," "bisexual," or "heterosexual." All men were expected to marry one woman and have children for the good of society, but this was a dull, businesslike arrangement; husbands would not even kiss their wives in public. For "pleasurable sex" with women, men hit the brothels or hired courtesans. And when they were feeling romantic, they would head to the gymnasiums and fall passionately in love with teenage boys, emulating the randy gods and heroes of Greek myth. (Even the ultimate he-man Hercules went through dozens of boyfriends and enjoyed a phase as a cross-dresser.) "Men were not castigated for sex with other men," says Cartledge, "as long as it was done at the right time, in the right way, in the right place, and with the right person." Grown men could have their way with adolescent boys up to the age of sixteen or so; it was even part of a Greek boy's education, as the older lovers would "mentor" them in the finer aspects of art and philosophy, while their fathers looked on with approval. But adults had to keep their hands off other grown men. The question of who was the active and who the passive partner was crucial; the older, socially superior male could give but not receive.

For the Greeks, the real scandal about Alexander's passion for the Persian boy Bagoas was that he was a barbarian and a eunuch—and thus barely human, in their eyes. Also shocking for the day was Alexander's ongoing romance with Hephestaion once he had become an adult; if it ever came out that the king was the passive partner, he would be the object of mockery and contempt. No one has posted an opinion on this, but it appears that Alexander's fantastic achievements in the battlefield allowed him to flout convention. Still, the pressure might have increased his severe

drinking problem: Alexander's vast wine consumption is blamed for his untimely death at the age of thirty-two.

SOURCES/FURTHER READING: Robert Aldrich (ed.), *Gay Life and Culture: A World History* (New York: Universe Publishing, 2006); Paul Cartledge, *Alexander the Great* (New York: The Overlook Press, 2004).

Pagan Beauty Pageants

A little lower on the list of ancient Greece's earth-shattering innovations is the beauty contest. These competitions were held at religious and athletic festivals, and usually between boys—the ideal of Greek beauty being a godlike adolescent "before the down appears on his cheeks." In one typical event in honor of the goddess Athena in the town of Elis, points were given to contestants for looks, manliness, and strength; the three winners were crowned with myrtle wreaths and would lead a procession to Athena's temple for a religious sacrifice. Although the beauty contests were rarer for unmarried girls, there are records of them in Sparta, Tenedos, and Lesbos. Because the misogynistic Greeks thought contests based on female beauty might encourage girls to vanity and wanton behavior, they were also judged on other, more socially acceptable attributes like their self-control, discretion, modesty, and *oikonomia*, good management of the household.

SOURCE/FURTHER READING: Marguerite Johnson and Terry Ryan, *Sexuality in Greek and Roman Society and Literature: A Sourcebook* (New York: Routledge, 2005).

When George Met Sally

(AD 1760)

With his powdered wig and poker face, Washington looks so standoffish in his painted portraits that historians were naturally delighted to discover a touch of human frailty: while engaged to Martha, it now seems possible that he was boffing his best friend's wife, the foxy Sally Fairfax. Others, more cautiously, say it was only a crush.

The evidence rests on two mysterious letters sent in September 1758, when George was a social-climbing twenty-six-year-old farmer-turned-army-colonel writing from the front lines of the French and Indian War, and Sally was the belle of Virginia, a pretty, sophisticated, and flirtatious minx two years his senior. George had met Sally several years earlier, when she married his Anglophile neighbor in Mount Vernon, Virginia. The Washingtons and Fairfaxes were old family friends, so young George spent many nights playing cards, dancing, and enjoying amateur theatricals at the luxurious Fairfax mansion. He became smitten by coquettish Sally and her playful humor. Then, in 1757, while he was still recovering from "bloody flux," or dysentery, in Mount Vernon he had, a little unconventionally, invited Sally to visit while her husband was away in London. She, solicitous, brought homemade jellies and teas for the invalid. Left alone for the first time, the pair evidently got on like a house on fire: the poorly educated Washington, from a socially modest family, was dazzled by the lovely, refined, and

aristocratic Sally. (Her one surviving portrait shows that she had a long face and sharp chin framed by dark brown hair—"an attractive woman," opines one biographer, "but not a raving beauty.") Sally was also attracted to the studly young George, who had a modicum of fame for his war exploits and was tall (over six feet two inches, a giant for the period) and handsome, with gray-blue eyes and auburn hair tied in a short pigtail—a dashing effect, despite poor teeth and mild facial scars from a childhood bout with smallpox.

And so in September the next year, 1758, when Sally wrote to congratulate him on his engagement to the rich, plump, and good-natured widow Martha Dandridge Custis, George wrote back with a convoluted letter implying that his real passion lay with her, Sally. ("Tis true, I profess myself a Votary to Love—I acknowledge that a Lady is in the Case—and further confess, that this Lady is known to you. . . . I feel the force of her amiable beauties in the recollection of a thousand tender passages that I wish to obliterate, till I am bid to revive them—but experience alas! Sadly reminds me how Impossible this is." His love, he goes on, is "an honest confession of a Simple Fact—misconstrue not my meaning—'tis obvious—doubt it not, nor expose it,—the World has no business to know the object of my Love, declared in this manner to—you when I want conceal it . . .") In the second letter, he explicitly compares himself and Sally to the fictional characters Cato and Juba—a pair of secret lovers in a famous literary work of the time. ("Do we still misunderstand the true meaning of each others Letters?" he writes. "I cannot speak plainer without—but I'll say not more, and leave you to guess the rest.")

Alas, it appears that, while George and Sally were quite possibly in love, the idea of an actual affair is another product of frustrated historians' vivid imaginations. But as with so many bedroom sagas, we will never know the truth. Naysayers point out that there is no hard documentary evidence of consummation, and that George

would not have risked his honor and career by indulging in a furtive liaison with Sally because of his friendship with her husband and father-in-law. Moreover, he was wildly ambitious, and already showing a stern self-discipline; their relationship, says the historian Joseph J. Ellis, fell under the category of "forbidden love" and was the first sign of the self-denial that would characterize Washington's life. His marriage to Martha, while perhaps inspired at first by her huge wealth, blossomed into a very happy and durable union; and before the Revolutionary War tore Virginia apart—Sally's husband declared himself a Loyalist and took her away to Britain—the foursome were close friends and visited often.

Romantics, however, will never quite be convinced that a twenty-six-year-old George would have been entirely ruled by pragmatism and social convention; after all, there is no evidence proving they *didn't* consummate their love. The pair's later correspondence was tinged with regret. A year before his death in 1799, by then one of the world's most famous individuals in his late sixties, Washington wrote frankly to Sally in Britain that he had "never been able to eradicate from my mind those happy moments, the happiest in my life, which I have enjoyed in your company." Then again, he included a note from Martha in the same letter, so the ambiguity of the message will forever remain.

SOURCES/FURTHER READING: Wilson Miles Cary, *Sally Cary: A Long Hidden Romance of Washington's Life* (New York: The Devine Press, 1916); Joseph J. Ellis, *His Excellency: George Washington* (New York: Knopf, 2004); John C. Fitzpatrick, *The George Washington Scandals* (New York: Scribner, 1929); William Sterne Randall, *George Washington: A Life* (New York: Henry Holt and Co., 1997); Harlow Giles Unger, *The Unexpected George Washington: His Private Life* (Hoboken, N. J.: John Wiley and Sons, 2000).

Washington's Shopping Tips

While most biographers concentrate on his military and political glories, a few valiant souls have set out to "humanize" the first president—trying to upset the consensus that he was the dullest man to ever grace the world stage. We now learn the following:

* Whenever he was bored, George liked to go shopping. As an ambitious and rather vain young Virginian landowner, he spent a fortune on his clothes—at age twenty-four in Boston, he blew 200 pounds, or $15,000 in modern currency, on the latest fashions, while throughout his life he enjoyed preening himself in military uniforms.

* Once he came into money by marrying Martha, George really let himself go. Historians estimate that in the first five years of the 1760s he blew the equivalent of two to three million modern dollars. He bought Madeira wine in 150-gallon barrels, invested in the finest thoroughbred horses for his fox-hunting passion, and kept a white servant and mulatto slave for his personal needs (in addition to the hundreds working his lands). In 1768, he went all out on a flashy "chariot," custom-made in London, with fine leather upholstery and his family crest on the doors.

* George was also a keen home decorator. He spent a fortune on Mount Vernon (whose expansion he had personally designed)—for example, in 1759, ordering an opulent canopied bed of blue and white curtains, matching window drapes, and seat cushioning "in order to make the whole furniture of this Room uniformly

(continued)

handsome and genteel." At an auction in 1774, he snapped up a range of mahogany furniture, including a two-tiered chest of drawers and a large gilt-framed mirror.

* George had unfortunate teeth, which began falling out in his twenties. By the time he was fifty-two, he had all his teeth extracted and then helped design his own dentures: four sets survive today (one is on display in the National Museum of Dentistry in Baltimore). Although legend still has it they were made of wood, they were actually finely crafted from a variety of materials—gold, hippopotamus ivory, lead, horse and donkey teeth, not to mention human teeth (which could be purchased on the black market, extracted from the poor; one of his dentists, the Frenchman Jean Pierre le Mayeur, advertised "three guineas for good front teeth from anyone but slaves"). The dentures were held together by fine springs. They were apparently large for his mouth, which might explain George's unsmiling portraits.

* According to reports of his fellow officers, George loved dirty jokes—but unfortunately, none of his favorites survive.

* Whether he got it on with Sally Fairfax or not, George was much admired by women for his athletic figure and personal charisma. He was an excellent dancer and an incorrigible flirt—charming enough to make Abigail Adams faint, and her husband, Vice President John Adams, seethe with jealousy. Even in his old age, George was not without sex appeal. Not long into his first presidency, after he had slept at a Massachusetts inn, the landlord offered his bed to a newly arrived stagecoach group. One gentleman indignantly refused to sleep on

the used and still-warm sheets, but a "young lady" reportedly announced, with gleeful coquetry: "she would sleep in the sheets ... If she could not be where [Washington] *was*, [she] was glad to be where he *had been*."

SOURCES/FURTHER READING: Joseph J. Ellis, *His Excellency: George Washington* (New York: Knopf, 2004); Thomas A. Foster, *Sex and the Eighteenth-Century Man: Massachusetts and the History of Sexuality in America* (Boston: Beacon, 2006); Harlow Giles Unger, *The Unexpected George Washington: His Private Life* (Hoboken, N.J.: John Wiley and Sons, 2000).

Holy Guide to Coital Positions

(AD 1215)

S omehow the human race survived the Middle Ages, no mean feat when you consider how much literature was out there condemning sex. Church thinkers like Saint Jerome announced that carnal relations were "filthy" even within the bounds of holy matrimony: "The wise man should love his wife with cool discretion," Jerome opined, "not with hot desire . . . Nothing is nastier than to love your own wife as if she were your mistress." Intercourse for procreation was tolerable, the holy fathers begrudgingly admitted, but anyone who indulged in sex because they were in love or seeking physical pleasure was on a fast track to damnation. This bleak attitude eventually led the church to legislate on the most intimate details of married life. In 1215, the cleric Johannes Teutonicus was the first to announce that there was only one "natural" coital position—what we today call "the missionary position," a term that was coined in the 1960s—which was also optimal for conception. Attempting any other position was a mortal sin, Johannes opined, involving exotic and unnecessary forms of stimulation.

The finest theologians soon began devoting a great deal of thought to which coital positions were more pleasurable—and thus more evil—and special handbooks were distributed to church confessors. Although not exactly the *Kama Sutra,* these *summae confessorum* described the offending positions and prescribed the

penance for each one. Alexander of Hales railed against *coitus retro*, the rear-entry position, as a mortal sin, for it was coupling "in the fashion of brutes." Saint Albert the Great discussed in detail four other forbidden positions: lateral (side by side), seated, standing, and anal sex. (Curiously, sodomy at this time was considered no worse if performed with a boy than with a woman; it was not until 1533 in England that male-on-male "buggery" became a criminal offense.)

The handbooks listed recommended penance of bread, water, and abstinence for exotic congress. A cross-section of the punishments includes the following:

Dorsal sex (woman on top): 3 years
Lateral, seated, standing: 40 days
Coitus retro—rear entry: 40 days
Mutual masturbation: 30 days
Inter-femoral sex—ejaculation between the legs: 40 days
Coitus in terga—anal sex:
 3 yrs. (with an adult)
 2 yrs. (with a boy)
 7 years (habitual)
 10 years (with a cleric)

Theologians were divided on the punishment for coitus interruptus, the withdrawal method that frustrated procreation, arguing for a penance of between two and ten years, while *semenem in ore* (semen in the mouth) could attract anywhere from three to fifteen years. Pierre de La Padule added that sex during menstruation, sex in churches, and sex preceded by kissing and fondling were almost as bad as the previously mentioned positions. Masturbation was so common that it incurred only a ten-day penalty for men and thirty days for monks, but women who used "erotic devices" did penance for one year.

By the 1400s, it seems, the church had to give up on such detailed analyses, possibly because the congregation was beginning to get ideas.

SOURCES/FURTHER READING: James A. Brundage, "Let Me Count the Ways: Canonists and Theologians Contemplate Coital Positions," *Journal of Medieval History* 10 (1984): 81–94; Jeffrey Richards, *Sex, Dissidence and Damnation: Minority Groups in the Middle Ages* (New York: Routledge, 1993).

Did Heretics Have More Fun?

(AD 1324)

I t certainly sounds like it, if you believe the lurid rumors spread
by the official church and Inquisition. Heretical sects like the
Waldensians, the Cathars, and the Free Spirits were all accused
of conducting bestial orgies in their churches; the devilish officials
were said to douse the candles after their masses so the congrega-
tion could get naked, announcing that "in the dark it is lawful for
any man to mate with any woman." Tragically, these tales all seem
to be fabrications. The leaders of heretical sects were usually puri-
tanical mystics, who were so disgusted by the lax carnal habits of
regular Christian priests that they tried to be *more* austere than the
nuttiest mainstream saints. Still, for the average, rank-and-file me-
dieval heretic, things weren't so harsh: they may not have attended
heathenish debauches where they nibbled the eucharist from one
another's naked bodies, but they found plenty of room for recre-
ational sex.

In the 1970s, the French historian Emmanuel Le Roy Ladurie
came across an intact cache of documents from 1324, when the
Inquisition arrested and interrogated dozens of peasants in the re-
mote village of Montaillou in the Pyrenees mountains, a last hold-
out of the Cathar heresy. The Cathar leaders, called Prefects, believed
that *all* sex was sinful, even for procreation. But the villagers of
Montaillou took a more practical attitude, deciding instinctively
that, if the fires of lust burned within them, they might as well be

doused. The logic seems to have been that if *everything* was sinful, one might as well go all the way and ask forgiveness in the confessional.

Reading the villagers' most intimate secrets today, it becomes obvious that in the medieval countryside not much had changed since the days of free-loving pagans; in fact, Montaillou could be confused with a Californian commune from the 1960s. Premarital sex was standard; there were few fifteen-year-old virgins. Young couples would move in together for a "trial run" before marriage. Elaborate affairs were conducted by married people—especially by young village women who had been saddled with older husbands. The peasants of Montaillou repeatedly declared that genuine physical pleasure must be innocent in the eyes of the Lord. The young Grazide Rives, an attractive peasant girl, admitted that she had lost her virginity to the village priest in a barn and kept up the affair as a married woman: "With Pierre Clergue, I liked it. And so it could not displease God. It was not a sin." Some of the interludes read like a French farce: Grazide's deflowering had actually been arranged by her mother, who was one of the priest's former lovers. The minor noblewoman Béatrice de Planissoles made love with a young vicar in a vineyard while her maid kept lookout. In the cheery soap opera ambiance of Montaillou, the church led by example: the aforementioned priest, Pierre Clergue, managed to have it off with almost every woman in the village, single or married, even in the confessional. No wonder village belles believed that priests "desire women more than other men."

Sodomy, meanwhile, was considered no worse than adultery or incest. The subdeacon Arnaud de Verniolles did admit in some shame that, as a youngster, he had slept in the same bed with a schoolmate, who after some months "began to embrace me and put himself between my thighs . . . and to move about there as if I was a woman." Later in life, Arnaud became wrongly convinced that he caught leprosy from a prostitute—his face had begun to

swell, possibly from an insect bite—so he swore to keep away from all females. "In order to keep this oath," he explains, "I began to abuse little boys." The big city of Toulouse offered more freedom in this quest—there were thriving gay subcultures in many medieval urban centers—so he moved there pretending to be a priest.

SOURCES/FURTHER READING: Michael Lambert, *Medieval Heresies* (New York: Oxford University Press, 2002); Emmanuel Le Roy Ladurie, *Montaillou: Cathars and Catholics in a French Village, 1294–1324* (New York: Penguin Books, 1980).

The Marquis de Sade's Mother-in-Law

(AD 1763)

Our word *sadism* comes from the depraved Marquis de Sade, but we would probably never have heard about his wicked ways if it wasn't for his overbearing mother-in-law, Marie-Madeleine de Montreuil, and her misguided efforts to silence him.

Upright, proper, married to a wealthy middle-class judge, Marie-Madeleine de Montreuil might at first seem no match for a man of Sade's nasty tastes. But she was also one of the most strong-willed women of eighteenth-century France, famous in Paris for her wit and intellect—"a flirtatious virago adorned in rose and pale violet," in the words of biographer Francine du Plessix Gray. Her relationship with her son-in-law has the elements of a love affair. She had at first been thrilled when, in 1763, she arranged for her eldest daughter, plain and chubby Renée-Pélagie, to marry the dashing young aristocrat from Provence. Donatien Alphonse François, the Marquis de Sade, was then twenty-two years old, a blue-eyed, golden-haired scion of one of France's most ancient, if impoverished, families. Admittedly, his habit of flagellating and sodomizing local prostitutes was getting him blacklisted at some of the high-class brothels, but this was by and large considered no worse than the antics of many other young nobles of the time. Evidently, the fortyish Marie-Madeleine, veteran of two decades with a dull husband, was captivated by her new son-in-law's rakish

charm and scabrous sense of humor. For his part, Sade seems to have regarded her as a surrogate for his own perennially absent mother, inviting her along to almost every social occasion in Paris with his wife.

In this honeymoon phase, no scandal of the marquis's could dent his mother-in-law's faith, especially as her daughter was clearly besotted with her new husband and bore him three children. It was Marie-Madeleine who rushed to his assistance when Sade was arrested only five months into the marriage for brutalizing a prostitute, screeching sacrilegious oaths, and masturbating into a chalice. (She evidently dismissed the incident as a boyish frolic.) She also saved his bacon in 1768, when Sade was arrested again for imprisoning a penniless beggar woman overnight, whipping her with a cat-o'-nine-tails, and shouting blasphemies. (He allegedly slashed her back with a knife and poured hot wax into the wounds, but this has never been confirmed.) To avoid a humiliating trial, Marie-Madeleine paid off the victim to drop the charges. It had been a "disreputable and unforgivable action," she wrote, then shrugged it off.

But as Sade began to run up fantastic debts at secretive parties, Marie-Madeleine began to suspect the truth—that her son-in-law's personality was marred by a breathtaking degree of self-obsession and stupendous amorality. A committed atheist, he believed there was no order in the universe and that the strong should feel no qualms about indulging their lusts upon the weak. For Marie-Madeleine, the real turning point came when Sade committed incest—seducing her younger daughter, the delicate and privately volatile convent girl Anne-Prospère, with the evident approval of his wife, Pélagie. She tried to control him by cutting off his cash flow, to little avail. So when Sade fell into trouble with the law again in 1772, the mother-in-law decided to get him out of the way. On that occasion, he had hired four prostitutes in Marseilles for an orgy that included plentiful whipping and the spectacle of Sade

being sodomized by his valet—standard eighteenth-century fare, except that Sade had plied the girls with candies spiked with the toxic aphrodisiac Spanish fly. Violently ill, they denounced Sade as a poisoner and sodomite; rumors of satanic rituals spread, and he was forced to go into hiding in Italy.

Sade seems to have had no idea how ruthless an enemy his mother-in-law would be. On one occasion, he blithely wrote to her for money giving his address in Piedmont. Marie-Madeleine promptly arranged his arrest. When he escaped, she hunted him like some eighteenth-century Terminator. Her next big chance came after the so-called Little Girls Episode. Sade had been forced to flee to Italy again after luring five adolescent girls and a boy "secretary" to work in his castle, then keeping them trapped for six weeks of sexual and psychic torment. (His wife, Pélagie, helped ship the nymphets, their bodies scarred by the marquis's pleasures, off to convents.) In 1777, feigning forgiveness, Marie-Madeleine invited Sade to Paris so that he could visit his own deathly ill mother. But no sooner had he settled into the city than he was surprised by a midnight door knock from the police. From that moment, except for one brief escape, the marquis remained under lock and key for the next thirteen years in the prisons of Vincennes and the Bastille. "Things could not be better or more secure," Marie-Madeleine gloated of her trap. "It was about time! . . . All is now in order."

Little did she know that she had guaranteed her son-in-law's immortality. Behind bars, Sade found himself with the enforced leisure time to develop his unique literary talents: he channeled his frustrated imagination onto the page and produced the violent pornographic classics that have secured his reputation even today for unrivaled depravity. In fact, incarceration offered a far cozier environment than anywhere in his previous, transitory existence: he decorated his cells with tapestries and bookshelves, a fine writing desk, paintings, and marble statuary. His wife, Pélagie, brought him the latest fashionable clothes from Paris tailors and pampered

him with his favorite foods, veal cutlets, fresh omelets, chocolates, and sweets. (Even so, Sade would complain bitterly if his whims were not fulfilled: "The Savoy biscuit isn't at all what I asked for; I wished it to be iced all the way around its surface, on top and underneath.") He also had his wife bring custom-made *prestiges,* the couple's pet word for dildos, of specific design and material— ivory, polished rosewood, wax—for his autoerotic rites. (One was confiscated later with the report that it "showed traces of its ignoble introduction.")

The now-elderly Marie-Madeleine even served as Sade's improbable Muse, as he wallowed in "the greatest case of mother-in-law hatred in recorded history," according to historian Robert Darnton. He filled his letters with savage outpourings of hatred against her and delighted in imagining whole encyclopedias of torture. ("I saw her, the bitch, being flayed alive, dragged upon a heap of burning coals and then thrown into a vat of vinegar. And I addressed her thus: Execrable creature, here's for having sold your son-in-law to executioners! . . . Here's for having made him lose the finest years of his life . . . ! And I . . . insulted her in her pain, and I forgot my own.") The vicious, misogynist strain, seething with images of rape, murder, and cruelty, ended up in his novels *Justine* and *Juliette* as well as the grinding catalog of sin *The 120 Days of Sodom.* (This latter work was composed when paper was short, on a forty-nine-foot scroll only five inches wide, in minuscule print; it was lost in the sack of the Bastille during the Revolution, carried off by a peasant, and published only when it turned up in Germany in 1904.)

Sade's volatile relationship with his mother-in-law had one last act to play. He was released after the Revolution and, despite his aristocratic origins, quickly rose to prominence in his former feudal territory as a great supporter of the people. (He had been transferred from the Bastille only a few days before it fell for inciting the crowds below the prison walls to violence; he cleverly used a metal funnel, originally designed for emptying bodily

fluids, as a megaphone.) In 1792, Marie-Madeleine and her husband learned that they were marked for execution because their children had emigrated, and they were obliged to beg Sade, then a judge, for assistance. Sade amused himself with the idea that he could send his now-aged nemesis to the guillotine. But for all his fearsome reputation, he had always opposed the death sentence, and ultimately intervened to have their names removed from the Terror's lists.

SOURCES/FURTHER READING: Laurance L. Bongie, *Sade: A Biographical Essay* (Chicago: University of Chicago Press, 1998); Robert Darnton, "The Real Marquis," *The New York Review of Books* 46, no. 1 (1999); Francine du Plessix Gray, *At Home with the Marquis de Sade: A Life* (New York: Penguin Books, 1999).

The Accidental Pornographer

If it hadn't been for his bad luck in the mother-in-law department, the Marquis de Sade might have taken up quite a different occupation—travel writer.

He had always fancied himself a man of letters, and the first manuscript he intended for publication was his pompously titled *Voyage in Italy, or a Critical, Historical and Philosophical Dissertation on the Cities of Florence, Rome and Naples, 1775–6,* an account of his experiences in Italy while on the run from the police under the assumed name of "Comte de Mazan, Colonel in the French Army." Written on the journey and his return to France, the work falls easily within the formulaic (and today excruciatingly tedious) genre of gentlemanly travel memoirs of the eighteenth century. Filled with descriptions of architecture and artworks, and erudite references to Dante and Petrarch, the book is distinguished from dozens of others only by its unusually eclectic scope, which includes long diatribes on religion and local social customs. Sade was particularly

offended at the Italians' lax attitude toward marriage, which he felt involved a shameful lack of affection. He hired an artist in Naples to illustrate his humble opus, but became distracted from its completion when he was arrested and never pursued its final publication. (It was eventually rediscovered in Paris and released in 1995.)

Instead, while languishing in the Bastille, Sade went over his notes from the Italy trip and culled the more sordid material for the first draft of his porn novel *Juliette*. The research proved fertile: Sade has his perverted heroine travel the same route through Italy as in his travel book, visit the same museums, and stay in the same inns, with less than edifying results. For example, *Voyage d'Italie* had included a visit to Florence's Uffizi galleries, with a clinical report of a celebrated ancient sculpture, *The Hermaphrodite*. In *Juliette*, the androgynous image inspires the heroine to flights of erotic fancy, as she admires "the most beautiful ass in the world . . ." while her male companion assures her that "he once fucked such a creature, and there is no more delicious pleasure on earth." Other picturesque Italian settings become the settings for Juliette's outrageous orgies and criminal acts. Sade remained a dutiful tourist: in his critical work *Ideas on the Novel*, he insisted that authors must do their on-site research. "I will not forgive you any improbable customs, or any mistake in costume, or even less, a mistake in geography . . ."

Sade was no libertine crusader: to his dying day, he denied being the author of any of his pornographic works, which he regarded as lowbrow moneymaking projects. Since his youth he had craved popular success as a respectable playwright, and he turned to erotica only as a stopgap financial measure.

(continued)

After his release from prison in 1789, he did manage to have several plays produced in revolutionary Paris—they were markedly straitlaced, devoid of bondage, rape, sodomy, torture, or any other "sadistic" element—and they garnered little interest and poor reviews. In fact, his most satisfying moments as an artist came while he was imprisoned at the end of his life in the insane asylum of Charenton and was permitted to direct a team of addled inmates in his demure social comedies. For several years in the early 1800s, these became the height of fashion for intellectual Parisians, who traveled from the capital to meet the now-obese author of *Justine* and *Juliette*. Sade wrote, directed, sewed the costumes, built the sets, and even acted as usher; afterward, he entertained pretty Parisian actresses at dinner in his cell.

The prudish Napoleonic government closed his lunatic fringe theater down in 1813, and Sade died the next year in his cell of stomach and lung ailments. Frustrated and bitter, he insisted in his will on being buried in an unmarked grave. His final, seventy-fourth year had, however, been enlivened by a fling with a seventeen-year-old washer girl in the prison. His diary entries feature the sign "Ø", which biographers tell us referred to the act of sodomy. One of the last entries from the elderly and enormous villain reads, rather forlornly, "The Ø was started but not followed up."

SOURCES/FURTHER READING: Jacques Guicharnaud, "The Wreathed Columns of St. Peter's," *Yale French Studies* no. 35 (1965): 29–38; Maurice Lever (ed.), *D.A.F. Marquis de Sade, Voyage d'Italie*, 2 volumes (Paris: Fayard, 1995).

Liberty, Fraternity, Gastronomy

The Invention of the Restaurant

(AD 1795)

Gourmands may find it hard to believe, but the bloodstained quarter century between the French Revolution (1789) and Napoleon's final defeat at Waterloo (1815) was also the inspirational testing ground for a beloved institution: the restaurant.

Prior to that time, fine dining was the preserve of the rich, who had their own grand kitchens and personal chefs, and even traveled with them from château to château. The only commercial eateries were seedy roadside inns, where travelers would sit with strangers around a mediocre family-style buffet. Sometime in the 1760s, the growing number of middle-class Parisians developed a new passion for healthy broths and bouillons, called *restaurants* or restoratives, and a number of vendors began selling them. It didn't take long for the owners to realize that there was a market for more elaborate fare and decor. By the 1780s, a few more reputable dining halls opened in Paris, where customers could sit at individual tables and even choose from a range of dishes.

The Revolution actually provided a boost to *les restaurants* (as these new institutions were now known) by flooding the working market with unemployed chefs from aristocratic kitchens and filling their wine cellars with excellent bottles sold cheap by fleeing nobles. By 1790, there were around fifty restaurants operating in Paris. Their businesses did become a little risky at the

height of the Terror in 1794: widespread food shortages led hungry patriots to sometimes denounce their owners as hoarders and black marketers. One restaurateur, Jean Francois Véry, was sent to prison because an old sign over his door read in Spanish, "We welcome people of the best sort"—a most undemocratic sentiment. Another restaurateur, Gabriel Doyen, who had once worked as a chef in Marie-Antoinette's kitchen, could not escape his aristocratic past and ultimately went to the guillotine. But most restaurants kept up a lively trade, their tables groaning with fine hams, roasts, and pâtés. Patrons also felt relatively safe in restaurants, joking that Robespierre could not afford to send his spies there.

But commercial fine dining really came into its own after 1800, when Napoleon seized power as First Consul and his police department issued a statement that, along with freedom of religion and dress, the French could now enjoy "freedom of pleasure." Having a good time was every patriot's duty. (Napoleon wisely reasoned that citizens who focused on champagne and sauce reductions were probably not conspiring in politics.) In addition, the enlarged French Empire brought fantastic wealth to Paris. The city was flooded with nouveaux riches who had made their money on the arms market or shady import deals, living like gaudy Russian mafia bosses today. Restaurants began to compete for customers with lavish marble decor and elaborate live entertainment. At one establishment, naked women dressed as Amazon warriors were lowered in golden chariots from the ceiling. These temples of gourmandise became tourist attractions on a par with Notre Dame and were featured in travelogues around Europe. Less affluent Parisians even enjoyed the occasional splurge, although it became almost common practice to steal knives and forks in order to recoup one's costs. A patron at the upmarket eatery Naudet's was spotted by the waiters and politely given a bill that included "Cutlery, 54 francs."

He paid up cheerily enough, tut-tutting, "How dear things are getting these days . . ."

It should be noted that the actual dining experience in these venues was slightly different from that in a restaurant today. A customer did not make a reservation; at least, there are no accounts of diners having to wait for a table. One could choose to sit in the main salon or in one of the *cabinets particuliers,* private rooms. Although they were popular among locals for romantic trysts, some foreigners simply chose these private rooms out of embarrassment: they had never eaten in public before, and wrote of their discomfort at the prying eyes of strangers; they were even more disturbed to see respectable French women quaffing champagne and admiring themselves in mirrors. Once they were seated, guests were presented with menus the size of newspapers. Trying to outdo each other in sheer choice, these *cartes* (literally, maps) were far more encyclopedic than those we have today, commonly offering two dozen types of veal preparation and a range of incomprehensible dishes such as *pigeon à la crapaudine.* The truth was, the first menus were more symbolic than practical, a formulaic list of all possible dishes the kitchen could prepare. The actual dishes on offer each day were far more limited, noted in the margins in handwritten amendments or explained by the waiters—a casual forerunner of the "specials board" scrawled in chalk by restaurateurs today.

SOURCES/FURTHER READING: Rebecca Spang, *The Invention of the Restaurant* (London: Harvard University Press, 2000); Amy Trubek, *Haute Cuisine: How the French Invented the Culinary Profession* (Philadelphia: University of Philadelphia Press, 2000).

Come Up for Coffee?
Libido Loss in Restoration London
(1674)

In seventeenth-century London, there were more coffee-houses per street corner than Starbucks in Seattle: some two thousand establishments catered to the craze imported from Arabia in 1615. But even then, caffeine was thought to have its downside, according to a group of Englishwomen who decided that the drink was sapping the sex drive of local lads. In 1674, a pamphlet appeared, signed by a string of disgruntled London ladies, who railed that the "Drying, Enfeebling LIQUOR" coffee had "Eunucht our Husbands, and Crippled our more kind gallants." After long hours in the coffeehouses, the women complained, their men emerge "with nothing moist but their snotty Noses, nothing stiffe but their Joints, nor standing but their Ears." Men quickly responded with their own pamphlet, claiming that coffee "makes the erection more Vigorous, and the Ejaculation more full," not to mention adding "spiritualescency to the Sperme . . ."

How Many Love Children Did Thomas Jefferson Have with His Slaves?

(AD 1802)

Six is the current consensus, of whom four survived infancy. None, according to the diehard Jefferson-worship groups that still refuse to accept the DNA evidence.

The slowest-burning sex scandal in American history took nearly two hundred years to properly break. It was back in 1802 that a scandalmongering journalist named James Callender published the first accusations in the *Richmond Recorder* that Thomas Jefferson was siring a second family at Monticello with one of his African American slaves, Sally Hemings. Jefferson, then serving his first term as president, refused to ever discuss the charges, but speculation began again long after his death. In 1872, one of Sally's sons, Madison, explained the family's complicated story in great detail to a reporter for the *Pike County Republican* in Ohio, an incendiary article that reopened the debate a third time when it was found in the 1950s. Jefferson's white descendants dismissed the suggestion as a sordid calumny, insisting that Sally's children had really been fathered by Jefferson's brother or nephew. White historians, nicknamed the "Jefferson mafia" for actively polishing the president's noble image, were even more dismissive of the charge, arguing that it was "radically inconsistent" with the character of their hero.

After years of back and forth, a 1998 DNA test published in the science journal *Nature* matched Y chromosomes from Jefferson's family to prove with over 99.9 percent certainty that he had fathered

the youngest of Sally's children, Eston, in 1808—and very likely all six, since records show that Jefferson was staying on the plantation when each conception would have occurred. Historians have done an abrupt volte-face, and even the august Jefferson Foundation at Monticello now accepts the scandal as true.

Jefferson's relationship with Sally Hemings evidently began in the tumultuous atmosphere of Paris on the eve of the French Revolution. He was the United States ambassador, a lonely widower in his mid-forties; she was a sixteen-year-old slave, born into servitude on the Jefferson family plantation and brought over from Virginia to attend his two daughters. Very little is known about Sally except that she was light-skinned—her lineage was three-quarters white— and that she was strikingly pretty, with long, straight black hair that flowed down her back. According to her son Madison, Sally had at first refused to leave Paris for the United States, since under French law she was a free woman in Europe. But Jefferson swore that he would free all of her children when they turned twenty-one if she crossed the Atlantic with him. On their return to Monticello in 1789, Jefferson went on to serve two terms as president and Sally went back to living in a one-room cabin with a mud floor.

In their thirty-eight-year relationship, six children were born, most while Jefferson was going back and forth to the White House. Only four survived past infancy, three male and one female.

* Harriet, b. 1795 (daughter), died in infancy
* Thomas Beverley, b. 1798 (son)
* Unnamed daughter, b. 1799, died in infancy
* Harriet, b. 1801 (daughter)
* Madison, b. 1805 (son)
* Eston, b. 1808 (son)

Confusingly, there were rumors of a seventh child who was conceived in France and born in the United States; if this is true, the baby

does not appear to have survived. Sally's four children worked in the main house at Monticello, living alongside Jefferson's two legitimate daughters and his grandchildren. Visitors to the plantation have recorded that they were startled to have their meals served by a pair of polite young slaves who looked eerily like their master. Evidently the situation was never openly discussed by the Jefferson family; slave owners' sleeping arrangements were a taboo subject in Virginia.

Jefferson did free his four surviving children by Sally. In the 1820s, he allowed Beverley and Harriet to escape. In his will executed in 1826, Jefferson freed his other two sons. Sally herself was freed by the family two years later. How many descendants are around in the United States today? Genealogists aren't sure. We know that the four Jefferson-Hemings children each married and had kids; some 150 African American descendants gathered at Monticello in 2003, and the total number is many times that.

Today, the most heated question among historians is whether the relationship was, in the parlance of sexual harassment cases today, "consensual" or "abusive." Here, we have to delve into the realm of speculation. It is hard to imagine that the affair could go on for thirty-eight years without some affection; the teenage Sally had nursed Jefferson's dying wife, which may have been a bond between them. But this hardly lets the third president off the hook. The slave master and his property, thirty years his junior, did not exactly meet on equal terms. And Jefferson's conscience is hard to fathom. When he was young, Jefferson opposed slavery and even tried to have a condemnation included in the Declaration of Independence. But later in life, as his relationship with Sally was in full swing, he wrote condemnations of sexual relations between blacks and whites and argued that all freed slaves should be deported back to Africa or the Caribbean.

SOURCES/FURTHER READING: R. B. Bernstein, *Thomas Jefferson* (New York: Oxford University Press, 2003); Annette Gordon-Reed, *Thomas Jefferson and Sally Hemings: An*

American Controversy (Charlottesville: University Press of Virginia, 1997). The Thomas Jefferson Heritage Society ("a group of concerned businessmen, historians, genealogists, scientists and patriots") argues against the DNA evidence in Eyler Robert Coates Sr. (ed.), *The Jefferson-Hemings Myth: An American Travesty* (Charlottesville: Jefferson Editions, 2001).

The Monster Fig Leaf of Florence
(AD 1504)

E ven in Renaissance Florence, everyone was a critic.

Before Michelangelo's *David* was revealed to the public on June 8, 1504, a few jealous artists carped that there were flaws in the vast nude—the right hand was a touch too big, the neck a little bit long, the left shin oversized, and something about the left buttock was not quite right. When the statue was being moved into the central Piazza della Signoria, a group of youths even attacked it with stones, which forced the city to mount a round-the-clock guard (although the vandals' anger was probably provoked by local politics, not aesthetics).

But the most disconcerting criticism at the time came from the powerful Piero Soderino, one of the top magistrates in the Florentine Republic. According to a tale told by the contemporary biographer (and avid Michelangelo fan) Giorgio Vasari, Soderino went so far as to tell the famously irascible artist that David's *nose* was much too large. Enraged, Michelangelo hid some marble dust in his palm, climbed back up his ladder, and pretended to do some more chiseling on the offending proboscis. While he did so he let some of the powder fall from his hand. The prattish Soderino was fooled: he examined the unchanged nose and announced it was much improved and far more "life-like."

The historian Paul Barosky adds a startling angle to this snout saga. In Florentine slang, he notes, the nose was used as a euphemism

for another prominent part of the male anatomy. Could it be that in the famous 1504 dispute over David, the city official Piero Soderino had ordered Michelangelo to reduce the size of the *other* feature? We know for certain that many Florentines had been offended by the statue's casual nudity; even Leonardo da Vinci, who like Michelangelo was a devoted admirer of the male physique, recommended that *Il Gigante* (as the statue was nicknamed) should be displayed to the masses with "decent adornment." At any rate, before the public unveiling, Michelangelo was obliged to cover David's genitals under twenty-eight copper leaves. (The sling and tree stump behind his right leg were also gilded, and the statue crowned with a gold wreath.) These extras remained until around 1550, when they were quietly removed.

SOURCES/FURTHER READING: Paul Barolsky, *Michelangelo's Nose: A Myth and Its Maker* (Philadelphia: University of Pennsylvania Press, 1990); Anton Gill, *Il Gigante: Michelangelo, Florence and the David, 1492–1505* (London: St. Martin's Press, 2003).

Michelangelo's Tax Returns

Renaissance Florence can be thanked for the invention of income tax, among its less celebrated contributions to civilization. In 1427, the city instituted its *catasto*, or register, whereby all heads of households had to file a report every three years on their current wealth—their income, their property, their debts, and their dependents. Personal deductions were allowed, domiciles were exempt, and tax was assessed by a progressive sliding *scala*, or staircase, system, where the wealthier paid a higher rate.

About one million pages of tax declarations are stored away in the state archives in Florence, making a fascinating resource for historians—especially because, unlike modern income

tax returns, citizens could include their own personal requests for special consideration. It seems Florentines took full advantage of this opportunity, bitching passionately about illness or deaths in the family, spendthrift sons, or unpaid dowries.

Despite their gifts to the world, Renaissance artists were just as perennially broke as their modern counterparts, and they were no less vocal about their financial woes. Their returns make melancholy reading. The great Paolo Uccelo, who pioneered the use of perspective in Western art, complained: "I am now old, and without business, and I cannot work, and my wife is ill." Privately, he whined about having to live on cheap cheese, until he worried that his body could be used as putty. The renowned sculptor and architect Michelozzo asked to be given a break for supporting his blind seventy-year-old mother and her nurse "at considerable expense and annoyance." (His request for a 200-florin deduction was denied.) The more obscure Giovanni del Monte refers to a long list of artworks he had delivered to rich patrons but had not been paid for, along with a bitter note that the money was unlikely to arrive in the foreseeable future. This was a common problem and the reason why the famed metalsmith Niccolò Grosso refused to start any job without a cash deposit or deliver it without payment of the balance, earning him the nickname *Il Caparra*, "the security deposit." The elderly master sculptor Donatallo took an unusually relaxed approach to his finances, carefully listing in his 1457 return all the money he was owed but adding that at the age of seventy-one he no longer cared about collecting it. ("A delightful philosophy," notes one historian.) Less resigned was the brilliant architect Filippo Brunelleschi, who griped in

(*continued*)

1442, "I am old and cannot profit by my industry"—something of a fib, since he was hard at work on the Florence cathedral. By then, tax evasion had been refined to its own fine art. One secret ledger has been found in the papers of a Florentine merchant, engraved ironically: "For the love of the tax man."

Some historians have argued that the *catasto* tax system fueled the Renaissance by encouraging a system of conspicuous consumption: since homes and their decoration were exempt, rich Florentines pumped their money into showy villas all around the city, with extravagant artworks making the ideal tax shelter. Even so, little of it made its way into artists' pockets—on the bottom of many returns, including Donatello's in 1433, the officials have scribbled in exasperation, "He has nothing!"—and the situation was little happier after 1497, when the *catasto* was replaced by a simple property tax.

A few geniuses did achieve financial security. The tax declarations of the "god-like" Michelangelo Buonarroti in 1534 reveal that he was one of the only artists in Florence who was making a decent living from his work. He had saved money from a steady flow of commissions, which, thanks to his unusually high rates, had left him a small net profit. (His *David*, for example, earned him 2 florins a month for two years, plus room and board for himself and assistants. The ceiling of the Sistine Chapel in Rome was finished on a tighter budget: the tightwad Pope Julius II paid him only 3,000 ducats, minus expenses for the colors, studio, and workmen, which gobbled up between 2,000 and 2,500 ducats.) Michelangelo eventually became rich, partly due to his frugal lifestyle (he dressed in virtual rags and shared a bed with his servant), but also by investing his funds in Florentine real estate. He ultimately owned an impressive range of houses and lots in the city. One investment property, on Via Ghibellina,

was bought in 1508, and, although he himself never lived there, it remained in family hands. Today it still stands in Florence as a museum, the Casa Buonarroti.

SOURCES/FURTHER READING: Jean Lucas-Dubreton, *Daily Life in Florence in the Time of the Medici* (London: Macmillan, 1961); Tim Parks, *Medici Money: Banking, Metaphysics and Art in Fifteenth-Century Florence* (New York: Atlas Books, 2005); Michael Veseth, *Mountains of Debt: Crisis and Change in Renaissance Florence, Victorian Britain and Postwar America* (New York: Oxford University Press, 1990); Martin Wackernagel, *The World of the Florentine Renaissance Artist: Projects and Patrons, Workshop and Art Market* (Princeton, N.J.: Princeton University Press, 1981).

MONEY DOESN'T STINK

*I*n the unsavory annals of taxation, special status must be given to the Roman "urine tax," the vectigal urinae. Matured urine was a viable commodity in the ancient world; it was used for tanning leather and when treated (by a now-forgotten process) was a prime source of ammonia used by laundries for keeping togas snowy white. Such businesses would simply get their supply from the public urinals—amphorae placed throughout the city where citizens, who had no facilities in their homes, would deposit their liquids. But in AD 71, Emperor Vespasian ruled that they should pay for the privilege. As expected, not everyone was enthusiastic. According to the Roman authors Suetonius and Dio Cassius, Vespasian's son Titus even complained that the tax was degrading for an imperial city. But the emperor held up a gold coin and declared Non olet, money doesn't stink—a credo that could be emblazoned over Wall Street. In Italy today, public urinals are still referred to as vespasiani.

Annals of Real Estate

A User's Guide to the Property Markets

of History

Real estate is a subject of obsessive interest at modern dinner parties, where we hang on the latest details of mortgage crises and rental coups. But perhaps it's time to take a longer-range view of the housing market and its endless cycles of boom and bust: whether you're a humble tenant or a sharklike developer, it should be possible to pick up some tips by examining the great deals of the past.

1 BR "Fixer-Upper" in Ancient Babylon: The world's oldest rental lease is a clay tablet dated to around 2000 BC, wherein a certain Akhibe leased a house from Mashqu for 1 shekel of silver a year—about 0.4 ounces. (Prices don't quite translate, since that amount of silver is only US$7 today.) Rental properties at the time were intimate, one-story mud brick affairs. Not only did they come unfurnished, they were all a "handyman's dream": tenants had to do their own carpentry, even fitting their own doors and windows. Rents were payable in advance every six months. Owners had to think very long term for investment return. If the house was still in your family about fourteen hundred years later, under King Nebuchadnezzar in the sixth century BC, Babylon would be one of the world's more desirable places to live, thanks to the fabled Hanging Gardens looming over the ziggurats and huge city walls decorated

with colorful enamel images of lions and griffins. Even so, rents had gone up only ten times the original figure.

26 BR Luxury Villa in Ancient Rome: Agents writing advertising copy for location should try "where the eyes of gods and men are fixed"—one contemporary description of the center of Rome, a white-hot real estate market for nearly three centuries. Aristocrats preferred to buy. Around 50 BC, Cicero snapped up a villa on the exclusive Palatine Hill for 3.5 million *sestercii*—about four thousand times the annual income of a laborer or legionary. The price was the same for your holiday villa in the Bay of Naples—the Hamptons of antiquity—which boasted swimming pools, docks for private boats, and the all-important eel farms (a favored delicacy). Luxury villas had become excellent investments: they could be rented in the off-season for a whopping 10,000 *sestercii* a year and prices never dropped; a century and a half later, around AD 100, the poet Martial reports someone paying five times that for a similar space. Despite substantial elbow room, Roman interior decor was peculiar by modern standards (although there might be a small market for it): violent erotic images of Europa being ravished by Zeus as a bull could grace the dining room wall, alongside paintings of skulls and marble busts of dead relatives.

. .

DOG DAYS FOR TENANTS

*R*enters *may complain today about the rates in New York, London, and Paris, but things were even harsher in ancient Rome. From the first century AD, over a million low-income citizens were crowded into the first great imperial city, and property developers made a killing. Landlords threw up hundreds of six-story tenements called* insulae, *or "islands," which were broken into apartments of barely one hundred square feet each. And much like today, rates were always being pushed to the limit: "Ever-rising rent*

was the subject of eternal lamentation in Roman literature," notes the historian Jerome Carcopino.

Ancient living conditions sound touchingly familiar today: the dwellings were notorious, one historian says, for "the fragility of their construction, the scantiness of their furniture, insufficient light and heat, and the absence of sanitation." Roman writers like Juvenal and Martial were constantly whining about claustrophobic spaces, which had no kitchens, bathrooms, or running water, and often had no windows. "Where has the purse of greed yawned wider?" Juvenal asked, wondering why Romans had not set up an altar to Mammon, the god of wealth.

Rome even had the first professional real estate agents. Called (appropriately enough) extractores, they were notoriously skilled at hiding an apartment's defects and avoiding costly building repairs: "The agents would prop up a tottering wall," observes one historian, "or paint a huge [ceiling] rift over, and assure the occupants that they could sleep at their ease, all the time that their home was crumbling over their heads." As Juvenal wailed, sounding like a tenant's advocate today: "All low-income citizens should have marched out of Rome en masse years ago!"

Studio in Medieval Tower, Edinburgh—Partial Views:
Space was always tight in walled cities, but one of the grungiest addresses in history was central Edinburgh, where overcrowding forced developers to construct incipient skyscrapers that were essentially eleven-floor walk-ups. Here, in a narrow alley called a "close," you could rent a top-floor apartment for a bargain 100 merks—or five and a half pounds sterling. The lower floors were the cheapest, since all upstairs tenants threw their refuse onto the street, creating rank odors and pestilence at ground level. (Residents cried *gardylou*, a corruption of *gardez l'eau*, French for "watch out for the water!") There was a recognized system for apartment hunting: you would hire a

savvy teenage "caddie" to guide you through the maze of streets, stopping occasionally in taverns for oysters and claret. But the city's poor hygiene could lead to drastic eviction proceedings. In 1645, when the plague broke out in Mary King's Close, city authorities boarded up the alleyway, leaving the residents inside to succumb, one way or the other.

Private Island in New World, Potential for Development: The colonial era is full of subversive deal making, but the world's most notorious real estate coup occurred in 1626, when the energetic Dutch settler Peter Minuit, as agent for the West India Company, purchased the unimproved woodland "island Manhattes," covering fifteen thousand acres, for 60 guilders worth of goods (around $24 today). The three hundred or so resident Native Americans, referred to in documents as the Manhatesen, were not aware they were selling their island paradise at all, simply allowing the Dutch to share it. As related by Russell Shorto in *The Island at the Center of the World*, the chief, Sackimas, deemed that the Dutch access to Manhattan's resources was a reasonable exchange for a valuable array of European items—knives, axes, hoes, awls, cloth, and coats, but probably not beads—and the additional promise of support by the Dutch against enemy tribes. For forty years, the casual sharing arrangement worked well, with Indians still hunting and fishing in the forests and riverfronts. But then the Manhatesen were squeezed out to a less enviable site off-island—forests in the north, now known as the Bronx. Still, the Dutch were no visionary real estate geniuses: in 1644, they traded Manhattan for Surinam.

• •

FIRE SALE IN THE DAKOTAS

*P*erhaps the second most famous U.S. land grab was Congress's illegal seizure of the Black Hills of South Dakota from the Oglala Lakota in 1877. Gold had been discovered three years earlier in the mountain region, which was guaranteed by an 1851 treaty as

part of the twenty-million-acre Greater Sioux Reservation. When their leader, Sitting Bull, refused to sell (he picked up a pinch of dust and told negotiators, "not even as much as this"), the Lakota were cornered into a war, defeated, and evicted to a desolate reservation in the parched nearby plains. To add insult to injury, in the 1930s four presidents' faces were carved on one of the sacred cliff faces, Mount Rushmore. In 1980, the Lakota nation sued the U.S. government for violating their treaty rights. The court awarded them $106 million compensation, but the Indians refused to touch the money even though their communities remained desperately poor. Today, the amount has grown to over $500 million in the bank, but Lakota leaders say they are still waiting for the United States to honor the 1851 treaty and return their homeland, and they wear badges saying "The Black Hills Are Not for Sale."

• •

6 BR Apartment in Mozart's Vienna, Walking Distance to Trendy Coffeehouses, Concert Halls: During Vienna's golden age in the late 1780s, Wolfgang and his wife rented a luxury first-floor apartment in a brownstone building for 1,280 gulden a year—the equivalent of $4,000 a month, historians estimate. It was the sort of place a rock star might rent short term today, with giant bay windows, high ceilings (in this case adorned with stucco cherubs), and space for grand pianos. Leasing procedures were simple in Vienna— provided you weren't Jewish. Tenants were obliged to sign a police declaration confirming their Christianity and attend compulsory confession every Easter. Unfortunately, the high rent (and his own spendthrift ways) eventually forced Mozart to a cheaper neighborhood called the Trattenhof, where, in a rambling apartment complex of over six hundred tenants, he paid less than a third the price for the same space.

Unfurnished Garret in Depression-Era Paris, Suit Artist: To the distress of French landlords, Paris instituted rent control

during the First World War, allowing a wave of expat American writers and painters to cling there like barnacles in the 1920s. Hemingway and Fitzgerald also had it good thanks to devaluation of the franc, but Paris became even cheaper during the Depression. In 1934, even the impoverished writer Henry Miller was able to stop sleeping on friends' floors and acquire his own apartment at 18 Villa Seurat for a song at 700 francs a month (then $46). Fellow writers helped him repaint the walls, a friend donated a record collection, and Anaïs Nin provided a rug and curtains. The previous tenant, actor Antonin Artaud (who had invented the "Theater of Cruelty"), left an out-of-tune piano. The apartment was situated on the second floor, with a sunny parlor, skylight, and galley-sized kitchen, but the main drawback for the bald bohemian was its poor heating. ("No shag-pate, what! I work with hat and shawl!")

In the same rental market, broke Brit George Orwell found a bargain apartment at 250 francs a month ($16). Orwell took a certain pride in its decrepitude, insisting that he could live on 6 francs a day (about 40 cents). His diet was mainly bread, margarine, and the occasional glass of wine. It was during this time, biographers suspect, that Orwell contracted the tuberculosis that killed him at age forty-six.

SOURCES/FURTHER READING: Jerome Carcopino, *Daily Life in Ancient Rome: The People and the City at the Height of the Empire* (New York: Read Books, 2007); Peter Hall, *Cities in Civilization* (New York: Pantheon, 2006); Russell Shorto, *The Island at the Center of the World: The Epic Story of Dutch Manhattan and the Forgotten Colony That Shaped America* (New York: Doubleday, 2004).

What Was J. Edgar Hoover's Favorite Party Outfit?

(AD 1958)

The spectacle of the fleshy FBI chief lurching around the corridors of New York's Plaza Hotel in drag is now indelibly lodged in American popular folklore. The story is deeply satisfying, since it proves that the powerful Hoover, who monitored, harassed, and blackmailed thousands of Americans about their sex lives, was a rank and villainous hypocrite. Unfortunately, it is based entirely on the testimony of only one witness—Susan Rosenstiel, the former wife of a wealthy liquor distiller, who was quoted at length in the overheated *Official and Confidential: The Secret Life of J. Edgar Hoover*, a 1993 biography by muckraking Brit Anthony Summers that was excerpted in *Vanity Fair* magazine.

For the record, Ms. Rosenstiel said that she and her husband went to a party with the gay McCarthy henchman Roy Cohn at the Plaza Hotel overlooking New York's Central Park in 1958. There she met Hoover wearing a fetching black curly wig, "fluffy" black dress, lace stockings, and high heels—and going by the name of "Mary." She says Hoover lifted his dress so that two young blond call boys (one wearing rubber gloves) could "work on him with their hands," then they all watched while her husband enjoyed the young pair. A year later, Rosenstiel recalls, she attended another party at the Plaza. This time, Hoover was wearing a red dress and sporting a saucy black feather boa, "like an old flapper, like you see on old tintypes." The same pair of blond call boys, now dressed in

leather, supposedly read from the Bible while fondling the ecstatic Hoover.

Memorable as her tale is, Ms. Rosenstiel proved to be not the most reliable source. Ronald Kessler, author of *The Bureau: The Secret History of the FBI,* reports that she was jailed for perjury in 1971 and may have wanted revenge on Hoover for supposedly putting FBI agents on her tail during divorce proceedings with her husband.

The only other evidence cited by Summers is the report of two anonymous sources in Washington, D.C., that they had seen photographs of Hoover in a blond wig and dress. Nobody else has ever seen these images. One former FBI agent recalled seeing blurry photographs that might fit the description, but could not be sure it was Hoover.

The cross-dressing account builds on the more persistent but unproven rumors that Hoover was gay. After all, he spent nearly forty years in close company with his young assistant Clyde Tolson. The pair were deeply attached; they took their holidays together and were buried alongside each other. (Richard Nixon, on learning of Hoover's death in 1972, reportedly declared, "Jesus Christ! That old cocksucker!") But the FBI agents who trailed Hoover as part of standard security routine insist that the two always went their separate ways at bedtime; as with Abe Lincoln and his supposed lover Joshua Speed, the "passionate friendship" was almost certainly unconsummated. And whatever his private inclinations, few can accept that the master blackmailer of the FBI, whose dossiers extended across the ruling elite of the United States, would have put himself so recklessly at risk by prancing about the Plaza Hotel in a dress—whether black or red.

SOURCES/FURTHER READING: Ronald Kessler, *The Bureau: The Secret History of the FBI* (New York: St. Martin's Press, 2002); Anthony Summers, *Official and Confidential: The Secret Life of J. Edgar Hoover* (New York: J. P. Putnam's Sons, 1993).

Triumphs of Transvestitism

The Old Testament, for one, did not take cross-dressing lightly: "A woman shall not wear man's apparel," rails the Book of Deuteronomy, "nor shall a man put on a woman's garment: for whosoever does such things is abhorrent to the Lord your God." This injunction, needless to say, has not stopped anyone from giving gender roles a modest twist in the last millennium or two.

C. AD 850: THE FEMALE POPE

The behind-the-scenes dominance of key women in the Vatican during the "dark" tenth century, especially the beautiful courtesan Morozia, who had popes assassinated and imprisoned, gave rise to the legend in medieval Rome that there was actually a female pope who passed herself off as male. According to the main variant of the tale, having worked her way up through the ranks to the top job, Pope Joan ruled for two years with great success, but became pregnant by one of her cardinal lovers. Her condition was made public only when childbirth cramps commenced prematurely during a procession through the streets of Rome; the crisis killed her. The story was accepted as gospel truth throughout Italy until fifteenth-century scholars disproved her existence by looking at the papal rosters; until then, busts of Joan had even stood in Siena Cathedral. A rumor still alive in Italy today states that newly elected popes must hoist their robes up and sit on a bottomless throne in the Lateran Palace for a physical examination to prove their gender.

1431: JOAN OF ARC

France's first fashion victim, literally speaking, was the lovely virgin who at the age of sixteen followed heavenly voices instructing her to head an army against the English. Her fellow soldiers were apparently too overawed by her short hair and military gear to be sexually aroused: the Duke d'Alençon, for example, admitted that when bivouacking together, "sometimes I saw Joan get ready for the night, and sometimes I looked at her breasts, which were beautiful. Nevertheless, I never had any carnal desire for her." But when she was captured and handed over to the Inquisition in Rouen, her cross-dressing was denounced as heretical and blasphemous. "Dress is a small thing," she protested to the court in a rather un-French manner, "amongst the smallest." As the trial dragged on, Joan abandoned her male clothing, changed her boyish haircut, and put on a dress. The court commuted her death sentence to life imprisonment, but only four days later she recanted and started wearing trousers in prison. Joan was retried and burned at the stake.

1777: THE CHEVALIER D'EON

Cross-dressing was popular in the eighteenth century for both male and female aristocrats, with abbots and politicians happily turning up to court in drag, but the Chevalier d'Eon went one step further. Up until the age of forty-nine, the French nobleman had cut a macho figure around Europe as a successful soldier and diplomat, although he remained

(*continued*)

aloof from the usual brothel visits and court affairs. But while living in London in 1777, d'Eon started putting out rumors that he was really a woman, and that he had only been forced to wear male clothes as a child by his cruel father. English high society was consumed by gossip, with partisans betting sums of up to 200,000 pounds on the chevalier's real sex. Just to complicate things, d'Eon kept wearing his male clothes and pretended that he was disgusted by this tavern speculation about his manhood. He even burst into a drinking house and challenged one of the participants in bets to a duel.

A group of the gamblers finally had to take d'Eon to court to settle the wager. There, it was decided that the chevalier really was and always had been female (although oddly he was not physically examined; the decision was based on the testimony of a male midwife who said that he had treated d'Eon for "women's troubles"). The disgraced d'Eon was forced back to France, where King Louis XVI ordered him to wear women's clothes. Deepening the mystery even further, he did so only under violent protest. The newly liberated *chevalière* then decided to present himself in a curiosity show as a female fencer, touring Europe dressed in a specially designed costume that was half male and half female, before finally dying in England at the ripe age of eighty-two, a solitary pauper.

But the story continues. When the corpse was dressed for burial, d'Eon turned out to be unquestionably male. A cadre of doctors arrived to examine his famous organ; they sketched it and had it cast in plaster as proof. Why precisely he became involved in this late-life sexual charade has been a matter of debate ever since; the most logical explanation is that the chevalier reveled in toying with everyone around him.

Today, there is still some confusion about his true sex: the venerable Ship Tavern pub in London has a plaque by its door boasting that it has hosted many historical celebrities, including the famous d'Eon, "a woman who lived as a man."

SOURCES/FURTHER READING: Elizabeth Abbott, *A History of Celibacy* (New York: Scribner, 1999); Mary Gordon, *Joan of Arc* (New York: Viking, 2000); Gary Kates, *Monsieur d'Eon Is a Woman: A Tale of Political Intrigue and Sexual Masquerade* (New York: Basic Books, 1995); *The New Catholic Encyclopedia* (Detroit and Washington, D.C.: The Catholic University of America/The Gale Group, 2003).

Pornography of the Kitchen

Birth of the Celebrity Chef

(AD 1805)

What sinister historical forces have conspired to create the freakish likes of Gordon Ramsay, Sandra Lee, Wolfgang Puck, and Emeril Lagasse? As with so much else in the history of dining, we can trace their rise to the early 1800s, when the cook was transformed from a humble artisan into a revered artist—the modern Prometheus.

Of course, there have always been great cooks throughout history, but they mostly stayed out of the limelight, as anonymous tradesmen in the sooty kitchens. Since the Middle Ages meals were, first and foremost, about extravagant presentation, and the most celebrated figure was the *maître d'hôtel*, or steward—the front man who designed all the special effects of a banquet. It was he who chose the dishes, oversaw the decoration, booked the entertainment, planned the seating, and choreographed the meal. The most famous of these impresarios was François Vatel, who in the mid-1600s staged spectacular dinners for his master, the Count de Condé. Vatel claimed immortality in 1671 when, during a feast for two thousand people in honor of the Sun King, Louis XIV, he was informed that the fish for the meal would not arrive on time, so he committed suicide, becoming France's first true martyr to gastronomy. (One version of the story goes that his body was found by a servant who was rushing to tell him that the fish had actually arrived. History sadly repeated itself in 2003, when French chef

Bernard Loiseau killed himself when told that his restaurant would lose one of its three Michelin stars.)

The meteoric rise of the chef began with a shift of dining etiquette. In Vatel's time, guests were ushered into a banquet hall to find the tables already set with food; most diners would serve themselves, and what one ate often depended on where one sat. Among the many drawbacks of this system, known as *service à la française,* was that the food was at best lukewarm by the time it was eaten. In the early 1800s, hosts began to change the procedure to the system we are most familiar with today—*service à la russe,* where meals were served by waiters in a series of distinct courses as they were produced by the kitchen. This style had been pioneered in restaurants, although it was named after the Russian ambassador to Paris who used it at an official function in 1810.

With *service à la russe,* the chef instantly gained in status. No matter how luxurious the dining room, it was the food itself that mattered. For the next century, it would be chefs who orchestrated the pace of the meal, sending out courses when they, not the diners, were ready. The logical final step was the modern "tasting menu," a now-universal fad whereby diners abandon all choice to the genius of the kitchen. This process, notes the food historian Cathy Kaufman, has led to "the chef's reign of terror," where diners are a passive audience awaiting the whims of hothouse prima donnas.

Probably the first person to really take advantage of the chef's new power was Antonin Carême, who leapt onto the Parisian stage in the early 1800s, a young and stylish Jamie Oliver in a jaunty white cap. Although he worked only for private patrons, he wrote the first cookbooks that described haute cuisine as a science, with its own coherent rules for sauces, soups, meats, pastries, and vegetables, all harmonized like a Mozart symphony. Carême would become as mythic a figure in the nineteenth century as Vatel had been in the seventeenth. Born into a dirt-poor family of twenty-five children, Carême worked his way up from a restaurant kitchen-hand to

international fame as the chef for Napoleon's gourmandizing foreign minister, Talleyrand. Carême astonished Europe's heads of state with his edible table settings: he created Greek temples of spun candy, complete with Cupid on a swing; medieval castles made of almond paste with jam moats; galleons made of hazelnuts. Later, in London, he was chef for the future King George IV; in St. Petersburg, for Tsar Nicholas I; and back in Paris again, for the millionaire banker James Mayor Rothschild. In classic romantic fashion, he even died of consumption, but really (says the admiring novelist Alexander Dumas) he was "killed by his own genius"—a fate that Gordon Ramsay and other modern celebrity chefs would do well to ponder.

SOURCES/FURTHER READING: Priscilla Parkhurst Ferguson, "Writing Out of the Kitchen: Carême and the Invention of French Cuisine," *Gastronomica* 3, no. 3 (2003): 40–51; Cathy K. Kaufman, "Structuring the Meal: The Revolution of *Service à la Russe*," in Harlan Walker (ed.), *The Meal: Proceedings of the Oxford Symposium on Food and Cookery* (Oxford: Prospect Books, 2002). Lawrence Selenick, "Consuming Passions: Eating and the Stage at the *Fin de Siècle*," *Gastronomica* 5, no. 2 (2005): 43–49.

A Menu for Lunatics

Futurist Food

(AD 1932)

If the Marx brothers had ever taken to food writing, they might have produced something very like F. T. Marinetti's marvelously slapstick work *The Futurist Cookbook*. The provocative (and regrettably Mussolini-approved) Italian artist Marinetti was infatuated by all things sleek, sharp, electronic, and shiny, but he was also an avowed enemy of pasta, which he denounced as a pathetic Italian addiction to nostalgia and tradition. Instead, he preferred his Futurist meals to combine the radical use of color, shape, music, lighting, and ideas—leaving taste and nutrition off the list entirely. In fact, the modern vitamin supplement industry should make Marinetti a patron saint; he argued that all sustenance should come from pills, freeing up food to be the raw material of art, preferably to be consumed while listening to the soothing hum of an airplane engine.

His oddball cuisine debuted in the first (and only) Futurist restaurant in 1929 Turin, an angular, alumina-plated interior called *La Taverna del Santopalato*, Tavern of the Holy Palate. It was an event Marinetti considered on a par with the discovery of America and the fall of the Bastille ("the first human way of eating is born!"). His cuisine was then replicated at various Futurist events across Europe, to the horror of many pasta lovers, and his 1932 cookbook has both delighted and mystified gastronomists ever since.

Some recipes can be visualized fairly easily, such as his sculpted

meat skyscrapers with geraniums on skewers. But other recipes are more conceptual:

Aerofood: A signature Futurist dish, with a strong tactile element. Pieces of olive, fennel, and kumquat are eaten with the right hand while the left hand caresses various swatches of sandpaper, velvet, and silk. At the same time, the diner is blasted with a giant fan (preferably an airplane propeller) and nimble waiters spray him or her with the scent of carnation, all to the strains of a Wagner opera. ("Astonishing results," Marinetti says. "Test them and see.")

Taste Buds Take Off: A soup of concentrated meat stock, champagne, and grappa, garnished with rose petals—"a masterpiece of brothy lyricism."

Italian Breasts in the Sunshine: Two half spheres of almond paste, with a fresh strawberry at the center of each, sprinkled with black pepper.

Chicken Fiat: A chicken is roasted with a handful of ball bearings inside. "When the flesh has fully absorbed the flavor of the mild steel balls, the chicken is served with a garnish of whipped cream."

Beautiful Nude Food Portrait: A crystal bowl filled with fresh milk and the flesh of two boiled capons, all scattered with violet petals.

Equator + North Pole: "An equatorial sea of golden poached egg yokes" surrounds a cone made of whipped egg whites. This is "dotted with orange segments like succulent pieces of the sun" and black truffle carved to look like airplanes.

The Excited Pig: A "whole salami, skinned" is cooked in strong espresso coffee and flavored with eau de cologne.

Candied Atmospheric Electricities: Brilliantly colored bars of marbled soup, filled with sweet cream.

Diabolical Roses: Red roses, battered and deep-fried.

Simultaneous Ice Cream: Vanilla dairy cream and little squares of raw onion frozen together.

Marinetti was not entirely indifferent to the romance of fine dining and does include a "Nocturnal Love Feast" in his cookbook. The meal, which should be eaten at midnight on the island of Capri, climaxes with a cocktail called the *War-in-Bed*—a relatively appetizing blend of pineapple juice, egg, cocoa, caviar, red pepper, almond paste, nutmeg, and a whole clove, all mixed in the yellow Strega liqueur. He declares that modern women (preferably sheathed in dresses made of gold graphic patterns) will inevitably be won over by the intellectual rigor of Futurist cooking, describing one beautiful donna's wide-eyed response: "I'm dazzled! Your genius frightens me!"

Although Marinetti's reputation suffered thanks to his embrace of Italian fascism and his taste for macho posturing, the goofy humor of his cookbook would influence a generation of younger artists, most notably the Spaniard Salvador Dalí. Dalí wrote obsessively about the connection between food and art, providing recipes for a Venus de Milo made from hard-boiled eggs (imagine the pleasure, he explained, of biting into her yolky breast) and championing the art nouveau style of Antonio Gaudí as a form of edible architecture, "whose softness seems to beg 'Eat me!'" He penned and illustrated his own cookbook (*Les Diners de Gala*, dedicated to his wife) and included loopy food imagery in many of his surrealist paintings, such as *Average French Bread with Two Fried Eggs Without the Plate Trying to Sodomize a Crumb of Portuguese Bread* (1932) and the famous *Soft Construction with Baked Beans: Spain, Premonition of Civil War* (1936). In the modern world, Dalí declared, "beauty will be edible or not at all."

SOURCES/FURTHUR READING: Robert Irwin, "The Disgusting Dinners of Salvador Dalí," *Proceedings of the Oxford Symposium on Food and Cookery* (1998): 103–11; F. T. Marinetti (ed. Lesley Chamberlain), *The Futurist Cookbook* (San Francisco: Bedford Arts, 1989).

LAGER LOUTS ON TOUR (1650)

*M*odern Italians have become wearily accustomed to Northern European tourists arriving in their cities to eat, drink, and pass out in an alcohol haze. It's a tradition that goes back more than four centuries. The pioneer ugly tourists were traveling Dutch artists—a staid enough lot until they arrived in Rome to study the wonders of the city. In 1650, a group of expat Dutchmen formed the first Schildersbent (Painter's Clique) and started performing their own version of "Bacchic rites"—in other words, beer binges that could last up to three days. The festivities usually began with a huge banquet and involved a procession to what they decided was "the Tomb of Bacchus." It was actually the sarcophagus of the ancient Roman princess Constantina, Emperor Constantine's daughter, but the grape decorations carved into its sides caused the confusion. There, each member of the artistic clique would scratch his name on the tomb and keep drinking until he passed out in an odiferous heap in a nearby gutter. This charming Dutch rite failed to impress the Romans, and it was banned in 1720 by papal decree.

Napoleon Unzipped #3:
Three Minutes with the Emperor
(AD 1810)

Power, as Henry Kissinger gloated, is the ultimate aphrodisiac. At Napoleon's highest point in 1810—he was then age forty-one—the emperor was the master of continental Europe, with forty-four million people under his control. Then, in a moment of candor, he confessed to an aide that he had done it all not for glory, patriotism, or ego, but for love: as the world's most powerful man, he could sleep with any woman he desired.

In the emperor's bedroom, however, the reviews were mixed. Just as he indifferently bolted down his food, paid no attention to his clothes, and could be self-absorbed and distracted in conversation, Napoleon's romantic style, admits one otherwise admiring biographer, was "anything but endearing." A description by the author Stendahl, backed up by members of Napoleon's staff, describes his "brutally abrupt" bedside manner at the height of his power. The emperor would work late, signing decrees. "When a lady was announced, he would request her—without looking up from his worktable—to go and wait for him in bed. Later, with a candlestick in his hand, he would show her out of the bedroom, and then promptly go back to his table to continue reading, correcting, and signing those endless decrees. The essential part of the rendezvous had not lasted three minutes. . . . To dismiss these gallant visitors after a mere three minutes of his time, to go on signing decrees, and

often without so much as unbuckling his sword, struck these ladies as an outrageous procedure."

Napoleon's archenemy, the Duke of Wellington, was another famous ladies' man. After winning the Battle of Waterloo in 1815, Wellington was feted in Paris, even sharing the bed of several of Napoleon's former mistresses. One, the actress Mademoiselle Georges (whose real name was Marguerite-Josephine Weimer), was asked at a dinner to compare the two. "Ah, sir," she replied, "the Duke was by far the more vigorous."

SOURCES/FURTHER READING: Evangeline Bruce, *Napoleon and Josephine: The Improbable Marriage* (New York: Scribner, 1995); Julius Bryant, *Apsley House: The Wellington Collection* (London: English Heritage, 2005).

JFK's Home Delivery Service

(AD 1960)

Napoleon had a lot in common with America's youngest president: they were both compulsive womanizers and yet distracted lovers. According to Robert Dallek's definitive biography, JFK's motto in his student days at Harvard was "wham, bam, thank you ma'am," a policy he maintained throughout his political career. (The quaint phrase, incidentally, was first recorded in the United States in 1895; it originally meant stealing a quick kiss in the back of a frontier wagon as passengers bounced over a pothole.)

As a debonair young congressman, JFK squeezed his romantic trysts between busy business meetings, telling one woman in the 1950s, "I wish we had time for some foreplay," and another on the (admittedly hectic) 1960 presidential campaign trail, "We only have fifteen minutes." "He wasn't in it for the cuddling," one of JFK's conquests noted dryly. The breakneck pace only increased in the White House, as JFK bedded a small army of women who came into his orbit, including Hollywood starlets, his wife's press secretary, a pair of White House secretaries dubbed Fiddle and Faddle (whom he often entertained at lunchtime skinny-dips in the heated indoor swimming pool), and, anticipating Bill Clinton by three decades, a nineteen-year-old intern who had been hired despite the fact that she had "no skills" and "couldn't type." As Dallek records, he even had sex in a White House cupboard while the lady's husband

entertained next door. Despite her famously sizzling rendition of "Happy Birthday, Mr. President" at JFK's forty-fifth in 1962, there is still surprising disagreement among historians as to whether Marilyn Monroe and the president were actually lovers; Dallek thinks she was too unstable and notorious even for JFK, who otherwise seemed addicted to high-risk romances.

The presidential love life obviously required huge logistical support. To keep the party going, the nighttime duties of the Secret Service were broadened. Hardened agents found themselves ferrying women back and forth from the Washington airport and guarding the door of the White House swimming pool from intruders when JFK was dallying inside. When the president was on the road, JFK's longtime friend and campaign aide Dave Powers was in charge of procuring women every night. At stopovers from Florida to Oregon, Powers (whose official title was Special Assistant to the President) hired call girls, escorted them to and from JFK's hotel suite, sorted out payment, and warned them to keep quiet about what they had done. For his exposé *The Dark Side of Camelot,* esteemed *New Yorker* writer Seymour Hersh interviewed several Secret Service agents on the record about the nuts and bolts of this home delivery process. Although devoted to Kennedy, most found the situation surreal. They were not permitted to search for weapons in the handbags of the steady stream of prostitutes under Powers's wing. "You were on the most elite assignment in the Secret Service, and you were there watching an elevator or a door because the president was inside with two hookers," said one, Larry Newman; "we couldn't even protect the president from getting a venereal disease." (JFK was actually suffering from chlamydia, a fact that was suppressed in the autopsy notes by the family.) Another agent, Joseph Paolella, was enraged for another reason: the girls weren't good-looking enough. "You'd say, 'Geez, what's the president doing with something like that?' We might think he could do better." Some agents got into the spirit of the debauchery themselves, drinking all night with stray women

from the entourage. In December 1962, Secret Service men had to keep California state patrolmen from interrupting a poolside bacchanal at Bing Crosby's desert estate in Palm Springs, where the shrieks of partygoers were being mistaken for howling coyotes. "We didn't want them to see that the president was swimming with all these ladies and they were all nude," said Newman.

While Napoleon had flaunted his affairs around Paris, an essential part of JFK's image in puritanical America was as a happy family man. How did he keep his hectic sex life secret? It appears that nobody had any interest in exposing it. The famously poised first lady appeared to those around her to have become resigned, keeping her husband's staff closely informed of her schedule so that there would be no embarrassing encounters. Although stories circulated in fringe right-wing newspapers, the mainstream press kept mum. In a pre-Watergate world, the mostly male press corps preferred to maintain JFK's wholesome public image while privately admiring his jaunty love life. Republican politicians seem to have had their own secrets they preferred to keep quiet. According to Hersh, whenever scandals threatened to break loose, JFK's brother Attorney General Bobby Kennedy would use his personal influence to fix things: in 1963, he had one sordid story silenced by directly contacting the Hearst Company publishers; on another occasion, he had a twenty-seven-year-old call girl who had been identified as a possible East German spy deported. And—for a while—JFK had a lot of luck.

SOURCES/FURTHER READING: Robert Dallek, *An Unfinished Life: John F. Kennedy 1917–1963* (Boston: Little, Brown and Co., 2003); Seymour Hersh, *The Dark Side of Camelot* (Boston: Little, Brown and Co., 1997).

The Curse of Self-Abuse

(c. AD 1712)

Masturbation's bad rap can be dated with surprising accuracy. Around 1712, a short, anonymous pamphlet called *Onania* began to circulate around the coffeehouses of London, published by the private press of one P. Varenne. Little did anyone know it would become history's most successful advertorial. The pamphlet made the sensational claim that masturbation was responsible for a whole range of illnesses—from headaches to rheumatism, shortsightedness, bowel disorders, and gonorrhea—and that, left unrestrained, the habit would inevitably lead to a lonely and agonizing death. Up until that time, the world had been blissfully indifferent to the health risks of self-pleasuring; the habit elicited a few tut-tuts from the church, but it was considered an insignificant and harmless vice. In fact, doctors since the Roman Galen had argued that the retention of sperm by males was physically dangerous and that females could also avoid hysteria and madness through autoerotic release. But thanks to *Onania*, "self-abuse" would now and for centuries afterward be identified as European society's most pernicious public health threat, a cancer that was eating away at the bodies of its children and youth.

In the best tradition of pop medicine, *Onania* identified both the disease and its instant cure: concerned parents were advised to buy two miracle drugs from the publisher at the sign of the Seneca's Head pub in central London—"Strengthening Tincture" and "Prolific Powder." It comes as no surprise to learn that these medicines, which

would deaden any dangerous nocturnal urges, were rapaciously ex-
pensive, at 10 shillings a bottle and 12 shillings a bag, respectively
(the price of about three hundred cups of coffee at the time).

The identity of *Onania*'s author remained a mystery until 2002,
when Berkeley scholar Thomas W. Laqueur traced the authors who
had worked with the publisher Varenne before and fingered the
unsavory London quack John Marten (1670–1737). This shadowy
figure was a self-educated surgeon and medical huckster, who had
been clapped in irons for obscenity over a fanciful book on vene-
real diseases. Emerging undaunted from prison, he evidently
knocked out his magnum opus *Onania* at the age of forty-two.
(Marten took his title from the biblical figure Onan, who "spills his
seed on the ground" rather than procreate with his wife and is
struck dead by a vengeful God. Although Onan's sin might well
have been coitus interruptus, or the withdrawal method, the pam-
phleteer insisted it was definitely masturbation.) Marten must have
been a little surprised to find he had penned a bestseller; London
was already flooded with pseudoscientific claptrap, but his work
tapped into eighteenth-century fears that the unbridled imagina-
tion, especially of children, could become a destructive force. He
quickly expanded *Onania* into an eighty-eight-page tract, padded
with soft-porn "testimonials" from readers that mostly seemed to
involve attractive young women feverishly fondling themselves.
Typical was a report from the distraught parents of a comely farm
girl who had taken to self-abuse at age fourteen, fallen ill, then
turned into a nymphomaniac. The harlot evidently died in hyster-
ics at age nineteen from an infected "gland" in her clitoris.

It was a winning formula. *Onania* went into twenty-eight editions
and was widely translated in Europe. The first pirate U.S. edition
came out in 1724 in Boston; a copy worked its way into the library of
Thomas Jefferson in Monticello, among other high places. In Lon-
don, *Onania* stayed in print for seventy-five years, but its bleak influ-
ence would last far longer, provoking guilt and hypochondria for the

next two centuries. In 1760, the celebrated Swiss doctor Samuel Tissot expanded on Marten's ideas in his hugely successful book *L'Onanisme*. Tissot argued that semen is "an essential oil"—one precious ounce is worth forty ounces of blood, with terrible effects on the body if wasted—and that young women were in just as much danger from the deadly disease of "vulvovaginitis" as young men were from "spermatorrhea." The fear of self-abuse provoked hysteria well into the early twentieth century and produced some relics still with us today: both graham crackers and Corn Flakes were invented by frenzied antimasturbation campaigner John Harvey Kellogg as nonstimulating foodstuffs to reduce the sex drives of the young.

SOURCES/FURTHER READING: Thomas W. Laqueur, *Solitary Sex: A Cultural History of Masturbation* (New York: Zone Books, 2003); Jean Stengers and Anne Van Neck, *Masturbation: The History of a Great Terror* (New York: Palgrave, 2001). (The full title of *Onania* is unwieldy, if bracingly blunt: *The Heinous Sin of Self Pollution, and all its Frightful Consequences, in both SEXES Considered, with Spiritual and Physical Advice to those who have already injured themselves by this abominable practice. And seasonable Admonition to the Youth of the Nation of Both Sexes* . . .)

Do You Suffer from . . . ?

Like marijuana in the 1950s, masturbation in the eighteenth century became a handy scapegoat for a host of mental and physical disorders, especially in teens. By the 1850s, it was commonly claimed that self-abuse had led to more deaths than all of history's wars and epidemics. Specialists identified an eclectic range of symptoms:

* Cerebrospinal system: Vertigo, migraines, cerebral congestion.
* Nervous system: Melancholy, hysteria, convulsions, drooling, stupidity, insanity.
* Skeletal system: Stunted growth, rheumatism, rickets, gout, gibbosities (humps).

* Muscular system: Weight loss, paralysis, chronic weakness, pallor.
* Cardiovascular system: Palpitations, heart lesions, blackouts, aneurysms.
* Respiratory system: Scrofula, catarrh, tuberculosis, sinus blockages, discharges.
* Digestive system: Heartburn, ulcers, chronic stomach pains, diarrhea.
* Genitourinary system: Impotence, sterility, gonorrhea; spermatorrhea for men (excessive ejaculation, constant emissions); miscarriages for women.
* Prognosis if untreated: exhaustion, memory loss, sores covering entire body. Debilitation continues to an agonizing and pathetic death. Dr. Tissot described one victim in 1757 as "sunk below the level of the beast, a spectacle of unimaginable horror, it was difficult to believe that he had once belonged to the human race."

BREAKING THE HABIT

Medical manuals offered detailed prescriptions to curb masturbatory tendencies in children, including plentiful exercise and bland diets. It was recommended that boring books on "morals, philosophy or history" should be snatched up "as soon as the desire to masturbate overcomes you." Victorian specialists also sold "preventative undergarments" for girls made of soft calf's leather, the direct descendants of chastity belts. Boys could wear spiked rings around their penises that would make sure they were jerked awake if they became aroused in their sleep. One high-tech version gave an electric shock to unruly genitals.

Of Saints and Supermodels

(AD 1375)

I f Kate Moss had been around seven hundred years ago, she might now be revered as a saint. At least, that's one conclusion we can draw from a study of 241 Italian holy women (female saints, "blesseds" and "venerables" officially recognized by the church) from the years 1200 to 1700 conducted by Rutgers University professor Rudolph Bell. It turns out that about half of the sacred figures we have information about suffered from eating disorders, Bell discovered, starving themselves, losing up to a quarter of their body weight, and regurgitating what little they did eat. In other words, they suffered the classic symptoms of the curse of modern models, ballet dancers, gymnasts, and actors—anorexia nervosa.

In contrast to today's social pressures, which proclaim the rake-thin waif as an ideal of sexual attractiveness, the earliest epidemics of anorexia were the result of religious demands for women to loathe their own bodies as "unclean vessels": the less you indulged the flesh, the holier you were. Rituals of radical self-denial permeated daily life, with fasting the most common. Cathedral frescoes depicted in graphic detail how gluttons were punished with terrible torments in hell, and the more suggestible and neurotic women, especially in convents, took their dieting regime to extremes, eating nothing but the eucharist until they themselves were wafer-thin. In Italian provincial towns (quite unlike permissive cities like Venice), there was also an atmosphere of sexual hysteria where teens took to self-flagellation with whips and lying on

sharp sticks to quell any carnal stirrings. Desire crept out in peculiar ways: it was not uncommon for such girls to go into a state of otherworldly euphoria, possibly induced by the fasting, and experience delirious visions of being "married" to a virile, barrel-chested version of Jesus himself. In many Italian villages, such unearthly adolescents were revered by the Christian faithful, even treated with awe for achieving their sanctified state.

A typical case was Catherine Benincasa (b. 1348), a zealous woman from Siena who from the age of twenty-five put herself on a virtual starvation diet. On one occasion, she was forced by concerned relatives to toss some herbs into her mouth, but she retched them straight back up again. Catherine had cultivated a "holy hatred" of her own body, she explained, and in delirious states would cry out, "Vainglory, no, but the true praise and glory of God, yes." Finally she refused even water and died muttering about heaven and hell at the age of thirty-three. At first, male church officials had been shocked by her suicidal behavior; they were surprised she lived as long as she did and thought that she was really being fed in secret by the devil. Others scoffed that Catherine's "holy" self-denial was really motivated by the eternal sin of vanity, a desire to elevate herself from her run-of-the-mill peers. But Catherine's spellbound public believed that her rejection of the most basic physical needs did place her closer to God, adding authority to her strident denunciations of church corruption and earthly evil. The pope canonized her not long after her death as Saint Catherine of Siena, and she is still the patron saint of Italy.

Hundreds of young women were likewise inspired to avoid food as the devil's work: to eat was mortal, to starve oneself, divine.

According to Bell's study, the incidence of anorexia declined dramatically in the later Renaissance, when society began to shift its value system. Church leaders started acknowledging women for the good works they performed for the poor rather than their masochistic self-denial—in other words, rewarding what they did

for others rather than what they did to themselves. The cycle of narcissism was broken.

In recent years, feminist historians have debated what lessons, if any, can be gleaned from the Italian holy women and their self-destructive road to emaciation. While modern scientists have identified a wide range of causes for anorexia, few would deny the enormous peer pressure on adolescent girls to make their bodies conform to an unrealistic ideal of thinness. This, of course, is a very recent phenomenon. It was not until the 1870s that anorexia nervosa was named and defined as a psychological disorder, and only in the early 1900s was its incidence noticed outside specialist medical circles. Although the Victorian upper classes did have a passion for "hourglass" waists, it took until the 1960s for a rake-thin figure to become widely accepted as the ultimate ideal of feminine beauty, thanks to the popularity of models like Twiggy, and cases of anorexia began increasing to plague proportions.

Who knows? Perhaps only a genuine shortage of food for all classes will shift the ideal back to a Rubenesque, well-fed appearance, as was the case for much of history.

SOURCE/FURTHER READING: Rudolph Bell, *Holy Anorexia* (Chicago: University of Chicago Press, 1985).

Aphrodisiac Attack

The Christian feast of Saint Valentine, February 14, was first associated with romance in the Middle Ages— possibly because it was near the official start of spring and the beginning of the birds' mating season—and by the mid-1800s, it was evolving into the big business of chocolates, candies, and candlelit dinners we know today. But the idea that certain foods are conducive to love dates back to the

ancient Greeks, although their criteria for aphrodisiac food was either its physical appearance, a powerful odor, or some symbolic property. The goddess of love, Aphrodite (the Roman Venus), had emerged from the sea, so thinkers reasoned that erotic potions should be concocted from seafood; even in the eighteenth century, it was believed that the Lenten diet of fish made people more lecherous. The oyster was considered especially arousing because of its vulva-esque appearance, while phallic-looking gourds were, not surprisingly, significant. Eggs of all kinds were thought by association to promote potency and fertility. Sparrows were seen to mate madly for hours on end, so were devoured by the dozen, as were the "lascivious" mullets.

From the earliest times, it was believed that consuming sexual fluids in meals would create a magical bond between lovers. Greek women would bake their secretions into honey cakes for the men they admired. The Roman scientist Pliny the Elder argued that excrement was also an aphrodisiac and should be slipped into meals, a recommendation that continued throughout the Renaissance: in 1552, Nostradamus included "oil of faeces" as an ingredient for a love potion. (The Romans had no shortage of odd romantic tips: a graffito found in the baths of Pompeii suggests rubbing a tick taken from a dead dog on your genitals to inspire sexual desire, and "you will marvel at the results.")

Even by the Enlightenment, there was no abatement of folksy aphrodisiac experiments. The French king Louis XV and his lover Madame de Pompadour ate rams' testicles in the Palace of Versailles before nights of passion. Years

(continued)

later, when the madame's beauty was fading, she resorted to a diet of sexually shaped vegetables such as truffles and celery, as well as desserts scented with the vaguely vaginal vanilla. (Evidently the results were disappointing, and the madame finally confessed to Louis that she had never had much interest in sex. Undaunted, Louis set up his own brothel at Versailles called the Parc-aux-Cerfs, filled with attractive nymphets between the ages of nine and eighteen, but continued to meet with his former lover. Instead of forcing down plates full of truffles, they read together the titillating reports of the Parisian vice squad that chronicled the more baroque perversions of the French aristocracy.)

The Enlightenment also saw a revival of interest in the ancient remedy known as "Spanish fly"—a powder made from dried, ground green blister beetles. The beetles contain the chemical cantharidin, which, when ingested, causes the genitals to tingle and swell, which was mistaken for sexual arousal. Unfortunately, cantharidin is also a poison and can cause kidney malfunction or internal hemorrhaging if consumed in large quantities—as the Marquis de Sade found in 1772, when he plied two prostitutes with large quantities of aniseed sweets laced with Spanish fly and saw them collapse in agony, clutching their stomachs and vomiting. As we know, Sade was charged with attempted murder and forced to flee France, mystified at what all the fuss was about.

SOURCE/FURTHER READING: Miriam Hospodar, "Aphrodisiac Foods: Bringing Heaven to Earth," *Gastronomica* 4, no. 4 (2004): 80–93.

Vatican Hall of Shame

Lord, give me chastity and self-control—but not yet.
—Prayer of the young Saint Augustine, c. AD 380

The church has always waged a losing battle with its own vice-ridden staff. The problem was that transgressions from official policy often began at the top. One of the first popes, **Sixtus III** (432–40), was put on trial by fellow priests for seducing a nun. He was acquitted after quoting from Christ in his defense: "Let you who are without sin cast the first stone." In the centuries to follow, political skulduggery and a corrupt election process thrust one improbable candidate after another into the position, while God-fearing believers looked on in impotent horror. In fact, so many vicars of Christ have been denounced as the "Worst Pope Ever" that we have to settle for a Top Ten list.

Top Ten Papal Lechers

1. **Sergius III** (904–11), known as "the slave of every vice" by his cardinals, came to power after murdering his predecessor and had a son with his teenage mistress, thirty years his junior, the prostitute Marozia; their illegitimate son grew up to become the next pope. With top Vatican jobs auctioned off like baubles, the papacy entered its "dark century."

2. The sixteen-year-old **John XII** (955–64) was accused of sleeping with his two sisters and inventing a catalog of disgusting new sins. Described by a church historian as "the very dregs," he

was killed at age twenty-seven when the husband of one of his mistresses burst into his bedroom, discovered him in flagrante, and battered his skull with a hammer.

3. **Benedict IX** (1032–48) continually shocked even his most hardened cardinals by debauching young boys in the Lateran Palace. Repenting of his sins, he actually abdicated to a monastery, only to change his mind and seize office again. He was "a wretch who feasted on immorality," wrote Saint Peter Damian, "a demon from hell in the disguise of a priest."

4. After massacring the entire population in the Italian town of Palestrina, **Boniface VIII** (1294–1303) indulged in ménages with a married woman and her daughter and became renowned through Rome as a shameless pedophile. He famously declared that having sex with young boys was no more of a sin than rubbing one hand against the other—which should make him the patron saint of Boston priests today. The poet Dante reserved a place for him in the eighth circle of hell.

5. All pretense at decorum was abandoned when the papacy moved to Avignon in southern France for seventy-five years. Bon vivant **Clement VI** (1342–52) was called "an ecclesiastical Dionysus" by the poet Petrarch for the number of mistresses and the severity of his gonorrhea. Upon his death, fifty priests offered up Mass for the repose of his soul for nine consecutive days, but French wits agreed that this was nowhere near enough.

6. Decamping back to Rome, the papacy hit its true low point in the Renaissance. (Church historian Eamon Duffy compares Rome to Nixon's Washington, "a city of expense-account whores and political graft.") **Sixtus IV** (1471–84), who built the Sistine Chapel, had six illegitimate sons—one with his sister. He collected a church tax on prostitutes and charged priests for keeping mistresses, but critics argued that this merely increased the prevalence of clerical homosexuality.

7. The rule of **Innocent VIII** (1484–92) is remembered as the Golden Age of Bastards: he acknowledged eight illegitimate sons and was known to have many more, although in between love affairs he found time to start up the Inquisition. On his deathbed, he ordered a comely wet nurse to supply him with milk fresh from the breast.

8. The vicious Rodrigo Borgia, who took the name **Alexander VI** (1492–1503), presided over more orgies than masses, wrote Edward Gibbon. A career highlight was the 1501 "Joust of the Whores," when fifty dancers were invited to slowly strip around the pope's table. Alexander and his family gleefully threw chestnuts onto the floor, forcing the women to grovel around their feet like swine; they then offered prizes of fine clothes and jewelry for the man who could fornicate with the most women. Alexander's other hobbies included watching horses copulate, which would make him "laugh fit to bust." After his death—quite possibly poisoned by his pathological son, Cesar Borgia—this pope's body was expelled from the basilica of St. Peter as too evil to be buried in sacred soil.

9. **Julius II** (1503–13) is remembered for commissioning Michelangelo to paint the Sistine Chapel's ceiling. He was also the first pope to contract "the French disease," syphilis, from Rome's male prostitutes. On Good Friday of 1508, he was unable to allow his foot to be kissed by the faithful as it was completely covered with syphilitic sores.

10. Incurable romantic **Julius III** (1550–55) fell in love with a handsome young beggar boy he spotted brawling with a vendor's monkey in the streets. The pope went on to appoint this illiterate seventeen-year-old urchin a cardinal, inspiring an epic poem, "In Praise of Sodomy," probably written by a disgruntled archbishop, to be dedicated in his honor.

SOURCES/FURTHER READING: Eamon Duffy, *Saints and Sinners: A History of the Popes* (New Haven: Yale University Press, 2002); Peter De Rosa, *Vicars of Christ: The Dark Side of the Papacy* (New York: Crown Publishers, 1988).

Catherine the Great and
the Horsey Affair

(AD 1796)

The list of misogynist rumors about strong women leaders is long and fertile, but none lodge in the memory quite so vividly as the notorious "horse story" involving the empress of Russia Catherine II. Upon her death in 1796, word swept around Europe that she had been involved in a tryst with a stallion; the horse was supposedly being lowered onto her by servants using pulleys, when the ropes snapped, crushing her to death. In reality, the sixty-seven-year-old Catherine suffered a stroke on the privy in the Winter Palace of St. Petersburg and died in bed. But the scurrilous equine rumor has proven unshakable for more than two centuries. Where did it come from? According to biographer Virginia Rounding, its elements had been brewing among her enemies for decades.

Wide-eyed stories about Catherine's appetites had been circulating since she was in her twenties, when she took a parade of lovers rather than sleep with her husband, the hapless tsar Grand Duke Peter. The German-born empress was strong-willed, intelligent, witty, and a correspondent with Voltaire. She was also strikingly beautiful; Russian courtiers forgave her thin face and pointy chin, remarking instead on her blond hair, her prominent, expressive blue eyes, and (as one admirer put it), "a mouth which seemed to invite kisses." She made no secret of her love life, telling one of her beaux, Prince Grigory Potemkin, that she needed a

virile young man in the imperial bed for the sake of her health, and she was unable to rule Russia properly when sleeping alone. Eligible young noblemen would be "tested" by her ladies-in-waiting before making appearances in the empress's night chamber: "She selected a new favorite, or agreed to the selection recommended by her 'experts,' much as she selected a new painting for her collection," writes Rounding. Catherine would become infatuated with one or another of these *vremenshchiki,* "men of the moment," who could linger in her bed from a few months to several years, and she remained a connoisseur of Russian manhood even into her dotage, when she was formidably overweight, dripping with diamonds, and wore a bright dollop of rouge on each cheek. There was no shortage of volunteers: ambitious youths gladly accepted the honor of sharing the empress's bed for their families and careers.

All this was perfect grist for the boys' club of European rulers, threatened by an unmarried woman who had ousted her husband in a coup and confidently expanded the Russian Empire. Ribald jokes circulated that the busiest thoroughfare in St. Petersburg, the Venice of the North, was the Catherine Canal, and pornographic pictures of the empress appeared in France and Great Britain when war seemed near. But how did the equine element come into play? Some English travel writers had once reported in the West that, along with their beer and bread, Russian peasants habitually enjoyed sodomy with horses. More probably, Catherine had enjoyed a reputation as a fine horsewoman when young; upon her arrival in St. Petersburg, she had shocked the imperial court by straddling her horse like a man instead of sidesaddle. When news reached the outside world of the empress's death, the "equine fable" was simply a leap of the imagination.

SOURCE/FURTHER READING: Virginia Rounding, *Catherine the Great: Love, Sex and Power* (London: St. Martin's Press, 2006).

Milestones of Misogyny

Strong women rulers have always inspired violent attacks on their sexuality. To the Romans, Cleopatra was the "harlot queen," the woman "whom her own slaves would grind." In the Middle Ages, Isabel of England got the same treatment from her enemies, as did Catherine of Medici and Anne of Austria. Even Elizabeth I of England, the Virgin Queen who masterfully remained above the male fantasy mill, could not stem all rumors of her "uncontrollable female desires" and was thought to have been behind the death in a riding accident of her longtime friend Robert Dudley's wife.

But the most tragic victim was Marie-Antoinette. From early in her rule, the Austrian-born queen inspired in her French subjects the most virulent misogyny. Whole libraries of violent pornography flooded the market, depicting her as a wasteful and treacherous nymphomaniac who conducted orgies at Versailles, fornicated with cardinals and generals, and spied on France for the Austrians while satisfying her lusts. The most inventive, mock-serious work, *Historical Essay on the Life of Marie-Antoinette,* hit the underground market in 1781 and was updated almost every year until her death, with vivid illustrations of the queen lifting her skirts for the entire male court. It was soon supplemented by *Anandria,* which showed her in a lesbian love triangle with her ladies-in-waiting—the "German vice" being an object of particular obsession with the French— and sexually molesting her young son, the eight-year-old dauphin.

This hallucinogenic strain of pornography might sound too extreme to have been taken seriously, but it resurfaced

after the Revolution with concrete force as Marie-Antoinette was shuffled into ever more humiliating prisons. Her every public appearance was met with streams of abuse about her carnal desires; even a farewell to her most loyal friend, the Princess de Lamballe, who would soon end up on the guillotine, was reported in the press as a lascivious lesbian embrace. The low point came at her trial in 1793, when the deposed queen—by now frail, pallid, and gray-haired—was accused before the packed court of committing incest with her son, the dauphin. She and her aunt had supposedly slept with the boy between them and taught him to masturbate; in the pseudoscience of the day inspired by *Onania*, this meant that the "Austrian harlot" had weakened the vigor and intellect of the heir to the French throne, a treasonable act to undermine *la patrie*. "What mother would do such a thing?" Marie-Antoinette pleaded, to no avail.

SOURCE/FURTHER READING: Simon Schama, *Citizens: A Chronicle of the French Revolution* (New York: Vintage Books, 1990).

Cocktails, Sodomy, and the Lash

How Lust Kept the British Empire Strong

(AD 1900)

The empire may have been built by men and women trying to escape Britain's terrible weather—or even, as Cecil Rhodes once said, to avoid the lamentable cuisine—but it was kept fully staffed by refugees from the conservative sexual code. Accounts of life in colonial Bombay, for example, read as if the entire subcontinent was managed like a sleazy gentleman's club, with enterprising local agents procuring a series of "native wives" and "colored sisters" to warm the bed of every newly arrived heterosexual army officer and bureaucrat. Gay men, meanwhile, quickly became addicted to the freedom in the colonies, luring writers like E. M. Forster and Somerset Maugham.

These impulses were certainly not just British. In French slang, *faire passer son brevet colonial,* "to give a man the test for his colonial diploma," meant to initiate him into sodomy. The peculiar opus *The Art of Love in the Colonies,* written in 1893 by someone calling himself Dr. Jacobus X, describes under the guise of an academic anthropological handbook the erotic pleasures to be found by Gaugin-esque Frenchmen in every backwater of the tropics.

But it was the British who had the most success with their libertines. A key figure was Captain Sir Richard Burton (1821–90), explorer, secret agent, soldier, scientist, translator (he spoke

twenty-nine languages), opium addict, and insatiable sexual adventurer. Himself an aficionado of the brothels of India, he was sent at the age of twenty-four on an undercover mission in Karachi to expose a trio of houses that peddled boys and eunuchs to British soldiers. Burton reported back to his superiors with what many felt was an excessive wealth of detail on the practices, probably indicating firsthand experience. But most of Burton's carnal energies were spent on women, who seemed to both fascinate and terrify him. For the rest of his life, in between becoming the first white man to visit the holy city of Harar and making an undercover pilgrimage to Mecca, Burton wrote without inhibition on all manner of erotic practices. Convinced that the English needed some serious help on sex, he decided as a social service to translate the most salacious Eastern texts, starting with the *Kama Sutra,* to which he added his own detailed and kinky annotations on aphrodisiacs, circumcision, infibulation, polygamy, masturbation, and sadomasochism. Victorian readers who opened its straight-looking volume were astonished to read, for example, about Indian women pleasuring themselves with "bulbs, roots, and fruits having the form of the lingam." Burton had almost finished his masterwork, a translation from the Arabic of the scholarly *The Perfumed Garden of Shakyk Nefzawi*—which described a series of obscure sexual positions including "frog fashion," "the screw of Archimides," "the tail of the ostrich," "fitting on the sock," and "the one who stops in the house"—when he suddenly died of unspecified causes.

The true depth of Burton's obsessions will never be known. In 1860, he had married Isabel Arundell, a virginal, blond, blue-eyed English girl, and upon his death she burned all of her husband's manuscripts and most of his possessions in a giant bonfire.

SOURCES/FURTHER READING: Edward Rice, *Captain Sir Richard Francis Burton: The Secret Agent Who Made the Pilgrimage to Mecca, Discovered the Kama Sutra and Brought the Arabian Nights to the West* (New York: Scribner, 2003); Frank McLynn, *Burton: Snow Upon the Desert* (London: John Murray, 1990).

Colonial Boy Toys

The pantheon of British imperial heroes is filled with men who are now claimed as pillars of the gay movement:

General George Gordon (1833–85), hero of the Boxer Rebellion in China, governor of Sudan, martyr of Khartoum. Aides report he became obsessed with poor orphan boys of the Sudan—invited them home, mended their clothes, bathed them personally. Lifelong bachelor, declared "I could make no woman happy."

Cecil Rhodes (1853–1902), diamond magnate, creator of Rhodesia (now Zimbabwe), designer of scholarship bringing young Americans to Britain. Had a fondness for Aryan-featured young men, whom he nicknamed his "apostles" and "lambs." A vocal racist and misogynist, developed a passionate relationship with a young secretary named Pickering in his De Beers company. The pair shared a small tin shed in what one top official confirmed was "an absolute lover-like relationship." When Pickering was tragically injured in a riding accident, Rhodes nursed him, refusing to answer crucial telegrams and losing a three-million-pound lease. Wept hysterically at the funeral.

Henry Morgan Stanley (1841–1904), of Dr.-Livingstone-I-presume fame, happily admitted that he "never was an admirer of women." In 1873, wrote a panting novel about two African Apollos in love, *My Kalulu: Prince,*

King and Slave, based on two bearers he took on his famous Central African expedition. Still wound up in a marriage of convenience.

General Sir Robert Baden-Powell (1857–1941), Boer War hero, founder of the Boy Scouts movement. Married at age of fifty-five despite lifelong hostility toward women, including regular denunciations of the female figure. "A clean young man in his prime of health and strength is the finest creature God has made in the world," he declared. Enjoyed a passionate friendship with his aide Kenneth McLaren, whom he nicknamed "the Boy"; favorite pastime was watching and photographing his young scouts swim naked.

In a long military career, **Field Marshal Horatio Kitchener (1850–1916)** avenged Gordon's death in Khartoum, won the Boer War by inventing concentration camps, sent millions to their deaths in the trenches in World War One. Another vocal misogynist; a Reuters reporter in China noted that Kitchener had "a taste for buggery." (Less convincingly, some biographers decided that his neatness and taste for fine porcelain are evidence of gay leanings.) Died when his ship hit a mine in the North Sea, with his consort of nine years, the handsome young aide Oswald Fitzgerald.

T. E. Lawrence, aka Lawrence of Arabia (1888–1935), masochist hero of Palestinian campaign in First World War, subject of David Lean epic. Dedicated his memoir *The Seven Pillars of Wisdom* to young Bedouin donkey-boy and wrote enigmatic passages about "friends quivering together in the yielding sand with intimate hot limbs in supreme embrace." Admitted to being

(continued)

repelled by women's physiques, "but men's bodies, in repose or in movement . . . appeal to me directly and very generally." Said he was raped by Turkish soldiers when captured in disguise in 1917, although the details are hazy and possibly fabricated; after the war, routinely hired men to beat him viciously across buttocks.

SOURCES/FURTHER READING: Robert Aldrich, *Colonialism and Homosexuality* (London: Routledge, 2003); Frank M. Richardson, *Mars Without Venus: A Study of Some Homosexual Generals* (Edinburgh: W. Blackwood, 1981).

Napoleon Unzipped #4:
The Last Stand

(AD 1815)

Perhaps the legends surrounding the man had simply gotten out of hand, but even after he was defeated on the battlefield and exiled to St. Helena, Napoleon's privates, it seemed, admitted no Waterloo. Rumors of his sexual activities continued to circulate around Europe. Some whispered that he was having an affair with the pretty young wife of one of the loyal generals in his household, the Countess de Montholon, and even fathered a daughter by her in 1819, whom she named Napoleane-Josephine. (Conspiracy theorists even suggest it was the jealous count who poisoned the ex-emperor with arsenic as a result.) Others fancifully linked him to a fifteen-year-old island girl and a certain English rose named Miss Robinson. More believably, the French author Jean-Paul Kauffman discovered in the personal papers of Napoleon's valet, Ali, an enigmatic reference to island prostitutes being secretly spirited into the ex-emperor's bedroom in Longwood House. It was not the most romantic setting for a tryst: the mansion was an unhealthy, mildew-filled pile perched on the most exposed and windswept side of the South Atlantic island, and Napoleon slept in an austere little bedroom alternating between two single army pallets.

SOURCE/FURTHER READING: Jean-Paul Kauffman, *The Black Room at Longwood: Napoleon's Exile on St. Helena* (London: The Harvill Press, 1999).

Scent of a Führer

(AD 1937)

Guests at the Berghof, Hitler's private chalet in the Bavarian Alps, must have endured some unpleasant odors in the otherwise healthful mountain air.

It may sound like a Woody Allen scenario, but medical historians are unanimous that Adolf was the victim of uncontrollable flatulence. Spasmodic stomach cramps, constipation, and diarrhea, possibly the result of nervous tension, had been Hitler's curse since childhood and only grew more severe as he aged. When he was a stressed-out dictator, the agonizing digestive attacks would occur after most meals: Albert Speer recalled that the führer, ashen-faced, would leap up from the dinner table and disappear to his room.

This was an embarrassing problem for a ruthless leader of the Third Reich. With uncharacteristic concern for his fellow human beings, Hitler had first tried to cure himself when he was a rising politician in 1929 by poring over medical manuals, coming to the conclusion that a largely veg diet would calm his turbulent digestion as well as make his farts less offensive to the nose. A rabid hypochondriac, he would also examine his own feces on a regular basis and administer himself camomile enemas. Hitler decided to swear off meat completely in 1931, when his niece (and presumed romantic interest) Geli Raubel committed suicide: when presented with a plate of breakfast ham the next morning, he pushed it away muttering, "It's like eating a corpse." From that squeamish moment

on, great piles of vegetables, raw or pulped into a baby mulch, were Hitler's daily staple. (All cooked foods, he decided, were carcinogenic.) He showed a particular fondness, culinary historians assure us, for oatmeal with linseed oil, cauliflower, cottage cheese, boiled apples, artichoke hearts, and asparagus tips in white sauce. Strangely, Hitler was unfazed by the fact that this high-fiber diet was having the opposite effect on his digestion than what he had intended. His private physician, Dr. Theo Morell, recorded in his diary that after Hitler downed a typical vegetable platter, "constipation and colossal flatulence occurred on a scale I have seldom encountered before."

Hitler's stomach problems may even have played their part in his losing the war, thanks to this shadowy figure of Dr. Morell, an incompetent quack who took over Hitler's medical care in 1937. The pair had met at a Christmas gathering in the Berghof, the bucolic mountain retreat decorated with Bavarian knickknacks and edelweiss, the year before. Morell was an unpleasant figure even by Nazi standards—grossly obese, with froglike features, sulfurous BO, and venomous halitosis. But when he cured a painful case of eczema on Hitler's legs and provided temporary relief for his stomach cramps, the führer was won over. To the irritation of other Nazi doctors, Hitler then proceeded to swallow any of Morell's advice, no matter how harebrained, for the next eight years.

For example, to combat recurrences of the volcanic stomach problems, Morell plied him with a remedy called "Dr. Köster's Anti-gas pills," which contained significant amounts of strychnine—and Hitler often took as many as sixteen of the little black pills a day. The sallow skin, glaucous eyes, and attention lapses noted by observers later in the war are consistent with strychnine poisoning; another ingredient in the pills, antropine, causes mood swings from euphoria to violent anger. Even more peculiar were the injections of amphetamines that Morell administered every morning before breakfast from 1941, which may have exacerbated the erratic behavior,

inflexibility, paranoia, and indecision that Hitler began to display increasingly as the war ground on. And there was a barrage of other supplements—vitamins, testosterone, liver extracts, laxatives, sedatives, glucose, and opiates—all intended to combat the dictator's real or imagined ailments. After the war, U.S. intelligence officers discovered that Morell was pumping Hitler with twenty-eight different drugs, including eyedrops that contained 10 percent cocaine (up to ten treatments a day), a concoction made from human placenta, and "potency pills" made from ground bull's testicles. But despite the barrage of medicines, Morell's diaries (which were recovered from Germany and are kept in the National Archives in Washington, D.C.) make clear that the bouts of "agonizing flatulence" remained a regular occurrence.

A relatively healthy man when he met Morell, Hitler degenerated quickly toward the end of the war until he was a physical wreck. Hitler's arms were so riddled with hypodermic marks that even the normally passive Eva Braun complained to her mother about Morell as "the injection quack." When Hitler came down with jaundice in 1944, three Nazi doctors tried to have Morell fired. But the führer remained fiercely loyal—or just as likely, addicted to his chemical cocktails—and dismissed the trio of troublemakers instead. Morell stayed with Hitler in the bunker almost until the bitter end, as his patient began to fall apart completely (and a tremor in his left hand became uncontrollable, a probable symptom of advancing Parkinson's disease). On April 20, 1945, days before the Russians took Berlin, Hitler suddenly refused Morell's hypodermic and ordered him to strip off his uniform and leave. Desperately ill himself, Morell was soon captured by the U.S. Army and kept in prison for two years of interrogations, but he was never charged with war crimes. He was hospitalized immediately after his release and died in 1948.

If he had not been so cravenly devoted to Hitler, a hero worship he expressed over and again to U.S. interrogators, one might have

thought Morell a spy. It was a suspicion that had occurred to other Nazis, especially during the 1944 jaundice attack. Heinrich Himmler interrogated Morell's assistant Richard Weber in Berlin's Gestapo headquarters about whether the doctor was deliberately poisoning the führer with his treatments. "Out of the question," Weber replied. "Morell's too big a coward for that."

SOURCES/FURTHER READING: Jesse Browner, *The Duchess Who Wouldn't Sit Down: An Informal History of Hospitality* (New York: Bloomsbury, 2004); D. Doyle, "Adolf Hitler's Medical Care," paper given to the Royal College of Physicians Edinburgh, 2005; Bertram Gordon, "Fascism, the Neo-Right and Gastronomy: A Case in the Theory of the Social Engineering of Taste," *Proceedings of the Oxford Symposium on Food and Cookery* (1987); Leonard and Renate Heston, *The Medical Casebook of Adolf Hitler: His Illnesses, Doctors and Drugs* (New York: Cooper Square Press, 2000); David Irving, *The Secret Diaries of Hitler's Doctor* (London: Macmillan, 1983); Robert G. L. Waite, *The Psychopathic God: Adolf Hitler* (New York: Da Capo Press, 1993).

Damned Doctors

An ancient Roman tombstone erected on the Appian Way advised passersby: BEWARE OF DOCTORS! THEY WERE THE ONES WHO KILLED ME! This suspicion of the medical profession has hardly abated in the last two thousand years, and records of the last days of historical celebrities offer little encouragement. The tragedy for many patients was that doctors felt they had to do *something*, even if it did not help.

George Washington was bled four times on his last day of life in 1799, losing five pints of blood, which left him dehydrated and on the verge of hemorrhagic shock. As the coup de grâce, he was then given a purgative of substances today known to be poisonous, inducing horrific cramps and diarrhea.

(*continued*)

Napoleon had always held the medical profession in contempt until his exile on St. Helena. Although he was suffering from probable stomach cancer compounded by hepatitis, he was pushed into the grave by two physicians, the obnoxious Dr. Antommarchi and the British regimental doctor, the befuddled Archibald Arnott. Napoleon was fed a disgusting regimen of magnesium sulfate, opiates, and tinctures while being given enemas and laxatives (a treatment that was "from a medical point of view . . . incomprehensible, indeed unforgiveable," one modern medical author, Anton Neumayr, has noted). As Napoleon's constant diarrhea and vomiting became too frequent to even change the sheets, his followers could only look on helpless and aghast. On the last day of his life, the two doctors applied painful mustard-plaster poultices to the soles of the patient's feet, for reasons no one has ever quite guessed.

One can only sympathize with Casanova, who decided to defend himself by any means necessary from being forcibly bled by two surgeons in Vienna. With his last ounce of strength, he picked up a pistol from his bedside table and fired it at one doctor's head, nicking his wig and sending the pair scuttling off in terror. A maid gave Casanova water whenever he asked for it, and in four days he was "in perfect health," Casanova wrote. He even became celebrated as "the man who had defended himself from death by firing a pistol at it."

Casanova did realize that he could never let himself fall sick in Vienna again, since no doctor would ever make another house call.

Those Dastardly Robber Barons (What Did They Really Get Away With?)

(AD 1875)

T he 1980s may have become the signature decade for the greed-is-good philosophy, espoused by the character Gordon Gecko in the film *Wall Street*. But that era was just a bake sale compared to the 1870s, still the high-water mark for shameless capitalist free-for-all activity in the United States. Europeans were in awe at the speed with which a mere handful of industrial tycoons, emerging from the rubble of the Civil War, gathered mind-boggling fortunes with the open connivance of politicians in Washington. (The presidency of Civil War hero Ulysses S. Grant, 1869–1877, is now considered the most corrupt in U.S. history, even if Grant himself probably kept his nose clean.) And the press offered a chorus of support: no matter how below the belt their deals, the captains of industry were applauded across the nation as America's "natural aristocracy."

Today, we may still know the names of those mythic figures, but their identities have blurred into one—a sort of Snidely Whiplash character with a top hat and sinister smile. So how can we tell them apart? Who were the men behind those thick beards we see in photographs? And what were their most devious scams?

SOURCES/FURTHER READING: The classic account is Matthew Josephson, *The Robber Barons* (New York: Harcourt, Brace and Co., 1934); in recent years, biographies have included Ron Chernow, *The House of Morgan: An American Banking Dynasty and the Rise of Modern Finance* (New York: The Atlantic Press, 2001) and *Titan: The Life of John D. Rockefeller Sr.* (New York: Random House, 2003); David Nasaw, *Andrew Carnegie* (New York: Penguin Press, 2006).

KNOW YOUR ROBBER BARON

Scoundrel	Childhood	Big Break	Signature Coup
Cornelius Vanderbilt (Oldest of the robber barons—physically "bearlike"; irascible, foulmouthed, mean-spirited; sweeps around New York in a heavy fur coat and top hat all year.)	Son of poor Dutch immigrants; drops out of school at age eleven to become Staten Island ferry boy.	Uses $100 from plowing mother's stony field to buy small sailboat; uses it to build up lucrative ferry empire in Long Island Sound.	Master of "watering stock," printing shares in secret; manipulates rail freight charges to drive competition out of business, dropping them from $125 to $1 a car.
Jay Gould (Prototype capitalist, short, dark, humorless, "machinelike" manner. In 1869, dubbed "the Mephistopheles of Wall Street." 2005 biography lauds him as "an exemplary long-term CEO.")	Feral. Born to dirt-poor farmers in the Catskills, runs about barefooted and wild-haired.	As sixteen-year-old shop clerk, overhears employer's plan to buy bargain land; borrows money, purchases property for $2,500, then resells it for $4,000. (Sacked for disloyalty.)	Bilks Vanderbilt out of $7 million, then holes up in New Jersey hotel protected by police and soldiers. Travels to Albany with luggage stuffed with $1,000 bills for bribing legislature.

KNOW YOUR ROBBER BARON

Bid for Respectability	Secret Tip	Inspirational Quote
Bequeaths $1 million to Vanderbilt University, Nashville.	At séances, asks ghost of dead Jim Fisk for business advice. Disowns one son for extravagance; torments wife with niggardliness.	When skinflint is told on deathbed the doctor recommends champagne: "Won't sody-water do instead?" Bonus quote from son William, now world's richest man: "The public be damned!"
"Secret" donations to charities leaked to press.	As a schoolboy, the future Mephistoph-eles writes an essay on the theme "Honesty Is the Best Policy."	"I can hire one half of the working class to kill the other half."

KNOW YOUR ROBBER BARON

Scoundrel	Childhood	Big Break	Signature Coup
Jim Fisk (Likable, backslapping, womanizer, bon vivant; tall, portly, a snappy dresser—known for velvet vest and fingers covered in rings; nicknamed Jubilee Jim.)	Travels through Vermont with his father, an itinerant tin peddler.	During Civil War runs contraband cotton through Southern lines for Boston firm.	With partner Jay Gould, attempts to corner the gold market, setting off first Black Friday on Wall Street and 1869 depression. Pair walk away with $13 million.
John Rockefeller (Distinguished air, but has "a mouth like a shark's"; shy, reserved, parsimonious, pious Baptist.)	Impoverished childhood on family farm near Cleveland; at age seven begins hoeing neighbors' potato fields for 37 cents a day.	Saves $800 from his $180-a-year salary as a bookkeeper, then starts lending it out at interest.	Secret rebates from railroad companies allow Standard Oil to take control of Pennsylvania oil refineries.
Collis Huntington (Passionate and vindictive; with his lined face and thick black beard, reminds some of a Holbein character or "vicious Renaissance prince of the Church.")	Leaves home at age fourteen to become a peddler.	Marooned for three months in Panama with gold miners en route from California; clever trading earns him $4,000.	As chief of Central Pacific Railroad, sets up dummy construction company, milks $36 million from U.S. government.

KNOW YOUR ROBBER BARON

Bid for Respectability	Secret Tip	Inspirational Quote
Passionate art lover, liked to recline on Renaissance throne reading the *Saturday Evening Post*.	Blackmailed by former mistress; when refuses to pay, lover shoots him dead in the Grand Central Hotel (corner of Broadway and Fourth Street, New York City).	"Entrepreneur: A high rolling taker who would rather be a spectacular failure than a dismal success."
$600,000 for Rockefeller University, devoted to medical research.	Confesses that he discussed business deals with his pillow at night. ("These intimate conversations with myself had a great influence on my life.")	"The only way to make money is to buy when blood is running in the streets."
Builds $2 million mansion on Fifth Avenue (opposite current Trump Tower), but refuses to live in it, superstitiously convinced that men build houses only to die in them. Son starts Huntington Library, California.	Estimates it costs $200,000–$500,000 per annum to "fix" Congress. Always pays bribes by signed check instead of cash, so politicians are "ever afterwards my slaves."	"If you have to pay money [to politicians] to have the right thing done, it is only just and fair to do it."

KNOW YOUR ROBBER BARON

Scoundrel	Childhood	Big Break	Signature Coup
Andrew Carnegie (Unscrupulous tightwad; voracious autodidact; often speaks out for the worker, although his actions don't match the rhetoric.)	Child of poor Scottish weavers, raised near Pittsburgh; works twelve hours per day in clothes mills at age fourteen.	As assistant clerk to railroad magnate, tipped off to invest in railroad sleeping cars. Borrows $217.50 in stock, which soon earns return of $5,000 per year.	Locks out workers at Homestead steel mills and brings in scabs; violence leaves ten dead. National Guard breaks strike: mill profits $4 million; wages down 20 percent.
Pierpont Morgan (Blue-blooded Connecticut Yankee, brooding, brusque, silent, physically menacing—almost "Viking-like.")	Privileged upbringing; good education. Pays $300 to dodge Civil War draft (as do fellow scoundrels Gould, Carnegie, Fisk).	In London, at age nineteen, buys shipload of Brazilian coffee, creates shortage, then sells at huge profit.	During Civil War, buys defective rifles for $3.50, then resells to Union Army for $22; many men blow their fingers off. Bribes D.C. court to declare deal legal.

KNOW YOUR ROBBER BARON

Bid for Respectability	Secret Tip	Inspirational Quote
$350 million to charities and institutions of higher learning; starts 2,500 free libraries.	Asks golf partner, publisher Frank Doubleday, about profits. On learning the actual money in the book business, famed benefactor of libraries sniffs: "I'd get out of it."	After bloody Homestead strike, telegrams minions from holiday in Europe: "Congratulations all around—life worth living again—how pretty Italia."
$500,000 to build the Church of St. John the Divine in New York, the world's largest Gothic cathedral. Buys fortune in art, including a Vermeer, although he has never heard of the artist.	Throws food at slow servants; tours Egypt in luxury car but ignores spectacular ruins to pore over cablegrams from New York.	"If you have to ask how much something costs, you can't afford it."

The Fastest Food in the West

(AD 1875)

While industrialists were hammering out their vast empires in the nineteenth century, American chefs were refining their own contribution to world culture: fast food.

As with so much else, we can blame the ancient Romans for the original idea. As excavators have found in Pompeii, busy citizens would stand at stone counters called *thermapolia* and shovel down fried meat or rich stews ladled out of vats in the counter (an early form of steam table). Travelers even more pressed for time could order takeout from roadside inns scattered at regular intervals along the highway system. (One such ancient diner excavated in Germany has been nicknamed by archaeologists Big Maximus.) This stop-and-go dining reappeared centuries later in prerevolutionary France, where some of the earliest restaurants provided long benches for customers to sit down in fifteen-minute shifts, just long enough to scarf a plate of steaming broth. Conversation was discouraged and guests would be chased out by the eagle-eyed proprietors if they lingered. But it was the United States that really took the lead in high-speed dining, thanks to the boom in railway construction after the Civil War that culminated in the line across the Old West in 1869. The long-distance trains from Omaha to San Francisco had dining cars only for the first-class passengers. Everyone else had to wait until the trains stopped at specific stations for scheduled meal breaks, when hundreds

of passengers would madly dash into cavernous dining halls on the platforms. Inside, cadres of white-aproned waiters were poised to splash meat and potatoes onto their plates and granular coffee into their cups. The whistle would blow and patrons would have to abandon their half-eaten meals and dash back to the moving train. The whole indigestion-inducing process, travelers complained, might last only ten minutes.

Strangely, this high-speed refueling wasn't limited to travel. Even in the finest restaurants of New York, velocity was considered a big plus in the 1870s. At the famous Union Square venue of Delmonico's, the legendary chef Charles Ranhofer boasted about his power lunches. Diners in a serious rush could choose to have an eight-course meal in sixty-four minutes. While one course was being devoured, Ranhofer said proudly, another would already be coming from the kitchen, "so that the dinner can be served uninterruptedly and eaten while hot and palatable." Although Ranhofer was French-born, this development distressed visiting Continentals, who had largely reverted to leisurely meals; some critics compared a meal at Delmonico's to "the torture of Tantalus," where the guest was faced with "a long stream of dishes which they never have time to touch."

SOURCE/FURTHER READING: Cathy K. Kaufman, "Structuring the Meal: The Revolution of *Service à la Russe*," in Harlan Walker (ed.), *The Meal: Proceedings of the Oxford Symposium on Food and Cookery* (Oxford: Prospect Books, 2002).

The Semen of Hercules

(400 BC)

Y ou can't open the sports pages these days without learning about another doping scandal. Surely this devious practice is a modern scourge, a by-product of greed-ridden professional sports—and a far cry from the classical Greek ideal of athletics, which aimed to elevate the human spirit while perfecting the body. Ancient sculptures like the *Discus Thrower* portrayed the Apollonic moral purity of sporting champions, who had, according to the ancient author Lucian, "a sacred gift," and were even "equal to the gods themselves."

But the Greeks actually had their own equivalent of doping scandals, involving magic potions, charms, and spells. Although they might seem innocuous to sporting stars today, these enchanted performance enhancers were powerful influences on the athletic psyche and had the added benefit of being undetectable in urine.

According to the third-century Greek author Philostratus, who penned a useful volume called *Handbook for a Sports Coach*, the two professional groups most actively involved in sorcery were athletes and prostitutes. Fragments of papyrus spell books that survive today include magical formulae to enhance strength, speed, luck, and virility. There is one spell that when chanted to the sun god Helios seven times would pump up a wrestler's physique and guarantee success in the ring. It begins in Greek, then lapses into Egyptian, which was regarded as the language of magic, since the gods were

born by the Nile. (It reads: *"Rejoice with me, you who are set over the east wind and the world, for whom all the gods serve as bodyguards . . . you will rise from the abyss, you who each day rise as a young man and set as an old man, HARPENKNOUPHI BRINTANTENOPHRI BRISSKYMAS . . . I ask to obtain from you life, health, reputation . . . strength . . . victory over all men and all women."*) Wrestlers could also use a shorter chant that had to be said over an offering of oak charcoal and sacred incense, "with which has been mixed the brain of a wholly black ram . . ." An excellent spell for runners, called "Hermes' wondrous victory charm," directed to the god of speed, could be inscribed on a tiny gold medallion and hidden in a sandal—outside the gymnasium, that is, since the all-male athletes competed naked in ancient Greece. Other athletes wore grisly "victory amulets," like the leg of a lizard found in a cemetery, to put extra spring in their step. Details stipulate that the reptile in question had to be caught at night, have the right back foot cut off with a sharpened reed, then returned to its hole alive.

Then there were the oral fixes: potions concocted from hundreds of mysterious ingredients, including herbs and roots that had to be gathered under certain phases of the moon. Of the 450 or so plants mentioned in the surviving papyri, few have been identified by modern scholars. Many were simply given code names: wormwood was known as the Blood of Hephaestus; buckthorn was known as Bone of Ibis. Other active ingredients included Ethiopian dirt, the blood of a tick found on a black dog, piglet's milk, the flesh of a spotted gecko, and the wine in which a raven had been drowned. Sadly, we can only hazard a guess at the specific pharmaceutical use of squeezed mustard-rocket leaf, known to the Greeks as "the Semen of Hercules."

Such abuses clearly disturbed the Greek sports organizers, who managed some 350 festivals around the Mediterranean world in a rotating cycle. At the ancient Olympics, athletes had to make a solemn oath over a slice of bloody boar's flesh, which had been placed

in front of a menacing statue of Zeus wielding his thunderbolts, that they had used no unfair means to gain victory—a safeguard aimed at both corruption and magic. Judges even forced Olympic contestants to live together in a barracks for thirty days before the Games, so they could keep an eye on them and make sure they didn't get juiced up on nefarious potions or other substances recommended by their coaches.

This didn't seem to stop athletes—mostly because, in ancient Greece, the winning stakes were even higher than they are today. In addition to the huge cash prizes and victory parades awarded by the champion's home city, athletes could pick up an honorary priesthood, front-row seats at the theater, or a lifetime supply of olive oil; some even parlayed their victory into a career in politics. There may not have been any corporate sponsorship deals in antiquity, but Olympic victors earned huge fortunes just by making appearances at the many provincial games, touring the Greek world like members of a traveling circus. Worshipped by fans, these top-ranking athletes were guaranteed "sweet smooth-sailing" (as the poet Pindar put it) for the rest of their lives.

In short, the ancient sports celebrities were as removed from their fellow citizens as NBA stars are today. The temptation to cheat, it seems, was irresistible. They may have been treated like demigods, but they were only human, after all.

SOURCES/FURTHER READING: Hans Dieter Betz (ed.), *The Greek Magical Papyri in Translation, Including the Demotic Spells* (Chicago: University of Chicago Press, 1992); Fritz Graf, *Magic in the Ancient World* (Cambridge: Harvard University Press, 1996); Steven G. Miller, *Ancient Greek Athletics* (New Haven: Yale University Press, 2004).

Last Dinner on the *Titanic*

(AD 1912)

Even for the most die-hard history buff, nostalgia has its limits. One eulogized Edwardian dinner party you wouldn't want to have attended was held on board the *Titanic* the night of April 14, 1912. This was the fifth night of its maiden voyage, and as usual dinner for all three classes went off without a hitch—in fact, apart from the drop in outside temperature, diners noted the steady calm of the waters and the comforting thrum of the engines as the boat increased speed across a glassy black sea. There are two surviving menus from the regular First Class Saloon (one was retrieved from a victim, the other, in better condition, from a guest who made it to the lifeboats). They show that diners enjoyed an eleven-course French meal that began with Canapés à l'Admiral (shrimp in garlic, lime juice, and tomato served on thin baguette), moved on to Calvados-Glazed Roast Duckling, and ended with Peaches in Chartreuse Jelly. But for the crème de la crème in first class, to whom money was no object, the ship boasted the even more exclusive À La Carte Restaurant, where meals were charged extra to the passage price. Nicknamed The Ritz, it was an overdecorated Louis XVI–style dining room with rose shag pile carpet and floor-to-ceiling mirrors. Unfortunately, no printed menu survives—it was operated independently of the other dining rooms by veterans from London's top hotels, with its own kitchen and management—but survivors would remember

the courses in great detail as an over-the-top barrage of caviar, lobster, and quail.

Thanks to James Cameron, everyone knows the approximate timetable of the disaster by heart. And we all know that many more women and children passengers were saved than adult men (369 to 131). But one statistic less bandied about is a breakdown of survivors by meal class. Of the 1,317 passengers thought to be on board, a total of 500 were rescued, an average of 38 percent overall. Surprise, surprise, you had your best chances if you had dined on caviar and champagne that night: 143 out of 148 first-class women and children were saved (96.6 percent), and 58 out of 176 men (33 percent). Second-class diners were a little worse off: while 105 out of 117 women and children survived (89.7 percent), only 13 of 154 men did (7.8 percent). And of those who had endured the starchy third-class dinner, only 121 out of 259 women (46.7 percent) made it, and 60 out of 390 men (13.3 percent).

About a quarter of the 812 male crew survived, operating essential emergency positions. But what of the less crucial restaurant staff? The violinist and cellists who had been serenading diners all famously went down with the ship. But less notorious is that only 1 out of the 66 male workers in the fabulous À La Carte Restaurant survived—the French maitre d', Paul Maugé. According to the inquiry held in New York, Maugé saw a lifeboat being lowered only two-thirds full and dropped ten feet into it, breaking a lady passenger's legs in the process. Maugé said that he also tried to get the À La Carte chef to jump, but the man refused, saying he was too fat.

SOURCES/FURTHER READING: Rick Archibald and Dana McCauley, *Last Dinner on the Titanic: Menus and Recipes from the Great Liner* (New York: Hyperion, 1997); Walter Lord, *A Night to Remember* (revised edition, London: Bantam Books, 1976). The most thorough study of the passenger lists, down to individual case studies and photo portraits, can be found on www.encyclopedia-titanica.org.

Napoleon Unzipped #5: Shrinkage?

(AD 1821)

Emperor Bonaparte laid bare on the makeshift autopsy table must have been a shocking sight that afternoon of May 6, 1821—the day after he had died at Longwood House on St. Helena—but the eyes of some British observers crowded into the dark, dismal room were inevitably drawn to the mythic figure's most human regions. The body was plump and "effeminate," wrote one of the British doctors, Dr. Walter Henry, in his widely circulated autopsy report. "The pubis much resembled the *mons veneris* in women. . . . The penis and testicles were small in development." In his memoirs, published in 1828, Henry added a footnote in Latin for the delectation of the British public: *Partes viriles exiguitatis insignis, sicut pueri, videbantur.* (The private parts were seen to be remarkably small, like a boy's.)

These tart observations have long intrigued medical historians, who also note that in his midthirties, Napoleon quickly changed from a trim, handsome, Byronic figure with rich flowing hair to the corpulent, balding character who waddled about in a gray military coat. According to the nefarious Dr. Antommarchi, Napoleon once joked about his increasingly feminine figure: getting out of the bath one day, he remarked, "See, doctor, what lovely arms, what smooth white skin without a single hair! Breasts plump and round—any

beauty would be proud of a bosom like mine." (We do not know if Napoleon was somehow defiantly mocking the doctor—or if the taunt later provoked Antommarchi to emasculate the ex-emperor when he was at his mercy.)

A whole shopping list of arcane disorders has been produced to explain Napoleon's ever-morphing appearance. Some have suggested "hyperpituitarism," the excessive activity of the pituitary gland, which would explain, in addition to his fatigue and erratic behavior, his soft, round figure, his delicate hands, his man-breasts and, yes, his shrinkage. Or maybe it was "hypergonadism," a disorder of the chromosomes that occurs in about one out of every five hundred men. (Then there are the more exotic diagnoses: Frölich's syndrome, anyone? Pituitary eunuchoidism?)

At present, only one size issue has been resolved: the emperor was not all that short. He was actually five feet, six inches, slightly above average for men of the time. The misconception grew from a confusion over French measurements and the affectionate nickname given to Napoleon by his soldiers, *le petit corporal*. The modern phrase "Napoleon complex" is thus based on a false premise. The term evolved from the theory propounded by Viennese psychiatrist Alfred Adler in 1912 that short men suffer an inferiority complex and overcompensate by being more aggressive. But if history has shown us anything here, the complex should describe an entirely different deficiency in the male anatomy.

SOURCES/FURTHER READING: Frank McLynn, *Napoleon: A Biography* (New York: Francis Edwards, 1977); Anton Neumayr, *Dictators in the Mirror of Medicine: Napoleon, Hitler, Stalin* (Vienna: Medi-Ed Press, 1995); Fran Richardson, *Napoleon's Death: An Inquest* (London: Kimber, 1974).

Acknowledgments

The book would not have been completed without three distinctive New York institutions. It was written in the Drawing Room of Soho House club; the Wertheim Room of the New York Public Library; and the Writers Room in downtown Manhattan. I would like to thank all three for putting up with me and my piles of arcane books.

For my initial inspiration, I owe a great debt to the collector Dr. John K. Lattimer (now sadly deceased) for showing me his array of historical memorabilia—the most astonishing Cabinet of Curiosities in the U.S.—and his daughter Evan Lattimer, who allowed me to behold the Napoleonic "specimen." Many experts kindly cast their eyes over specific sections of the magnum opus: I am grateful to Professor Paul Cartledge of Cambridge University, for advice on ancient Greece and Rome; medievalist Julie Abbruscato, on the Middle Ages; Micah Morrison, veteran of the *Wall Street Journal*, on robber baron scoundrels; Professor Thomas W. Laqueur of U.C. Berkeley, on the general history of sex; author Brian Turner, on demented travelers and gourmands; Steffen White on J. Edgar Hoover; Bruno Magnani, on ancient Roman cuisine; author David Farley, on Jesus' foreskin; and Thad Sebastian for his general research assistance.

Warm thanks to my agent Henry Dunow, whose enthusiasm for my obsessions first got this book off the ground; Laurie Chittendon,

my excellent editor, for believing in its potential; and her energetic assistant, Will Hinton, for ushering it safely to completion.

Finally, I would like to reserve my deepest gratitude for my wife, Lesley Thelander, who not only pored over the manuscript at every stage of its development but added her fertile creative input, endless encouragement, and any of the decent jokes.

Index